莊明景
Mike CHUANG

目　錄

04 │ **部長序** / 史哲

06 │ **館長序** / 廖仁義

08 │ **攝影家自序** / 莊明景

專文
12 │ **明景即喻景**
　　——望穿「意映」與「寫照」交織的錦屏 / 胡詔凱

36 │ **繪影氣勢**
　　——莊明景風景攝影之神秘他性 / 姜麗華

57 │ **作品**

167 │ **口述訪談** / 胡詔凱

191 │ **傳記式年表** / 胡詔凱

216 │ **莊明景簡歷**

218 │ **圖版索引**

Contents

05 | Foreword from the Minister of Culture / Shih Che

07 | Foreword from the Director of NTMoFA / Liao Jen-i

09 | Preface from the Photographer / Mike Chuang

Essays

44 | From a "Clear View" to Metaphorical Scene:
Looking through the Brocade Screen Woven from "Reflection of Meaning"
and "Portraiture" / Hu Chao-kai

50 | Painting Images of Grandeur:
The Mysterious Otherness of Mike Chuang's Landscape Photography
/ Chiang Li-hua

57 | **Works**

184 | **Interviews of Mike Chuang** / Hu Chao-kai

191 | **Biographical Timeline** / Hu Chao-kai

217 | Mike Chuang (Chuang Ming-jing) Biography

218 | List of Works

部長序

《臺灣攝影家》系列叢書是以攝影家個人的生命史、創作歷程與藝術表現為主體,進行深入的研究、爬梳與評述書寫。文化部長期支持此系列叢書的撰研與出版,即期待藉由個別攝影家作品所展現的本土內涵、創作意識及時代文化脈動,構築一個以攝影為核心的知識體系與藝術史發展脈絡,並由此認識過去、關照當下、展望未來。

本年度出版的《莊明景》、《黃永松》、《侯淑姿》三冊專書,除了以專論文章來探討藝術家攝影實踐中的影像底蘊,亦經由深度訪談來梳理他們的創作軌跡,並匯集攝影家歷年來具代表性的重要影像作品。莊明景先生意境朗闊、氤氳靈動的風景攝影,是其不斷深入自然大化間潛心觀察、蹲點採景後,結合心境體悟的一種影像轉譯表現。黃永松先生以推廣民俗文化藝術為己任,他靈活運用與組合影像,創造攝影與文字並重的編輯報導形式,並以大量攝影作品熱忱地紀錄下臺灣特有的時代影跡。侯淑姿女士的作品關注攝影的藝術性以及其反映當代議題的能力,她探討性別、凝視、權力體系、自我與家/國及社會認同等相關議題,並在創作實踐中拋出自身對藝術及人生的思考,傳達其獨特的關懷視野。

影像可以見證歷史、召喚記憶,亦具有對應社會、文化議題並促成反思及影響的潛能;而攝影家自身的理念與訴求,則是賦予影像獨一無二的生命力,並成為傑出攝影創作的關鍵。《臺灣攝影家》系列叢書的出版,除了希望引領觀眾深入攝影家的影像視野,了解他們所視所感的臺灣文化紋理,並且以此向全心投注於攝影創作的藝術家們致敬,亦期待透過攝影家個人史料的蒐整、分析以及此系列專書的逐年出版,持續為臺灣攝影史的建構奠基。

文化部部長

Foreword from the Minister of Culture

The Photographers of Taiwan series conducts in-depth research, including the combing through of historical documents and producing written commentary, to provide insights into photographers' biographies, creative processes, and artistic performances. The Ministry of Culture is a long-term, staunch supporter of the compilation and publishing of this series. By examining the local context, creative awareness, and historic culture present in each photographers' work, the series supports photography-based knowledge systems and art history development. Readers of the series learn about the past, keep an eye on the present, and look ahead to the future.

The three books in the series this year, featuring *Mike Chuang*, *Huang Yung-sung*, and *Hou Lulu Shur-tzy*, contain articles that explore the meaning of the photography produced by each of these artists and in-depth interviews that revisit their creative trajectories. Important, representative images are included in each book. Mr. Mike Chuang's landscape photography is bright, expansive, dense, and clever. He closely observes nature, taking the time to examine a location before shooting photographs that present both his mood and experiences. Mr. Huang Yung-sung made it his duty to promote popular customs, culture, and art. He nimbly uses photography for illustrated reports that enthusiastically track Taiwan's history. Ms. Hou Lulu Shur-tzy, meanwhile, examines photography's artistic nature and ability to reflect on contemporary topics. She looks closely at gender, observation, rights systems, the connection between self and home/country, and social recognition. By using photography to present her thoughts on art and life, Hou reveals her distinct attention and perspective.

Images that bear witness to history and summon memories respond to social and cultural topics, facilitate reflection, and have the potential to effect change. The photographers who create these images seek to produce original, lively content that reaches the level of art. *The Photographers of Taiwan* series aims to provide readers with a deeper understanding of individual photographers' perspectives to show the Taiwanese cultural fabric that each photographer sees and feels. At the same time, the series pays homage to all artists devoted to photography. Gathering and analyzing personal historic data on photographers then publishing these findings in this series, year after year, continues to build a foundation for presenting the history of photography in Taiwan.

Shih Che
Minister of Culture

館長序

《臺灣攝影家》系列叢書自2016年策劃執行以來，已進入第六輯的階段。以深化對臺灣攝影家的研究為叢書編纂目標，國家攝影文化中心本年度針對莊明景先生、黃永松先生及侯淑姿女士三位攝影家進行詳實的研究，呈現出攝影家獨特的藝術視野以及創作歷程。

莊明景先生以扎實的經驗積累，仔細推敲、琢磨拍攝的時間、光、影等細節。他在翻山越嶺的自然行腳中，敏銳捕捉山川林野細緻動人的景觀律動，或運用高反差的調性呈現黑白相間的對比強度，或以高解析度的細膩色彩營造氣勢磅礴的奇觀異景。其精采絕倫的取景視角，是攝影家對大自然生命力的體會與禮敬，亦讓觀者經由他的鏡頭視野，體會作品中氣韻湧動的感性張力。

黃永松先生是位勇於多方嘗試的理念實踐者，半生投入民間文化採集與田野調查。他的攝影善於捕捉人物氣質，並巧妙靈活地運用近景、特寫、連續與停格影像的攝影形式，創作出極具敘述張力的攝影作品，生動地紀錄了臺灣的鄉土人文與民俗樣貌，也映照出其心心念念所牽掛的文化傳承志業。

侯淑姿女士是臺灣觀念攝影的先行者之一，她的作品從早期強調女性主體性、自覺意識的創作，逐步擴大為關注階級、族群、社區共同記憶等「身分認同」的主體性議題。近年來，她持續以田野調查方式，深入個體差異之身分認同經驗的分析與探討，結合長時間的傾聽、紀錄、行為構組影像裝置，建構深具個人特色的視覺政治語彙，也顯現出其對個體生命經驗的尊重與價值信仰。

本年度三冊專書，呈現三位攝影家各具特色的美感冶煉、理念形塑、創作生命折轉、以及他們對所處社會環境的回應、對話與影像詮釋方式。在此，除了要特別感謝三位攝影家對本系列叢書的支持，也要對所有參與撰述的研究學者致上最大的謝意。透過學者們的研究論述、精采的作品選介、深度訪談與大事年表，使讀者能以多角度的面向，理解攝影家的作品及其影像實踐的創作視野。

國立臺灣美術館館長

Foreword from the Director of NTMoFA

Since the start of the planning and implementation of *Photographers of Taiwan* in 2016, the series has already entered its sixth year. Continuing the series' objective of providing intensive research into Taiwanese photographers, this year the National Center of Photography and Images provides detailed information on three photographers: Mr. Mike Chuang, Mr. Huang Yung-sung, and Ms. Hou Lulu Shur-tzy. The books provide insight into the photographers' original artistic perspective as well as their creative process.

Mr. Mike Chuang leverages his years of robust experiences and careful thought to refine the time, lighting, and shadows that are part of his photography. On journeys into the natural world, Chuang keenly captures the rhythm of the mountains, rivers, and forests. Using high-contrast tones he presents the intensity that is shown by alternating blacks and whites. Using high-resolution and meticulous coloration he presents majestic spectacles and exotic scenes. Chuang's brilliants, marvelous perspectives demonstrate his familiarity and reverence for the natural world. Through Chuang's lens and perspective, viewers experience the character and sensibility present in his photography.

Mr. Huang Yung-sung, a multifaceted experimenter who puts ideas into practice, spent many years gathering information and conducting field investigations on folk culture. He is adept at using photography to portray people's manner, and nimble at using headshots, close-ups, continuous shooting, and stop motion techniques to create photographs with a strong narrative tension. These dynamic records of Taiwanese countryside culture and popular customs fulfill Huang's heritage aspirations.

Ms. Hou Lulu Shur-tzy, a pioneer of Taiwanese ideological photography, initially focused on female subjectivity and self-awareness before gradually expanding her attention to subjective identities that arise from shared memories of different classes, ethnic groups, and communities. In recent years, she has continued her field investigations to engage in analysis and investigation of identity recognition associated with individual differences. Together with her long-term practices of listening and recording, she built a visual and political vocabulary that deeply reflects her individual characteristics. This reflects the esteem and value she holds towards individual life experiences.

The three books in this year's series showcase development of the distinct aesthetic and philosophical views of these three photographers as well as their reflections on life, their responses to the social environment, and the interpretive methods they bring to dialogue and images. Besides thanking these three photographers for their contributions to this book series, I also want to express gratitude to all the researchers who participated in this effort. The research and discourse, the brilliant introductions to photographic works, the in-depth interviews, and the biographical timelines enable readers to understand the photographers' works, practices, and creative perspectives from a wide variety of angles.

Liao Jen-i

Liao Jen-i
Director of National Taiwan Museum of Fine Arts

攝影家自序

回顧六十多年攝影生涯，是命運的安排，也是個人生命的刻痕。雖然孤單獨行，卻不寂寞落空，歲月消逝在天之涯、地之角，帶回了無數的際遇與美景。影像中看到的是用過的時間，也抱回了無限的空間。與大自然的深緣，讓自己喜愛存在的無限性。不論是空間的延伸或是時間的久遠，在大自然中可以找到無障礙的融合。從狹義的生命起源，到廣義的宇宙永恆，探索兩者間接觸與延續的思維路徑。

風景攝影是追求「大氣」與「大地」的完美結合，也是探尋天時、地利、人和的巧妙機緣。外觀風景、內生心景，從心境提升到意境的起生。讓美感經驗帶來正面的人生觀，使生命的內涵，踏實而豐富。1971年到美國從事商業攝影謀生立足之後，卻放棄安定，回歸自然，流浪式的風景攝影生涯，把個人放逐了一段很長的時間，拍了很多北美洲的國家公園，還遠征阿拉斯加，不虛此行，也不負此生。

1981年赴紫禁城拍攝《北京故宮博物院》一書之後，開始接觸中國大陸，到處拍攝名山大川，對這片既熟悉卻陌生的土地，重新認識。最辛苦的青藏高原之旅，讓自己探訪了「秘境」與「淨土」，去尋找高原上的心靈高原。最後去了二十六趟的黃山，是攝影生涯中投入最多的主題。黃山氣象渾厚，有天與地的完美結合，讓人領會心靈的意境的成長，體會文人的澄懷觀道，如老子的滌除玄覽、莊子的坐忘、晉玄言清談等，達到藝術的最高境界。黃山有五絕，松、石、雲、泉、雪。白雲凌「風」，松石點「景」，前者動後者靜，動靜相融，山水相感，陰陽相成，天人合一。

春時初芽新綠，夏日滋長茂盛，秋紅成熟多彩，冬至休養待生，大自然的規律，給生命一定的秩序，人生甲子就像生命的巔峰時刻，飽和燦爛。回顧過去往年，運氣與機緣，有時錯過不巧，有時卻躬逢其時，刻意的努力與等待，留下的美景，讓此生有很多的彩色與黑白，追尋「風景攝影」的樂趣，永久、深遠、無止境。

攝影家

Preface from the Photographer

As I look back on my photography career of over 60 years, I see the workings of fate, and the marks it has left on my individual life. While this has been a lonely and solitary journey, it has not been fruitless. I spent my years traveling the ends of the earth; returning, I brought back with me a wealth of encounters and matchless scenes. What I see in those images is the time that I spent on them, and the limitless spaces I brought back with them. The deep connection I have with nature has given me a love for the infinity of existence. In nature, whether in the vast reaches of its space or in the depths of time, you can find unobstructed oneness. You can explore a line of thought where you find connection and continuity, between life's origins in the narrow sense, and in the larger sense, the eternity of the universe.

What we seek in landscape photography is an ideal combination of "the atmosphere" and "the earth". But it is also a wonderful opportunity to discover ideal combinations of times, places, and people. The scenery you see around you produces an inner image in your heart, and from there, your state of mind is elevated until it forms an artistic conception. The experience of beauty brings out a positive view of life, which creates a solid and rich sense of meaning. I went to the U.S. in 1971 to make my living in commercial photography, but later gave up the stability of that career to return to nature. I took up a career as a wandering landscape photographer, undergoing a long period of self-exile in which I photographed many North America national parks and even went on a long trek to Alaska. I do not regret those journeys, and my life has been worthwhile.

I first began to have contact with China when I went to the Forbidden City in 1981 to photograph for the book *Palace Museum: Peking, Treasures of the Forbidden City*. I traveled everywhere, photographing its famous mountains and rivers, and began to re-acquaint myself with this familiar, yet to me, unknown land. The toughest journey, to the Qinghai-Tibet Plateau, allowed me to visit its "secret realm", its "pure land", as I searched on its physical plateau for a spiritual plateau. In the end, I went to Huangshan 26 times, the most time I invested in any subject during career as a photographer. A powerful atmosphere surrounds Huangshan; it is a perfect meeting of the heavens and the earth. There you will understand the growth of the artistic conception in the mind, and how the literati would achieve their clear vision of the Tao, as with Laozi purifying his vision to achieve understanding, or Zhuangzi sitting in forgetfulness, or the philosophies of the Jin Dynasty period, and thus reach the highest realm of art. Huangshan has its "matchless five", which in its case are pines, boulders, clouds, springs, and snow. The white clouds ride upon the wind, the rocks and pines outline the scenery; the former are in motion and the latter still, so that motion and stillness blend together. Mountains and rivers are in communion, yin and yang complete each other, and man and the heavens are united.

In spring, new buds are green, and the summer is full of lush growth. Then the red autumn comes, mature and colorful, and after the winter solstice, we rest and wait for new life. The laws of nature give life a definite order. A cycle of 60 years in a human life brings you to the summit of your life, full and brilliant. I look back on the years past, the good luck and the opportunities, which sometimes unfortunately passed me by, but at other times came my way at just the right time. My deliberate effort and my waiting have enabled me to capture many beautiful scenes, which have brought so much richness and splendor to my life. The joy of pursuing landscape photography is perpetual, deep, and unlimited.

Photographer Mike Chuang

專文
ESSAYS

明景即喻景
——望穿「意映」與「寫照」交織的錦屏

文 / 胡詔凱

對象之美，有賴其形而上的本質在其表象中顯現出來。
　　——瓦迪斯瓦夫 · 塔塔爾凱維奇（W. Tatarkiewicz）[1]

一、前言

美感，不需要轉彎。

當我們面對事物對象「直覺」產生驚豔、讚嘆，或是從對象身上產生連結、想像，引起悲憫情懷或快感愉悅。這些關於美的感受，經常是對象本身的「鮮明性」所激起我們不由自主的情緒反應。當此自顯之「明景」[2] 與身懷自在心、構圖眼、直覺手的「（莊）明景」相遇，會交織出什麼樣的影像美感經驗與價值，是本文的核心議題。

若問美感的價值，可參考徐悲鴻以「惟妙惟肖」作為繪畫審美的判準——「惟肖」代表「寫實」的技藝功夫，「惟妙」則是屬於美、是精神上的反應，兼有情緒性、情感性，乃至（某特殊）情境上的聯想。

但是，就攝影的寫真照相而言，「惟肖」是與生俱來的本能，「惟妙」這種精神層面的感受，卻成了拍照的主要挑戰，但也成為作者可以發揮的空間。它既要取自於現實素材，又要「傳神」——透過現實外在表象傳遞苦難滄桑、喜樂釋懷等等的內在精神，總難免會在作者與讀者的認知之間，宛若隔上一層紗、一扇屏。因

而，相對於「主觀攝影」（Subjective Photography）[3]之鏡像心理投射，或「心象攝影」[4]過度強調個人化的觸景移情與感性投射—簡單樸素的「直觀／直覺」交流，即成為攝影走進群眾的方便法門。

蘭格（Susanne K. Langer, 1895-1985）的「表示論」（signification theory）藝術觀，認為藝術品並不表現藝術家個人親歷的情感，只表示藝術家對情感形式的了解，這就是藝術品的「意義」。[5]莊明景一言蔽之的說出攝影對他的意義，就是「美感經驗的累積與展現」。此觀點點出了他針對「美的情感」如何藉由攝影媒材「形式」予以展現的思考，與蘭格「藝術家對情感形式的了解」的觀點相互呼應。

「水仙花」生長於水邊的彎腰姿態，因為在視覺上宛若低頭「顧盼自己水面倒影」的形象，而被以「Narcissus——希臘神話中『顧影自憐』的美少年」之名來表示；此即因為事物鮮明的視覺連結，而被賦予共通喻意的例子。以（大／小）自然的姿態作為主要創作題材的莊明景，從視覺上尋找事物的自明性、顯明性美感，選擇適當形式將此外在的美感捕捉，以連結你我內在的共通情緒。

攝影照相的先天「寫實性」，可輕易滿足「惟肖」審美標準，只待攝影師確認原始風景的現場光源與曝光量。而若要追求「惟妙」，則涉及賦予意念感受的「寫意性」，不論是「明喻（simile）之景」或「隱喻（metaphor）之景」，均有賴攝影師做更多的觀察、面對、掌握事物天性與媒材本質、框取布局、設定、等待時機……這些是我們認識（莊）明景之／及喻景的準繩（criterion）。

「明喻」與「隱喻」兩者，同為借物敘述的手法，可以讓意義的傳達更加動人，唯差別在於，後者在追尋意義的巷弄裡多了個延伸，讓讀寫雙方的感受在「轉角」處相會。因此在巷口看得到的，以及轉角處也隱約看得到的視覺，融合在一起，同顯眼前。

然後，若要進一步轉進探詢超越表象的深處奧妙，則端視讀者是否願意和莊明景一樣嘗試，將事物自性歸還給自然，將天賦美感還諸天地。赫普沃斯（Barbara Hepworth, 1903-1975）即曾表示「具象或抽象的立意並無不同……有同樣的愉快」。[6]

本文架構將從莊明景的攝影生涯出發，探索他的攝影觀，分析其作品如何經由特有的形式，傳遞自然（含人文）美好的性質，從而歸結莊的攝影指紋——「寫意的胸中明景」與「寫實的屏幕明景」[7]交織的百般姿態。

二、出世與入世之間的人生

攝影創作是一種儀式：進入一個情境，面對對象、觀察、思考、架設設備、等待「奇點」[8]以按下快門，然後出脫情境、回到現實。此過程宛如禪定之式：放下世俗紛擾，放空生理之縛、心理之罣，觀鼻息、觀自在、

觀無，至於「頓悟」[9]覺知，然後回到那現實、那渺小得在一念之間即可放下的虛妄塵世。

攝影創作是一種遊戲、一種帶著實驗性格的儀式歷程：從準備遊戲器具、了解遊戲規則、思索布局、行動、依回應而調整布局與行動……。如此反覆，直到獲得滿意的成果。在那專注忘我的歷程中，每一次布局與行動無不是「挑戰未知」的嘗試，遊戲主體從中獲得無涉功利的愉悅快感而上癮。

莊明景的一生，即是在進出現實與無我的攝影儀式情境中，在務實與忘我反覆嘗試的遊戲之間，自在游移。

莊出生於日本殖民統治末期的 1942 年，童年住在臺北市大稻埕及北門周邊，雖然幼年成長環境遇上二二八事件的敏感時空，但家族事業規規矩矩、經營有成，讓他能夠「與世無爭」的求學、成長，並走上一日為攝影、終身為攝影的生涯之路。

總括其一生的攝影之路，大致可分成四個（時間略有重疊的）階段：其一，從高中自學攝影到赴美前的「自遊」階段（約 1958-1970 年間）；其二，遠赴美國從事商業攝影到「壯遊」北美階段（約 1971-1983 年間）；其三，回臺發表作品、定居、並「遊走」兩岸拍照的階段（約 1981-2012 年間）；最後，則是開始使用數位相機與電腦後製，結合照相與造像、嘗試以軟體做二次創作的「遊創」階段（約 2008 年迄今）。

在初生之犢的第一個階段，莊已經自如地顯露攝影天分；從早期作品〈蘭嶼（轉與凝）〉（1968），〈蘭嶼（勢與穩）〉（1968）可看出，他雖未曾受過視覺藝術或攝影專業課程訓練，卻能以「單純無染」的拍照動機[10]嘗試報名攝影比賽而屢獲佳績。這樣如康德（Immanuel Kant, 1724-1804）所提的「純粹美」[11]態度，在多數以取悅大眾感官偏好、訴諸「依存美」動機的獎金獵人之環伺競爭中，莊仍能脫穎而出，可謂異軍突起。但即便是無爭的攝影

初衷，仍因為得獎作品被電影公司主管看到，進而受邀為美女明星拍攝宣傳照，能夠雙軌並行的同時在自主攝影與遵循現實要求之中，展露長才。

然而，他並不以此自滿，強烈的冒險性格，促使他放棄收入穩定的家族企業工作，開啟第二階段攝影生涯，於 1971 年勇闖美國紐約進入商業攝影圈，蹲低姿態，從攝影助理做起，一路順應「世俗的」審美價值，贏得正職的（junior）、乃至資深的（senior）攝影師資歷，直到 1980 年。[12]

上述「世俗的」審美價值，表面上是滿足現實功利的價值需求，但其背後必須具備一定實力，才能在紐約的市場競爭中存活下來。這實力是莊明景憑藉其舉一反三的應變與實戰經驗的累積，所練就的「預視化（pre-visualize）、依需前置操作（on demand preproduction）、因應後製（postproduction）預行調整」[13] 的相關職能。這種能力，要能讓攝影對象散發（或昇華出）藝術的氣息、使讀者透過照片對於商品（如手錶珠寶）激起超越實用性的「想像」，以為工業產品注入美感（附加）價值。帕克（H. Dewitt Parker, 1885-1949）指出「現實工業藝術中的美對功利的依賴性……（和）不受實用態度束縛的自由（美），並不矛盾。因為，美仍然是在想像的領域中，而不是在使用的領域中。它是在預期到怎樣可以在對象的形式和材料中……所產生的快感，而不是在占有對象或得到它的好處時所產生的快感」。[14] 顯然，莊明景如此造就對象、使其昇華為藝術品的法門，對於後來的攝影創作，勢必產生作用。

1981 年，是莊明景攝影生涯的另一轉振點。這一年，他辭掉商業攝影師的工作，開始為期三年的壯遊攝影旅途；這一年，他還受邀赴北京拍攝文物與紫禁城景觀，以作為故宮文宣圖片之用。此中、美兩地的攝影因緣，讓他再次經歷雙軌並行的路程、遊走於俗世與世外的情境——一方面，在北美洲所拍攝月曆海報需要的影像，和北京故宮拍攝觀光文宣的影像一樣，都須滿足消費者需求、依循世俗功利；另一方面，北美洲自主拍攝大自然（兼拍人文）風情，和北京故宮近距離觀看的山水畫意境一樣，都讓莊浸淫在世外桃源珍視一草一木、蟲魚鳥獸……「眾生平等」的世界。

攝影所描述的空間，是班雅明（Walter Benjamin, 1892-1940）所稱「光學無意識」（optical unconscious）[15] 狀態下的另一種自然（本質），現實世界的一舉一動、大小對象、快慢舉止，在鏡頭前方都是等價的；亦即相機所見的、不同於人眼所見，是沒有人類意識介入的世界。在莊明景的觀看裡，如同相機所見，框景中的每一個元素（眾生）皆平等一不論是山水（畫）風景或北美風情，都不能忽略人造或日月光源在任何角落的「照明」（lighting）效果。這種來自世外光源的體驗，與實用攝影的打燈作業需要，成就了他獨具的「構圖眼」[16] 觀視法則。

1981-1983 年，是莊明景攝影生涯第二與第三階段的交疊期。此時，他的足跡跨越美國、中國大陸與臺灣，同時壯遊美國、回臺舉辦展覽，並開始黃山系列的攝影旅程。1984 年回臺定居之後，莊專注於海峽兩岸，拍攝臺灣國

家公園，以及大陸安徽（黃山）、四川（九寨溝）、廣西（桂林）、青藏的景觀與（兼拍）人文，自此完全進入第三階段攝影生涯。

當時，大陸實施改革開放政策不久，黃山與青藏仍是人煙罕至的化外之地，即使出入不便、景觀原始、生活簡陋，相對於臺灣經濟起飛後的都會繁華，莊明景對於那麼不健全的環境，依然怡然自得、等待與美的知交，享受那一個人的「侘寂」境界——在樸素、不完整事物中感受到美。[17]

這樣一個人的單身生活、沒有過多的包袱，讓他可以自如地在繁華塵世與清淨山水之間來去。所謂繁華塵世，是指莊在臺灣辦展覽、參與活動、成立藝術坊、發行出版品、受理照片典藏與授權事宜，乃至鑑賞、收藏骨董（偶爾也在徽州古董街購買）等，涉及商業營利事務的社會；但是，另一方面，他一旦投入攝影儀式情境中，即宛如一個修行者，投入與世隔絕的山林與曠野中，直到 2012 年最後一次登黃山。

二十一世紀初，黃山已漸成知名旅遊景點，旅館與纜車陸續興建起來，原本世外的清淨山水變得人聲鼎沸（尤其當導遊帶團等候觀看日出的時段），此情景和臺灣北海岸（龜吼、老梅）、東北角（外澳、龜山島）的景點類似，不知不覺中，化外之地變成了喧囂「塵」世。但莊明景的「孤獨修養」[18]功夫，讓他能夠泰然處於「肉身在塵世、心境則出世」[19]的攝影創作中。

自從 2008 年，開始進入數位科技參與創作的莊明景，一個人「獨居」探勘電腦軟體的「功」能如何可以「利」用在影像視覺的開發上。此時，他則處於「肉身如出世、心思問俗世（功利）」的境界。在這個「遊創」階段，事物表象的原質已趨曖昧，媒材本質透過位元體制（包含階調曲線等演算法）展露純粹形色之美。

這樣的美感經驗，宛若是經由骨董收藏品、古書畫、古建築的浸淫薰陶，在現實需求之外感受到材質的審美價值——木之紋理、

圖 1〈合掌屋〉/ 莊明景攝 / 歧阜縣白川鄉 / 日本 / 2018
Fig. 1 *Gassho-zukuri House* / photo by Mike Chuang / Shirakawa-go / Gifu Prefecture / Japan / 2018

草之溫潤、石之毓秀、岩之嵯峨、雪之白皙……在在讓我們超越功利，體會小自然花卉、大自然日月山川背後的本質天性。因而，侘「寂」的三種涵義「寂寥、古老、事物的本質」，[20] 頗適用於代表莊單獨在寂寥中，體驗古樹參天、雲霧縹緲、枝葉聊賴……的內外意境。（圖 1）

回顧莊明景自在優游於入世出世的人生，可以看得出他的作品，何以能在「共通（完美）理型」[21] 的基底上，發現狀似不起眼的事物美感形質。他曾表示「人生不外乎三件事：生活、生計、生命」。在生活上，沒有家累的他不因為單身而寂寞，反而視孤獨為一種修養，但這修養不是苦行僧式的修行，而是他先天開朗豁達、灑脫不羈的生命，看淡惱人的生計問題，讓一個人的生活化成自在悠遊、自如揮灑的攝影生命。

三、主體與客體之間的合和

大自然以其素顏面對觀看主體，畫家透過技藝將它給予魔法般的整型化妝，攝影家則是介於素顏和化妝之間，順著大自然的本性、酌予淡妝；此即莊明景自然風景的態度——觀察自然之理、順天之姿、顯露其天生之質。

身為主控鏡頭觀點的人，莊明景曾半開玩笑地自稱在取景時，會用觀看美女的心情來「觀視」自然。本文此處不用「凝視」二字，並非指莊在取景時沒有個人意念的投射，而是說他會放下穿鑿附會的主體意識，不刻意為賦新詞強說愁，更沒有唐宋以降文人面對故國山河的感時花濺淚，而是一貫地以純粹無染的心境去直觀天地，也因此，我們得以從他黃山、徽州、青藏的系列作品，體會到如同孔子閱讀《詩經》而發的「思無邪」，感受萬物真誠的生命情感。

基本上，歷經美國紐約十年現實主義取向的拍照經驗，更強化了赴美前本即掌握大眾偏好的共通（完美）理型原則。對莊而言，面對自然景觀做完美比例的掌鏡並非難事，但這是「存在於自然之忠實模仿」的第一真理，他進一步要尋求「（心目中）理想」的第二真理，[22] 嘗試在自然現象中取得與心中理想藍圖相互契合的「觀點」。

此「觀點」一方面代表莊明景鏡頭視點，同時也代表他的觀念與態度，即他以尊重而不踐踏的態度，來看待大自然的容顏。相對於某些為了獨占某視點（構圖），在拍完照後即予以（例如折斷樹枝、推落石塊）破壞原始景物配置，或為了開採獨特景點而「踩伐」蹊徑之類的心機攝影師，莊則只走既成山路，[23] 以事前調查、反覆觀察，一次、兩次、三次……多次的投入大地的懷抱，來尋求自己胸懷（但不獨占）的理想意境。

當我們踐躪大地以碳熱，大地則反撲以旱澇；若我們師法天地之節氣，則天地回報以宜時甘霖。莊明景反覆觀察自然規律、順應規律，而後就現場所面對情況與過去累積的經驗，做出因應的設定以及直覺的出手，杜威（John Deway, 1859-1952）指出「經驗是動物為了適應生存而與其環境發生互動的結果」，[24] 說明了莊不寄望天外飛來一筆的「意外」機會，踏實地以反覆行腳「觀天時、察地利、取人和」來與天地相互協調。

對莊明景而言，主體與自然風景之間，存在著相互吸收、「意」的交流關係。攝影誕生之後，依循繪畫美感價值的畫意派攝影，比照肉眼視覺經驗製造「低調模糊」[25] 的照片，屬於「全面」改寫自然的柔焦美感。但是莊則「留意時空自明」元素、讓「局部」事物對象自顯剛毅或柔意，如〈黃山（容與融）〉（1988）、〈黃山（容與融）〉（1990）之容留雲的縹緲、〈外澳〉（2020）、〈墾丁龍坑〉（2016）、〈老梅（勢與凝）〉（2021）之礁石上的海水凝流，此即他所謂的「元素攝影」。[26]

此外，從〈黃山〉（1985）與蹲低取鏡之〈龜吼（質與點）〉（2005）、〈老梅〉（2017）（圖2）的平視觀點，也可感受到物我之間存在著平等以對的關係。這和西方美學理型的平衡感（均衡）、平視感（平遠）相互呼應。

除了相互吸收、平等對待，莊明景也抱持著宛如對弈遊戲般、轉化物我之間的關係為意志拔河的「你進我退（移）、你退（移）我進」關係。他呼籲後進攝影同好在面對大自然時，要「觀看風景」而不要「被風景看」[27]——居高臨下時，我們不應以征服者心態，睥睨天地於腳下，泰山壓頂時，也不必畏懼於它的雄壯聲勢，而是要「敬謹交融」的感受大自然「天行健的物自身」（圖3）。此即其物我之間互為主體性（inter-subjectivity）的概念。

因此，大不可測的峻嶺、兀自成就如〈黃山（轉與易）〉（1984）之中峰橫亙；頂天挺直的樹／枝、妄自伸展如〈參天樹〉（1983）（圖4）之屹立參天——各個元素自明的姿態、自顯的行止，共構一個我們雖然無法

圖 2〈老梅〉/ 莊明景攝 / 臺灣 / 2017
Fig. 2 *Laomei* / photo by Mike Chuang / Taiwan / 2017

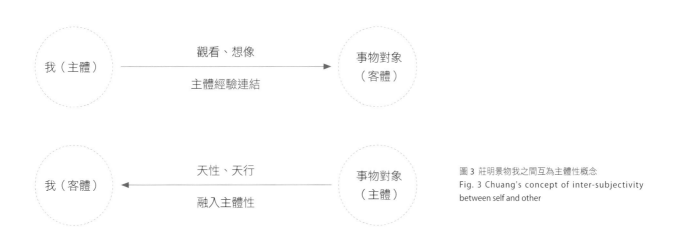

圖 3 莊明景物我之間互為主體性概念
Fig. 3 Chuang's concept of inter-subjectivity between self and other

全盤了解，但卻可靜觀細節規律的世界，布希亞（Jean Baudrillard, 1929-2007）指出「世界⋯⋯如果從細節來看⋯⋯總會存有一種完美的自明性」，[28] 莊明景融入其中、成為那個（主體）世界的他者（客體）。

相對地，現實景物也是身為主體的你我之他者（客體）。大自然，經由攝影師鏡頭的收納與調整，轉印在風景明信片上、或呈現於觀光機構的（網路）文宣中，遊客利用 APP 的美化功能將到此一遊的景觀做制式的修圖，使得無數的「風景名勝」（客體）被轉化成可以消費、按讚的「如畫風景」寫照。[29]

莊明景不論是受邀或自主拍攝國家公園、黃山等題材，雖也是呈現景觀表象「漂亮美麗」的寫照，但他並不強勢，透過反覆行腳、觀察與想像，扮演主客之間的橋樑，發掘自然天性中既是主體也是客體的交會，同時滿足以人為主體的視覺感官愉悅，也收受以自然為主體所自顯的天生麗質與生命百態。

對他而言，以此主客融合的概念來靜觀自然的生命本質，難免會興起帶著「侘寂」意味的觀想：「當我們對於普遍自然界的事物現象進行靜觀……例如花鳥風月，前二者（花鳥）是自身生物性的自然，而後兩者（風月）……作為我們的美學的意識對象，當中包含著廣大而豐富的生命現象。……透過『擬人』的轉化，無生命的個體具有了生命、具有了精神。」[30]

因而，他會從〈和尚岩〉（2022）岩石紋理聯想到宛如和尚袈裟隨風搖曳的意象、從〈隨舞〉（2020）之煙霧想像到宛如女性之飄逸舞蹈、從〈老梅〉（2020）看成宛如鯨豚族群之破浪、從〈龜吼〉（2019）（圖 5）岩石紋理發現獅王的狂狷英姿。這也就是郭熙透過擬人的轉化，描述季節變換下之山岳風貌：「春山澹冶而如笑，夏山蒼翠而如滴，秋山明淨而如妝，秋山慘淡而如睡」[31]的天人合一心境。

四、色階與模板之間的共舞

西方以忠於現實模仿而開發的形式（技藝），到了文藝復興（十五至十六世紀）已臻成熟，這些以線性透視、黃金比例為代表的完美理型法則，讓「藝匠」得以為王侯宮廷、商賈家園，營造出宏壯的風格、裝飾出華麗的氣息，來彰顯雇主的尊榮與德行。然而，如達文西（Leonardo da Vinci, 1452-1519）等「藝家」卻企圖在「再生古典」基礎上尋求超越——他將古典時期的完美理型觀，視為來自普遍自然之觀察與思索的「第一自然」；但他認為還要進一步從自然中找出優美的部分，運用「選擇」和「集中」以創造出「第二自然」。[32] 因此，所謂「純粹美」和「依存美」二元對立的概念，經過達文西嘗試在「第一自然」基礎上尋求「第二自然」的超越，獲得適度的融合。

從莊明景一生的作品，也可以發現他將前者呈現事物表象之美的形式（技藝），與後者訴諸事物本質之美的內容（選擇），兩者之間做了適度的「形質統一」。易言之，莊以光影與光圈快門在感光材料上的互動，來掌握色階與模板，如同山水畫以水墨比例

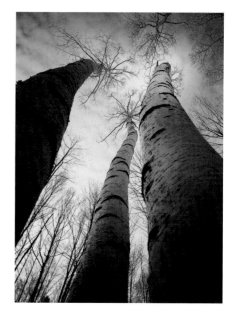

圖 4〈參天樹〉/ 莊明景攝 / 新罕布夏州 / 美國 / 1983
Fig. 4 *Towering Trees* / photo by Mike Chuang / New Hampshire / the U.S. / 1983

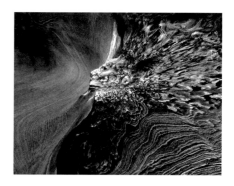

圖 5〈龜吼〉/ 莊明景攝 / 臺灣 / 2019
Fig. 5 *Guihou* / photo by Mike Chuang / Taiwan / 2019

（表 1）水墨、運筆與光圈、快門互動模組對照表

(Table 1) Comparison table of ink/pen and aperture/shutter interactive modules

水墨比例 與運筆速度		光　圈	
		大　光　圈	小　光　圈
快門	高速	水分多墨分少 運筆速度偏快	水分少墨分多 運筆速度偏快
	慢速	水分多墨分少 運筆速度偏慢	水分少墨分多 運筆速度偏慢

與運筆速度在畫紙上的互動、掌握質感與構圖（表 1），一樣是透過形式（技藝）的經營，讓觀者領受到事物的內在氣質、產生內容喻意的連結。

至於藝術家在作品中所喻之意為何？蔣勳曾以「寫胸中逸氣、寫胸中丘壑」來描述文人畫家所寫之意、所傳之神，然此與莊明景的山海攝影之喻意並非完全一致，文人山水強調作者個人主觀意念之「投射」，山海攝影則是莊與自然純粹的「意」之交流，將普遍表象中的美的本質「投映」到相機裡。若以桑塔雅納（George Santayana, 1863-1952）：「美是一種客觀化的快感」[33] 的理念來看，莊明景則呼應此美學觀，與大眾同體「寫共感逸氣、寫共感丘壑」之意——「氣」是由水而生的狀態，在高處是雲霧、在寒境是霜雪、在低處是河海，經過蒸發即成「空（氣）」；而「空」代表以某種形式存在的「虛／無」狀態，藉「實／有」之對比而生，它可以透過山石間距的「讓位」而呈現（如留白），可能隱身於山石所建構的型態（如鐘丘、如凹窪、如溝壑，或鼎立、或互臥、或蜿身），也可伴隨雲霧、水紋、（點）石、（點）樹、（點）日與（點）月等自然的元素所建構的生態，共同揮灑多樣的姿態。（表 2）

上述大自然的天然本質，如達文西所指的第二自然，被莊明景「選擇」和「集中」融入到第一自然的基底中。在中年以前，經過以西方美學為依歸之紐約商業攝影洗禮的人來說，對於「第一自然」的表現自不在話下，從美國〈紀念碑谷〉（1982）（圖 6）、〈拱門國家公園（勢與點）〉（1982）、〈拱門國家公園（容與穩）〉（1982）作品，甚至赴美前的臺灣（如蘭嶼、淡水）景觀，均可得見。但是，從黃山以降，莊的「選擇」產生一些相對於其他風景照片較為罕見的「元素攝影」、體現了「第二自然」特色。

其一，是減降深度空間感：莊不用廣角鏡頭來誇大遠近距離，而以標準鏡頭或微長鏡頭，來降低第三維（深度）的透視效果，如〈黃山〉（1985）。如此緩和的空間感和山水畫板塊化堆疊排列的平遠效果類似，使得觀者的眼睛，因為深度視覺的抽離，增加了眼球停留在畫面上下左右游移的時間。

（表 2）山水畫與莊明景風景攝影統合感性與理性對照表

(Table 2) A comparison of sensibility and rationality in landscape painting and the landscape photography of Mike Chuang

感 性 內 容	理 性 形 式	
	山 水 畫	風 景 照
寫「柔」意	水波紋（平行曲線）、暈染	慢速快門，累積雲水曝光量
寫「勢」意	大塊模板，刷，勾，巨碑式構圖，高遠構圖	延伸向量力矩，多線透視線
寫「紛」意	灑點	濾鏡效果，黴菌滋生
寫「蜿」意	深遠構圖	截取 S 型輪廓景物
寫「穩」意	平遠構圖	中軸對稱，平視
寫「容」意	留白，間距	圍成盆狀凹窿，間距
寫「轉」意	外框，硬邊轉折	藉剪影或無陰影板塊，強化輪廓線的轉折
寫「約」意	沒骨	簡約的、雙模板構成
寫「點」意	點景物	微小面積視覺焦點
寫「利」意	皴法	藉斜射光源強化紋理，中途曝光效果

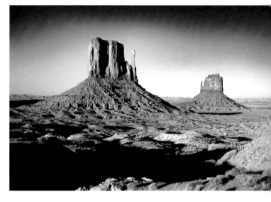

圖 6〈紀念碑谷〉／莊明景攝／亞利桑那州／美國／1982
Fig. 6 *Monument Valley* / photo by Mike Chuang / Arizona / the U.S. / 1982
此作結合加框構圖法、三角構圖法構成近中遠三層深度視野，是合乎「中景主體位於黃金比例分割線上」的完美理型典範
This work combines framing with a triangular composition, forming a field of vision layered into foreground, middle distance, and distance. It is a model of rational composition in which the subject in the middle distance is located on the line that marks the golden ratio.

如同國畫的長卷、立軸，壓縮第三維以延展橫軸（第一維）或縱軸（第二維）空間的形制，莊也運用搖頭相機、617 相機，拍攝類此延伸視域，以拉長閱覽時間軸的作品。例如〈墾丁（紛與覆）〉（1986）、〈玉山（凝與流）〉（1986）、〈梅里雪山〉（2015）。儘管當前的數位科技，讓我們可以使用「接圖」功能，將山／海景觀做縱／橫「沿」長，但這僅是複數紀實的拼裝，欠缺事物自性的彰顯。反觀〈天后宮〉（2016），莊純粹只做紅色牆面的延展，傳遞了以簡馭繁的寂寥與古意風情。

其二，是適時的時間加色法：色彩學的加色法意指光量的累加、愈加愈亮、終至純白。此時，山水畫之「有容乃大」[34] 的留白意境，與「空間的減殺、時間的積累」[35] 的侘寂意境，油然而生。

雖然，這只需延長快門時間，讓投射到感材的光能堆積，來製造白浪白雲的浮影效果，但也容易使近景或遠景的紋理淡化，所以莊

經常選擇晨昏時刻來拍照，製造難得的「大氣透視，影調透視」[36]
軟性縱深感，如〈黃山（揮與凝）〉（1991）。

其三，是以剪影塊面製造「圖／地反轉」效果：圖／地辨識原理 [37]
是人類視覺對於眼前事物做主體／背景分辨的原則。一般來說，
輪廓完整而清晰、位置偏下的事物易被視為圖，但莊明景卻運用
剪影效果，如〈黃山（勢與漸）〉（1989）使本應被看做主體的「黑
塊」變成背景，讓原為背景的淺明色調區域跳出來成為圖。此即
「圖／地反轉」[38] 效果。

其四，是「互為圖地性」（inter figure-background）的雙模板構圖：
如〈黃山（紛與覆）〉（1984）、〈優勝美地國家公園〉（1983）、
〈紀念碑谷〉（1983）（圖 7），畫中近景原應被視為主體，卻因
為面積大、密度低而容易被看成背景；遠景原應被視為背景，卻
因為面積小、密度高而被當作主體來看待。

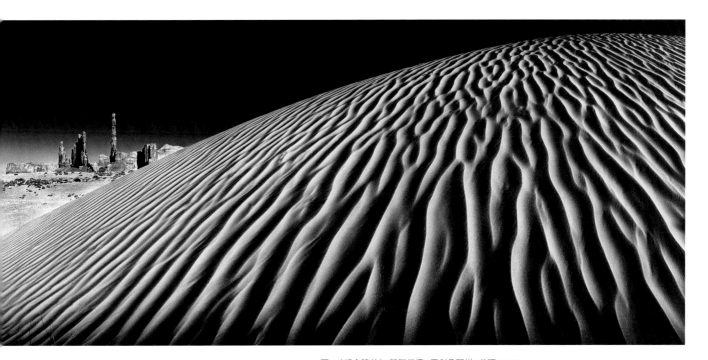

圖 7〈紀念碑谷〉/ 莊明景攝 / 亞利桑那州 / 美國 / 1983
Fig. 7 *Monument Valley* / photo by Mike Chuang / Arizona / the U.S. / 1983

其五，是營造「過牆視域」[39]的另類雙模板構圖：身高約一百八十五公分的莊明景，站在一般（家庭）的圍牆外，不需要（或偶爾只需）踮起腳尖，即可以「視覺翻牆」得見牆裡的乾坤。這樣的視覺經驗造就了莊採取比國畫「半壁江山」更大面積的「近景（牆前）」與更小面積的「遠景（牆後）」共構的雙模板構圖。如〈龜吼（質與點）〉（2005）、〈黃山（轉與易）〉（1984）、〈紀念碑谷（質與約）〉（1983）。

其六，是強化向量動勢：這是藉由將透視點偏移到超乎黃金分割位置，以拉長向量力距，以牽引出視覺動勢的張力[40]（圖 8）的手法。除了偏上的透視點強化鳥瞰的深遠效果，偏下的透視點以蹲低仰望來強化高遠效果，莊明景還嘗試挑戰偏左上的透視點，如〈老梅〉（2020）、〈南雅奇岩〉（2020）（圖 9），反而造就了（違反黃金比例之）不完美、卻依然美的典範。

其七，是巨碑散劈後營造的「氣場與間」[41]：破除巨碑式山水構圖的半壁江山或中峰頂立模式，衍生出三種寫「容」格局：（1）由中型巨碑圍成盆狀凹窿，如〈黃山（勢與紛）〉（1984）透過環繞的山岩在畫面中央區域圍出一個「盆窿」，宛若捧缽納天之倒立穹窿；（2）隨機散布的中型巨碑、彼此讓出不等寬的間距，靜待雲霧自來，如〈黃山（容與融）〉（1988）、〈黃山（容與融）〉（1990）之接納縹緲；（3）劈開巨碑之後，山岩向前後左右退散，眾星拱月地圈護著中央（小）岩／石；如〈拱門國家公園（容與穩）〉（1982）之中央「點」石、或如〈太魯閣（容與穩）〉（1988）之中央「鐘」丘。

其八，是漸層變化之運用：運用日月交接的時機，使得漸層階調急遽增減，濃度變化從等差級數、換成等比級數（圖 10），以強化遠近距離、修補中／近景因為逆光而導致立體感之減降。如〈紀念碑谷（漸與點）〉（1982）、〈黃山（漸與點）〉（1983）、〈陽朔〉（2010）。

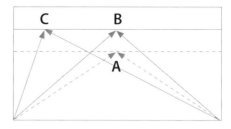

圖 8 原位於黃金分割位置的透視點（A 點）因偏移至更上方（B 點）或更左上方（C 點）位置，拉長視覺向量力距而強化動勢
Fig. 8 The perspective point (A), originally located at the golden section position, is shifted to an upper (B) or upper left position (C), which elongates the visual vector force distance and enhances the sense of inherent movement.

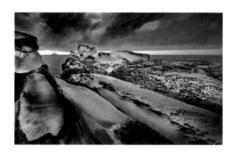

圖 9〈南雅奇岩〉/ 莊明景攝 / 臺灣 / 2020
Fig. 9 *Nanya Rocks* / photo by Mike Chuang / Taiwan / 2020

圖 10　圖上之等差級數色階變化，不如圖下等比級數漸層之遠近距離感

Fig. 10 The change in the color gradient series in the picture above doesn't compare to the sense of distance in the layered geometric series in the picture below.

其九，是「點景物」的妙取：小面積的點景物，雖然不起眼，卻可在視覺游移中成為趣味中心，反而後來居上，成為突出的焦點。如〈黃山〉（1983）、〈黃山〉（1986）之點景月，〈黃山〉（1988）、〈黃山〉（2000）之點景樹，〈青藏高原（揮與點）〉（1991）之點景馬，或〈墾丁龍坑〉（2016）之破曉點「日」。

其十，是巧奪天雲揮拂之姿：雲團構成的板塊造型變化多端，雲氣疏密關係造就不一的層次效果，或柔棉、或薄紗、或捺粉……。如〈青藏高原（揮與凝）〉（1991）之潑墨設色般的向天潑染、〈老梅（揮與凝）〉（1991）之宛若薄紗拂過、〈青藏高原（揮與點）〉（1991）如漁夫撒網般的向天拋撒、〈黃山〉（1988）如裙裾迴轉般的旋曳、乃至〈墾丁（揮與穩）〉（1989）、〈富士山〉（2017）如彩帶般的一筆揮灑，如此多樣的雲層姿態、深值細品。

曾經，「謝赫六法」[42] 開啟了文人山水畫的形式審美標準，惜因後來過度形式主義 [43] 取向而走入「窄巷」。[44] 攝影（術）發明之後，郎靜山繼承文人山水構成模式，採用蒙太奇暗房技術，首創結合銀鹽媒材階調與文人畫形制的「集錦攝影」而驚豔全球，[45] 卻也因此成了後進取景時觀摩套用的構圖模式。莊明景稱此所謂「沙龍調」的典型模仿為「記憶攝影」。

相對地，莊使用「元素攝影」──透過反覆觀察、專注於鏡頭裡的材料與光影構成，以做出適當的（可表現）「元素／手法選擇」，加上經驗累積「預視化」能力醞釀「直覺」出手的攝影觀，或可為風景攝影（乃至山水畫）之讀寫開啟一扇新視窗。

五、清晰與模糊之間的共伴

林文月教授（莊明景的大學老師）曾以「冷筆寫空間、熱筆寫時間」探析楊衒之在《洛陽伽藍記》中，融合「（地理）理性紀實、（歷史）感性情節」的敘事模式於同一作品中。[46] 莊明景的風景攝影，也有類此兼融「雙性格」[47] 於一作之中的「對映」例子，猶如讓我們感受到同一母體孕育之龍鳳雙胞胎、彼此相伴成長的觀看興

味。這和西方美術歸納的「對比」模式，例如雷蘭德（Oscar Gustave Rejlander, 1813-1875）〈兩種人生〉（The Two Ways of Life）所營造的戲劇張力，同具意趣。唯「對映」和「對比」之區別，在於後者傾向於（但非絕對）二元對立事物或情節的經營安排，前者傾向於（但非絕對）事物發展前／後之時空對照，且容或三元（以上）事物的共伴呼應；而莊的作品增加了時間向度的參與，讓作品遊走在對映、對比之間。

〈黃山〉（1983）黑塊剪影將山石的質感，讓渡給雲的層次，造就山形稜線所劃切出來的多轉折線條，使得山勢輪廓的明晰，與勻棉雲霧的朦朧，相互輝映。

〈布萊斯峽谷國家公園〉（1982）掌握陽光局部露臉的時機，運用陽光入射角，使得山壁質感宛如花布覆蓋大地般的「繽紛斑斕」，同時與周邊山嶺圍繞成盆隆的「壯闊大器」相互映照。

〈黃山（轉與易）〉（1984）、〈龜山島〉（2020）暈翳的天光，投映在中峰巨碑的背上，形成的馬赫帶（Mach Band）效應，[48] 宛如在教堂仰望聖者雕像時，聖像背後的崇高光環；在周邊光暈圍繞下，輪廓清晰的主體、因逆光使樣貌晦暗，而散發玄祕的距離感。

〈黃山（勢與漸）〉（1989）滾滾的雲氣做前導，夾帶綿密雲團做殿後，以漸層的陣勢向中峰巨碑飛撲而來；巨碑以黯黑難辨，如犀利銳牙（輪廓）之神祕面容嚴陣以待；兩造共構天雲氣勢與巨碑氣勢的對峙關係。

〈落磯山國家公園〉（1982）宛如將骨董明式家具的簡約、清式家具的裝飾整合對照，將地面的「雪白簡潔」，和前後景如「流蘇裝飾」的樹林線條，兩者並置呼喚。

〈龜吼（蜿、覆與凝）〉（2019）岩石表面覆蓋的粗礪質感與沙灘堆紋形成對比，蜿蜒的水沙流道與凝捺的棉雲形成對映。

無庸置疑，利用物理光學現象，讓焦點所在的景深域內，與模糊圈（circle of confusion）干擾的景深域外，形成的清晰與模糊效果，以製造圖／地的主／從關係，是攝影學的基礎知識；然其關鍵在於如何超越，將科學分析「圖／地、主／從、或遠距／主體／近距的絕對關係」之算計，賦予「凝／流／疾／徐／融……」的喻意（表 3），以化解極端的科學與浪漫之對立。原本「清晰」與「模糊」是兩種情感家族的代表，前者可與具象、明確、犀利、靠近、分明、精細等感受「括弧」在一起，後者可與抽象、迷濛、混沌、遙遠、曖昧、隱約等感受做連結，兩者難處一室。但我們發現，莊明景卻能巧妙地利用快門時間與時機、結合陽光條件（涉及季節／晨昏）與鏡頭的框取，將「清晰」與「模糊」整合在一起。

（表 3）因應事物動靜而寫意的快門使用對照表
(Table 3) Freehand shutter use comparison table according to the movement of things

	緩慢移動事物	快速移動事物	靜止事物
高速快門	凝，融，覆，易	勁	勢，柔，蜿，約，轉容，紛，穩，利，點
慢速快門	徐，揮，漸	流	

〈亞利桑納州（凝與流）〉（1982）在細樹條立的精確空間中，兼容浪漫的時間留流。巧妙地將畫意派的柔焦效果，與掌握超焦點距離（Hyperfocal Distance）所製造的長景深效果，集於一身。

〈京都（流與覆）〉（2016）對於人眼的「圖／地判讀原則」反將一軍。先以色彩轉換、製造高彩度的「圖」顯效果，再以模糊化的軌跡、使其退位成裝飾性「地」位，讓整幅作品看起來，上下兩者均既是圖、也是地。

〈外澳〉（2021）以清楚筆直的地平線、二元對立的為天地劃界，卻輔以蜿蜒的水流、綿延的雲層，形成剛柔並濟的和合狀態。

〈黴之灑綴〉（1990）、〈黴斑弄紋〉（1990）[49]、〈老梅〉（2010）在觀者與對象之間，宛如覆上一片水漬染料圖層，或一層從天落下的紛飛灑點，將現實賦予化外之境的疏離感。不可忽視的是，如此的空間距離感，也有時間演化（如前兩例黴菌洗禮之「時間」醃製作品，與後例之延長快門「時間」）所賦予的距離感，使得事物變遷、流動、歲月、古老、滄桑、痕跡，成了值得緬懷與感悟的美感。如〈新罕布夏州〉（1983）、〈北埔〉（2010）（圖 11）之斑駁牆面，又如〈杭州〉（2010）之滄桑孤影。從這些作品蘊含的時空距離感，我們不難體會莊明景心中的侘寂韻味。如大西克禮（Yoshinori Ohnishi, 1888-1959）所感：「世間萬物，無一不因時間而劣化。對於象徵時間的流逝、不看作劣化，而是接受，並從中感受美，便是侘寂之心」。[50]

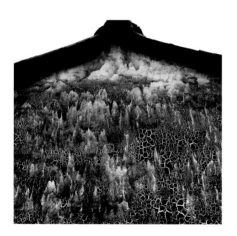

圖 11〈北埔〉/ 莊明景攝 / 臺灣 / 2010
Fig. 11 *Beipu* / photo by Mike Chuang / Taiwan / 2010

布洛（Edward Bullough, 1880-1934）認為「心距」是產生審美經驗的必要條件，它存在於「自我與引起情感的對象之間」，而「時空距離」則是心理距離的（其中）兩個形式。[51] 表面上看起來，「變動不定、隱約依稀」的「模糊系」距離形式，和前述阿奎納斯主張「鮮明、明亮、清楚」的「清晰系」美感條件，兩者似乎矛盾。而今，從莊明景的作品看來，兩者毫不違和──他天生是一位智慧型的月下老人，於攝影的儀式中，將「清晰」與「模糊」牽情配對、共伴相映。

六、實境與幻境之間的玄妙

莊明景擁有的鏡頭預視能力，讓他能夠在某些陽光條件下，直覺判斷框景內的事物變化是否能夠符合心中的美感預期。然而，由於事物現象之瞬息萬變，為了確保沒有意外，莊會引用包圍曝光（bracketing exposure）或連拍等「多量取樣」的方式，對同一框景做「包裹式」拍照，再檢視成果。

這彷彿是科學實驗──在設定的研究框架下，操控「自變項」以觀測「依變項」的反應是否合乎預期假設。事實上，攝影本身就是一種實驗、一種具有遊戲性格的嘗試過程。

莊明景的嘗試冒險精神，當然不會安於「黴菌／時間自變項」參與造就媒材的演化成果，也躍躍欲試於影像處理軟體的潛能探索遊戲──在既定演算法的數理框架中，嘗試不同的參數設定、試試各種可能性，直到獲得美感愉悅的作品成果。他將這一系列拿自己照片所進行（二創／後製）的「遊創」，稱為「繪影行空」，即代表這遊戲是在無預設立場、無意識狀態下，「天馬行空」的操控程式輸入指令，以獲得不可預期的「新視覺」。

這些新視覺的開發，雖然多是從自己既有的風景母片取材，具有互文性（inter-textuality）的後設意涵，但卻超越原始母片文本的寫實性，孵化不可知的、非現實的，卻又「依稀感覺到原生自然」的幻境。

二十世紀前葉，繪畫從傳統的模仿現實演繹出兩個反向的取徑：一個是不像現實、違背現實視覺經驗的超現實（surreal），一個是高度現實、精細臨摹照相的超寫實（hyperreal）。超現實取向試圖打破具象的可能，回復蘭格（Susanne K. Langer, 1895-1985）認為「繪畫是假的景象、虛構的影像（virtual scene）」[52] 之本質、以及格林伯格（Clement Greenberg, 1909-1994）倡議的「二維平面」之本體；以馬諦斯（Henri Matisse, 1869-1954）為代表的野獸派（Fauvism）發展出違逆現實的主觀色彩，以蒙德里安（Piet Mondrian, 1872-1944）為代表的幾何抽象（Geometric Abstraction）把現實畫約成直線與色塊的構成；以波洛克（Jackson Pollock, 1912-1956）為代表的抽象表現（Abstract Expression）更加「行空」的挑戰線條與顏料的極限。

圖 12 圖左莊明景的繪影與圖右常玉的繪畫，同樣具有簡約構成、明亮設色、與簡潔的造型與線條之特徵（常玉，〈荷〉，1955，國立歷史博物館典藏）
Fig. 12 Chuang's "image painting" on the left and the Sanyu painting on the right both feature simplified compositions, bright colors, and concise lines and shapes. (*Sanyu, Lotus*, 1955, National Museum of History Collection)

其中，我們發現：被譽為「東方馬諦斯」的畫家常玉，與莊明景兩人之間有若干心有靈犀的共通點。例如，兩人皆不受流派理念的束縛，「純粹」只是想表達自己的心境，[53] 同樣個性灑脫不羈、但一生精力全部投入藝術創作中，也都巧妙地融合了中國書畫精神與西方現代美術超越事物表象紀錄的呈現手法。

〈荷鏡〉（2015）與〈荷〉（1955）（圖 12 之圖左與圖右）以違反現實長度的細長葉枝、各自獨立伸展的姿態，隱喻形單影隻的孤獨感，卻又以高明度、高彩度的顏色做為背景，體現中國宮廷與貴族的裝飾色彩。而莊明景以「色彩反轉」（color reversal）機制處理的大膽設色，與常玉諸多「陰陽翻轉」作品，同樣推翻了你我色彩恆常性（color constancy）的知覺依賴，更見兩人的無形默契。

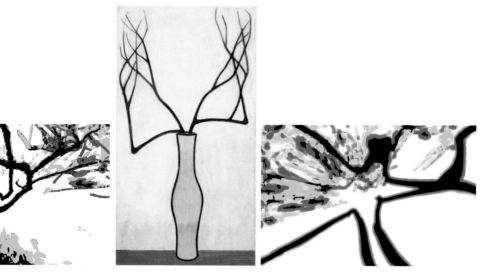

圖 13 從圖左與圖右的莊明景繪影，與圖中常玉的靜物寫生 (局部)，可發現三圖的樹枝轉折姿態均具有書法運筆的意味（常玉，〈靜物〉，國立歷史博物館典藏）
Fig. 13 The flavor of calligraphic brushwork can be seen in the bends and twists of the branches in both Chuang's "shadow paintings" on the left and right and in the detail of the Sanyu still life painting in the middle. (Sanyu, *Prunus Branches*, National Museum of History Collection)

圖 14 圖左莊明景的「破壞性創造」、與圖右常玉的「創造性破壞」，兩者殊途同歸、在表現時空距離上有異曲同工之妙（常玉，〈小魚〉，國立歷史博物館典藏）
Fig. 14 Chuang's "destructive creation" on the left, and Sanyu's "creative destruction" on the right. Both express a sense of distance in time and space, using different methods to achieve similar ends. (Sanyu, *Fish*, National Museum of History Collection)

〈桃花系列〉（2005）與〈靜物〉（1921-60）（圖 13 之圖左／右與圖中）同樣具有簡約構成、單純用色（一為黑白、另一只多「紅綠藍」三原色）、簡潔有力的線條等特徵。但巧合的是，兩人不約而同的從樹枝轉折姿態，發現並發揮了書法運筆精神，讓剛毅的「枝」線在過彎處、處以圓融／弧形的婉轉，將陽剛與陰柔調和在一起。

〈黴之灑綴〉（1990）與〈小魚〉（1921-60）（圖 14 之圖左與圖右）兩者創作過程或有不同。前者是藉黴菌滋生、導致畫質劣化的「破壞性創造」；後者是為了塑造水面蕩漾效果而做的「創造性破壞」──先以黃色油彩在木板上打底，並繪上游魚，再以摻有高揮發性溶液稀釋的黃綠色顏料──做大筆塗刷，使得底層與上層因乾燥速度不同且不相溶、產生斑駁剝落的質感。然而，不論是「破壞性創造」或「創造性破壞」，兩人同樣嘗試突破現狀的精神，使得不論是染料或顏料，均能夠異曲同工地呈現了一種距離的美感效果。

整體而言，莊明景企圖將現實視覺記憶的原型原色解放，仍依循「元素攝影」的「選擇」精神嘗試做破壞性的創造：要不，將事物原型變換，讓面積延展（如〈天后宮〉（2016））、或輪廓模糊；要不，讓事物色彩／階調背離真實，或調／換色（如〈紅岩〉（2022）圖 15）、或色彩反轉、或做中途曝光（Solarization）、或海報化（Posterization）效果⋯⋯不一而足。但雖然事物原始的形或色被解放了，現實被變換了，他卻很少同時破壞原型與改寫原色，使得結果卻又不是完全抽象。齊白石強調繪畫意旨「作畫，妙在似與不似之間」，[54] 莊的「行空」繪影，或從低調的模糊、轉換成高調的模糊，或從漸層的階調、轉換成階級的層次⋯⋯那些似與不似之間的玄妙、那些不期而遇的美感愉悅，都是在「無意識」狀態下所試探而來的。

「無意識」狀態有兩個涵義，一指精神分析學所指的潛意識（unconscious）精神（如「夢境」）；另一指沒有前提意念主導、或沒有個人意識介入內容取捨，把意識（狀態）暫擱、放空或壓抑的自由（或隨機）精神狀態；前者是超現實主義（Surrealism）藝術經常引用的創作材料，後者則有以「自動性作用」[55]（Automatism）帶出不合現實邏輯的情節，宛若一種視覺的遊戲方式、一系列的隨機性形色實驗，如〈京都〉（2016）、〈隨舞〉

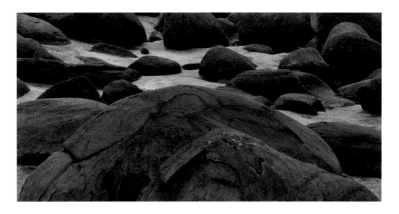

圖 15〈紅岩〉/ 莊明景攝繪 / 2022
Fig. 15 *Hongyan* / photo by Mike Chuang / 2022

（2020）、〈和尚岩〉（2022）作品之流線，製造「運動的形上學」，[56] 兼有自動作用的操作與自在捉拍的影子，帶有如夢似幻、如虛如實、隱約曖昧的魔幻意境。

此外，這些將原始事物型態變換掉的效果，反而令作品變成「裝飾性」畫面，增添了商業應用的可行性，例如使用在服裝花紋、包裝紙、壁紙、海報或雜誌封面的設計上，其效果宛若骨董收藏品、或建築的裝飾，[57] 在似與不似（現實）之間的肌理、色彩與線條布局，產生快感情緒。

此時，去追索作品中被隱晦化、模糊化的事物代表什麼意義，並不重要。莊明景只是在追尋意義之巷弄轉角處，安置一個折射鏡，將巷弄盡頭的原始影像轉換出來，與大眾分享變幻形色。

七、結語：梳理莊明景攝影之「心／手／眼」取徑

莊明景的鏡頭書寫，以大自然的生命為大宗，揚棄刻意營造的場景、穿鑿附會的認知，或勉強的情感，不求天外一筆的賜予，體悟事物本即生滅、何須掙扎的天性，憑著渾然天成的「構圖眼──預視、平等看待、掌握元素特質」觀察能力，練就出一系列又一系列的自主攝影創作。

他的自主創作，可以 1983-2012 年間登山二十六次的「黃山」系列為代表，旁及美國、臺灣、青藏、徽州、四川、日本的景觀。這些總數以百萬（格）計的影像檔案，幾乎都是莊明景單純無染動機的鏡頭寫照，若能善加整理、爬梳其攝影行腳與觀點脈絡，或可提供更多視野的比較攝影研究。[58]

就內容上來說，視覺藝術以模仿現實與自然起家，而自然包含天然（非人工、非刻意）生產的事物，及其產生的法則。[59] 莊明景鏡頭的主要內容，正是自然姿態之「寫照」，及其生息規則之「意映」──風起、雲湧，浪起、潮落、日落、月昇，寫「勢」意、寫「容」意、寫「凝」意、寫「徐」意、寫「利」意、寫「穩」意……。

就形式上來說，傳統西洋繪畫與中國山水畫一樣從模仿現實起家，卻因媒材的不同，開發的形式手段自有差異：西畫油彩發展暈塗法、勾線法、擦拓法、搔刮法……，[60] 國畫水墨則是暈染法、皴法、沒骨法、勾勒法、潑墨法……；西畫顏料載體，從牆壁到畫布都在有限空間模仿現實（透視），國畫從衣布、立屏到絹布、宣紙，則試圖將「如畫之景」的「錦繡河山」轉寫成「如景之畫」的「河山錦繡」。

同屬平面視覺藝術的攝影媒介，即使鏡頭光學透視與感光材料造就了「投映客觀現實」的宿命，在莊明景手上，以空間減法與時間加法的策略，讓出有容乃大的空間，也讓時間著色、為自然輕撫淡妝，將大眾偏好的如畫風景「寫照」形式，與天然本質所「意映」的內容，巧妙地融合與交織。

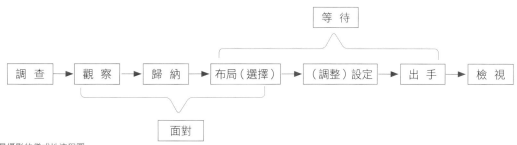

圖 16 莊明景攝影的儀式性流程圖
Fig.16 Flowchart of Chuang's photographic process

當我們將攝影視為一種儀式，那麼在整個儀式過程中（圖16），「面對」與「等待」即是迎取奇點的重要伏筆，而兩者的交集即為「布局（選擇）」，涉及鏡頭的框景／元素與工具的調整設定。如郭熙所云「真山水之川谷，遠望之、以取其勢，近看之、以取其質。真山水之雲氣，四時不同，春融怡、夏翁鬱、秋疏薄、冬黯淡」。[61] 此言反映了莊明景調和心／手／眼運作的核心所在——因時因地制宜的選擇／布局。

在做這些選擇／布局的背後，不可忽視的，還有「互為主體性」概念與嘗試精神的支持，始能讓「自然自然得自然」，[62] 讓「（莊）明景」得以不斷創作「形質交織——既鮮明又喻意」的明景。謹此，本書將他「當下存有」的重要明景，統整為「時空軌跡」（本書作品「鏡觀的旅程」單元），「空間形質」（本書作品「山海經」單元），「時間形質」（本書作品「時間的顏色」單元），以及「時空跨越」（本書作品「變換與變幻」單元）等四大系列。

而今，莊明景的創作仍在進行式中，他的作品產出猶如自然運行之生生不息，即使是昨日已完成作品，可能會在明日演化出不同新（寫）意的影像。

梅洛一龐蒂（Maurice Merleau-Ponty, 1908-1961）表示，「如果……沒有任何作品稱得上絕對的完成，那麼，每一次創作，都（是）在預先更改、變造、釐清、深化、確證、提升、推陳出新和創造其他的創作。」[63] 在尋求「明景」的意義、理念、表現手法之路並沒有盡頭，本文建議——把握當下、以「坐看雲起時」（圖17）的自然心境，直覺體會莊明景每一幅錦屏作品中「形質合一」的美感！

圖 17〈河口湖〉／莊明景攝／山梨縣／日本／2018
Fig. 17 Lake Kawaguchiko / photo by Mike Chuang / Yamanashi Prefecture / Japan / 2018

1　引自Władysław Tatarkiewicz著，劉文潭譯，《西洋六大美學理念史》，臺北：聯經，1989年，頁281。

2　阿奎納斯（St. Thomas Aquinas）認為「美」應包含三個條件，即「完整或完美，適當的比例或和諧，和『明亮』或『清楚』」。循此「明亮（brightness）、清楚（clarity）」的審美標準，本文所指「明景」代表具有顯明性美感之景象。參見劉昌元，《西方美學導論》，臺北：聯經，1992年，頁19-21。

3　主觀攝影為1950年代由德國光形（Fotoform）團體發起，後成為國際性運動的攝影潮流。影像形式涵蓋報導與抽象的實物投影（photograms），透過非結構性的、獨創性造形等特有的攝影手段，產生深刻的心理感受，以傳遞作者自己對世界的主觀看法。Gilles Mora, *Photo SPEAK: A Guide to the Ideas, Movements, and Techniques of Photography, 1839 to the Present*, (New York: Abbeville Press), 1998, pp. 187-188.

4　心象攝影為1980年代臺灣特有的攝影名詞，屬於主觀主義的攝影；作者透過自我詮釋，表現個人心理深層所觀看的視覺效果，融合現實物件與強烈主觀意識，達到另一個影像境界。參閱姜麗華，《臺灣近代攝影藝術史概論：1850年代至2018年》，臺北：五南，2019年，頁216。

5　參閱劉昌元，《西方美學導論》，頁195。

6　朱狄，《當代西方美學》，新北：谷風，1988年，頁508。

7　前者「寫意的胸中明景」是指莊明景經過對自然的觀察、意喻美感本質之畫面；後者「寫實的屏幕明景」泛指以一次快門機會的寫真照相，經過基本（事前事後）處理與印製裱裝，滿足大眾偏愛、呈現在景幕或顯示（display）在各式屏幕的畫面。

8　「奇點」一詞引用自數學術語，意指一個「除以零導致結果為無限」的（函數）點、或「連續曲線中一個斷掉的點」，此恰可用以比喻「拍照時按下快門、外在現實被截斷消失在感光材料的那一時間點」，故此處以「奇點」代表將現實時空「擷取／抽離」收納至相機裡、化為無限（永恆）的快門瞬間。

9　禪宗的理念在於「明心見性、見性成佛」，以透過禪修達到「頓悟成佛」境界為主要修行法門。參閱北京社會科學研究院編譯，《金剛經・六祖壇經》，臺北：博遠文化，2006年。

10　莊明景在臺大求學期間，完全沒有包袱的自由創作，一個人優游於淡水、蘭嶼等，大多是尚未開發成熱門景點的化外之地。但也因為經常進入這類純樸無邪的環境，逐漸發展出「純粹無染」的拍照動機。他表示，當時報名攝影比賽，純粹只想知道自己實力如何，並不是為了獲獎榮耀或獎金而參賽。請參閱本書之〈口述訪談〉。

11　康德早期觀念認為，真正的美應該是無涉功利的「純粹美」。到了晚期，則提出「依存美」概念指出「美在理性內容表現於感性形式」，亦即形式上的感動背後，應有其倚賴之內容意義。這和他早期提出不涉及內容意義的、無目的性的「純粹美」，形成二者對立的概念。參閱朱光潛，《狂飆時代的美學》，臺北：金楓，1991年，頁113-117。

12　這十年間，莊明景會運用工作餘暇前往中華文物收藏家翁萬戈府上，協助拍攝書畫檔案與製作相關動畫，這段因緣，開啟了他前往北京拍攝故宮文物、以及後來登上黃山攝影的歷程。請參閱本書之〈口述訪談〉。

13　關於此三種職能的實戰經驗，請參閱本書「傳記式年表」1980年之敘述。

14　轉引自朱狄，《當代西方美學》，頁488。

15　Walter Benjamin, "A Small History of Photography, " in *One-Way Street and Other Writings* (New York: New Left Books, 1979 [1931]), pp. 240-257.

16　此構圖眼，是指涉及觀察／取景／布局等的攝影思考力，包括眾生平等的觀察力、預視能力、選擇值得強調形質（規則）的元素等。請參閱本書之〈口述訪談〉。

17　大西克禮著，王向遠譯，《日本美學3：侘寂——素樸日常》，新北：不二家，2019年，頁93。

18　「孤獨是一種修養」語出莊明景被問及單身一事的回應。請參閱本書之〈口述訪談〉。

19　從莊明景在北海岸的即席揮毫，可得知他專注於攝影時，將旁人拋諸腦後、把握鏡頭世界裡每個當下的處遇。請參閱本書之〈口述訪談〉。

20　同註17，頁50-51。

21　此指合乎黃金比例（1:1.618）的均衡、對稱、對比、調和（或協調）、韻律之畫面構成基本原則。

22　同註1，頁375。

23　以峨嵋山為例，如果既有登山路線沿途沒有適合的景點，莊明景即使拍了許多畫面，寧可不發表，也不會為了強行「搜刮」景點而侵犯峨嵋的自然本色。請參閱本書之〈口述訪談〉。

24　同註2，頁117。

25　1889年，攝影家愛默生（Peter Henry Emerson）倡議攝影藝術應模仿人眼視覺經驗的「自然式攝影」（Naturalistic Photography）理念，提出以「稍微失焦」的鏡頭焦距來拍照。此柔焦效果，更早可見諸1860年代中期卡梅隆（Julia Margaret Cameron）的肖像攝影作品，烏利西（Ullrich）以「低調的模糊效果」稱之。沃夫岡・烏利西（Wolfgang Ullrich）著，胡育祥譯，《模糊的歷史》，臺北：一行，2021年，頁32。

26　除了追求鏡頭前方被攝體的構成元素或某一物件（特性）。此處尚指，為了局部（元素）的表現所採用或調整的（部分）操作。請參閱本書之〈口述訪談〉。

27　莊明景經常藉由演講或「面對名家」活動，向學生闡述此「要觀看風景、而不要被風景看」的觀念。請參閱本書之〈口述訪談〉。

28　林志明，〈布希亞論攝影〉，《複多與張力：論攝影史與攝影肖像》，臺北：田園城市，2013年，頁221。

29　此處除了以「寫照」代表，如寫真攝影般的「屏幕明景」（參閱註7）、滿足「依存美」理念的形式包裝（參閱註11）；也以「如畫風景」象徵「大自然」成了可以被大眾消費的「美」。參閱大衛・貝特（David Bate）著，林潔盈譯，《攝影的關鍵思考》，臺北：城邦文化，2012年，頁134-136。

30　同註17，頁97-98。

31　語見郭熙，《林泉高致集》。轉引自陳傳席，《中國繪畫理論史》，臺北：東大，1997年，頁97。

32 朱光潛，《西方美學的源頭》，臺北：金楓，1991年，頁280。

33 同註2，頁24-25。

34 蔣勳點出「『空白』是一切……『空白』不是沒有，而是更大的可能」之「留白」美學。蔣勳，《美的沉思：中國藝術思想芻論》，臺北：雄獅美術，2003年，頁169-171。

35 同註17，頁88。

36 麥可‧弗里曼（Michael Freeman）著，吳光亞譯，《攝影師之眼》，臺北：大家，2009年，頁54。

37 人類視覺對於眼前景象中，具備「輪廓閉鎖未斷的、被包圍的、面積小的、密度高的、形狀單純的、位置在下方的（前提是上下兩塊面積差不多）、有動感或旋轉感型態」等條件的事物，容易視之為主體／圖（figure），反之則視之為背景／地（background），此即圖與地知覺原理。參閱王秀雄，《美術心理學》，臺北：臺北市立美術館，1991年，頁129-133。

38 同註36，頁44-45。

39 「過牆」二字，係借用電影攝影之「過肩」鏡頭而來，代表鏡頭視線是越過「近物上方」而得見遠物，但通常電影鏡頭焦點多設定在遠物，近物（肩膀局部）只是陪襯。而莊明景運用長景深使近物和遠物被同等視之。

40 同註37，頁289-322。

41 此處「化整為零」的空間分析概念，係參考日本「氣場與間」的美學意識：捨棄「整體」的概念，才能察覺「間」的本質，從而把「間」理解為「氣（場）」所化身而成的「空間」或「時間」。參閱黑川雅之著，李柏黎譯，《八個日本的美學意識》，臺北：雄獅圖書公司，2019年，頁78-80。

42 謝赫六法出自《古畫品錄》之〈論畫六法〉，探討畫家必備的六種功夫，包括氣韻生動、骨法用筆、應物象形、隨類賦彩、經營位置，和傳移模寫。參閱高木森，《中國繪畫思想史》，臺北：東大，1992年，頁123-129。

43 莊明景接受訪談時，指出中國國畫的構圖之所以會形成「八股（制式化）」的表現，受到文人從「從官方到民間收藏者」的偏好影響極大；也可說是典藏風氣與取向，引導了形式風格的一味模仿。文人畫因此，如高木森所言，走上形式主義的道路。同註42，頁310。

44 中國山水畫特色，除了皴法的建立，將外在世界的結構與內在心靈的脈動相聯結。可惜，在元代以後，中國繪畫已局限在一條「窄巷」裡，大自然被數種「固定造型」所取代，形成刻板化、制式化的表現模式。參閱倪再沁，《水墨畫講：文人美學與當代水墨的世紀之辯》，臺北：典藏藝術家庭，2005年，頁39-42。

45 據吳嘉寶統計，郎靜山在世界各地國際沙龍比賽獲獎次數（累計）高達一百九十三次，足見其在全球攝影藝術界的成就與聲望。參閱吳嘉寶，〈郎靜山和他的「超凡」〉，《郎靜山詩畫意趣攝影特刊》，臺北：臺北市立美術館，1988年，頁16-19。

46 參閱林文月，〈洛陽伽藍記的冷筆與熱筆〉，《臺大中文學報》第1期（1985年11月），頁105-137。

47 在本文中，「雙性格」代表「攝影手法上兼具紀實性、表現性」，也代表「被攝內容上的二元事物共存（例如雲與霧），或同一事物對象的二元對照（例如同一人年輕時與年老時對照）」。如同研究《洛陽伽藍記》之冷筆與熱筆，既探討該文「紀實理性、抒情感性」的敘事手法，也分析「同一地理場景，先後發生的歷史事件對照」的內容架構。

48 馬赫帶效應為「側抑制作用」（Lateral Inhibition）所引起的視覺錯覺。參閱Robert L. Solso著，梁耘瑭編譯，《視覺藝術認知》，臺北：全華，2004年，頁66-71。

49 此兩例取自《無盡的影像：莊明景攝影集》，該專集是以黴菌滋生造成底片劣化、產生不可預期效果的畫面集結。

50 同註17，頁5。

51 同註2，頁96。

52 同註2，頁192。

53 關於常玉的作品解析，參見：國立歷史博物館網站「典藏查詢系統」之「常玉」專區，網址：https://collections.culture.tw；石浩吉、劉家蓉發表於「非池中藝術網」之《太極陰陽解析常玉》系列專題」，網址：https://artemperor.tw/focus/2558，檢索日期：2022年4月5日。

54 同註31，頁404-405。

55 關於「自動性作用」的創作方式，請參閱游本寬，《論超現實攝影：歷史形構與影像應用》，臺北：遠流，1995年，頁11-13。

56 此指靠「運動和光」的構成，破壞事物原形狀態，使得觀者的視知覺從影像看見「能量」。同註25，頁145-150。

57 同註6，頁489。

58 閱讀莊明景大量的作品檔案，尚可從比較攝影的觀點，將他同一題材作品與其他作者作品予以並置比較，從而發覺不同時空背景條件下誕生的影像檔案，有何不同、又為何不同。例如，可從莊的玉山照片與日本殖民時期為觀光宣傳的新高山（即今之玉山）照片做對比。關於日本殖民時期的觀光宣傳照片分析，可參閱張世倫，〈台灣「風景」的寫真建構〉，《台灣攝影史形構考》，臺北：影言社，2021年，頁137-178。

59 古羅馬人承襲希臘文的概念，認為「自然」（natura）既表示「可見表現萬物之總和」，也表示「自然物之產生的法則」。同註1，頁357。

60 擦拓法、搖刮法為德國藝術家恩斯特（Max Ernst）所發明。參閱梅洛—龐蒂（Maurice Merleau-Ponty）著，龔卓軍譯，《眼與心：身體現象學大師梅洛龐蒂的最後書寫》，頁97。

61 語見郭熙，《林泉高致集》。轉引自陳傳席，《中國繪畫理論史》，頁97。

62 「自然自然得自然」語中，第一個「自然」代表萬物生命，第二個「自然」代表自在隨性、不刻意，第三個「自然」是指顯現其天性、天然的本質。

63 同註60，頁147。

繪影氣勢
——莊明景風景攝影之神秘他性

文 / 姜麗華

在攝影裡，「風」是一種氣候變化、光線變化，所以叫做「風景」。「風」在動，地上的「景」不動——動靜之間的配合就是風景最主要的元素。

——莊明景[1]

一、前言：風景／地景攝影的深廣度

現今對風景攝影（Landscape Photography）[2]的認知有不少歧義，往往將風光與風景攝影混為一談。本文強調風景（landscape）不等同於風光（scenery），「『風景』不再只是『風光明媚、景色秀麗』的縮詞，而是真正的回復到較大、較寬領域的『景觀』」，[3]尤其當代的風景攝影，包括原始的與人為的，以及自然與文化社會的景觀，甚至風景攝影能富有人文的底蘊與美感經驗的共感，並非指向追求唯美夢幻般的風光攝影。儘管理想的風景繪畫與風景攝影創作的媒材雖異，然描繪自然風景的景觀皆具有美感，產生藝術性的概念雷同，故有「風景入藝」（Landscape into Art）之說，筆者亦認為兩者皆是「從自然中擇取而組成，就如詩的用字選自日常話語。亦即『畫即詩』。」[4]本文引用肯尼斯・克拉克（Kenneth Clark, 1903-1983）此種說法，似乎可以從臺灣當代風景攝影家莊明景（1942-）的作品得到印證。莊明景善於運用高反差的調性呈現黑白相間的對比強度，或者以高解析度細膩的色彩，營造澎湃氣勢的奇觀異景，而非俗豔的風光美景。令人好奇的是：他是如何想望拍攝所見之自然？又如何攝取這些既是詩又如畫的奇景？

〈黃山〉/ 莊明景攝 / 中國 / 2000
Huangshan / photo by Mike Chuang / China / 2000

聲音宏亮、體型壯碩的莊明景，易給人一種天地不懼、好膽量的印象。1983 年當他千里迢迢到達安徽，目睹中國黃山高聳入雲的群山峻嶺，並親臨海拔一千六百八十三公尺高的始信峰（號稱黃山第一奇觀，如入畫境，始信黃山風景奇絕）之際，便立下征服黃山的決心，為了拍攝黃山四季勝景，前後十年間攀登二十六次，因此榮登「游山名人」之列於《黃山志》。[5] 他鏡頭下的黃山，選以高反差的黑白呈像，景致如同水墨山水畫，意境飄緲、氣勢非凡。闖蕩美國商業攝影多年有成的他，領悟「無中生有」的商業攝影是難不倒他，但面對大自然的風景，如何在「有中去無」去蕪存菁地擇取心目中之美，才難。

1986 年當莊明景受邀拍攝臺灣的屋脊玉山，他選擇以橫幅的全景攝影，表現出雄冠東北亞的臺灣神山，宛如一條龍翻騰駕霧於千峰萬壑之間，[6] 諸峰似龍鱗高陡峻峭；面對臺灣獨特地質的海岸線與岩石（墾丁、南雅、龜吼、老梅、外澳、太魯閣等地），他善於應用小光圈慢速快門曝光，凸顯不同地形紋路與水氣流蘇之美。他在山海天地之間，用其個人式的攝影構圖之眼，捕捉精采絕倫的瞬間景觀。他總自謙是大自然選擇了他，讓他得以按下快門，或是因其自身具有美感經驗[7] 的藝術感知，讓他從自然中擇取而組成如詩如畫的景觀。莊明景這樣的說法，正如德國哲學家海德格（Martin Heidegger, 1889-1976）在〈藝術作品的本源〉一文中所言的「藝術」。因為藝術作品雖來自藝術家的活動，唯作品才能

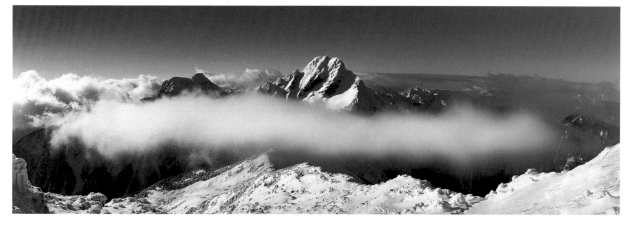

〈玉山〉/ 莊明景攝 / 臺灣 / 1986
Yushan / photo by Mike Chuang / Taiwan / 1986

〈老梅〉/ 莊明景攝 / 臺灣 / 2016
Laomei / photo by Mike Chuang / Taiwan / 2016

使創作者成為藝術家，而且是作品召喚藝術家進行創作活動，但若沒有藝術的先決存在，就沒有藝術家與藝術作品。換言之，莊明景的影像景觀呈現高聳入雲的孤傲感，展現俯視天下的氣勢，他的風景攝影已入藝，成為一種藝術的表現，不再是風光明媚、景色秀麗之意，還能引起一種「出世」心靈作用並觸及美感哲思。

二、氣與勢的風景攝影

關於「風景」兩字，臺灣大學哲學系畢業的莊明景，使用說文解字的方式描述：「『風』在動，地上的『景』不動一動靜之間的配合就是風景最主要的元素。」[8] 因為風在動，所以有氣；景雖然不動，因此有勢。筆者認為莊明景的風景攝影則是將兩者結合，氣勢可以指影像中的力量感，亦可指四季風景的力量與態勢，他的風景攝影體現自然環境的大氣磅礴、岳聳淵深、大自然的鬼斧神工等態勢，同時他在風景攝影裡呈現的氣與勢，氣可以是一種力量，也是一種氣氛；勢可以是一種姿勢，也是一種動勢，並且不同的氣勢造成不同音樂韻律與情感氛圍。尤其當我們觀看他在歷經造訪百餘次北海岸石門區的老梅石槽，所呈現此海岸特有地景的千姿百態影像，不免誤以為他不是拿相機，而是手持畫筆自如地揮灑，遠近雲山海天一抹，濃淡對比強烈，繪影出詩境般的樂章，同時也繪影出一股神祕的氣勢。不論是一隻隻宛如鯨魚或鱷魚般（莊明景自己形容）的「海蝕溝」，像似齊心奮力游向大海；

〈老梅〉/ 莊明景攝 / 臺灣 / 2020
Laomei / photo by Mike Chuang / Taiwan / 2020

〈老梅〉/ 莊明景攝 / 臺灣 / 2016
Laomei / photo by Mike Chuang / Taiwan / 2016

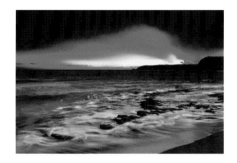

〈老梅〉/ 莊明景攝 / 臺灣 / 2018
Laomei / photo by Mike Chuang / Taiwan / 2018

或是一塊塊孤石似粽的火山礁岩，背景以像似凹凹凸凸的線條、紋理與形態的皴法，表現出被洶湧浪濤包圍；或是海水如絲綢般的滑順，呈現一種虛幻渺茫、虛無縹緲之動勢。這些地景攝影有些是在同一個地點，不同角度、氣候與時辰所拍攝的景觀，其表現形式具備動靜的韻律節奏感與氣勢，然而幀幀不盡相同，猶如聆聽韋瓦第（Antonio Vivaldi, 1678-1741）的《四季》小提琴協奏曲，包括有快板、行板、急板、極柔板等，讓我們感受到自然界在不同季節裡萬物豐富的變化。

莊明景將長年累月經過浪花滋潤石槽岩面滋生的「石蓴」或稱「扁石髮」的綠色海藻，當成畫龍點睛的色彩，在大面積黑白渲染的背景裡，一抹抹的鮮綠色，點綴出此景觀的靈氣；或是他等待豔陽高照的日出時分，映射在海灘上白浪黑石之間，染紅廣袤無際的穹蒼，天地一色的情景，難以分辨是天上抑或人間。彷彿大自然賜予他顏料彩繪，而他掌控得宜並營造動靜兼備的氣勢與氛圍。

日本攝影家杉本博司（Hiroshi Sugimoto, 1948-）喜愛收藏骨董甚至兼職骨董商，因身處當代藝術界常有機會接觸西方現代藝術，他的《海景》系列屬性靜多於動，讓風景攝影「委身於綿延不絕的時間之流，流向茫茫遠方」，[9] 經由亙古永存的水與空氣，散發遠離凡塵的氣氛。同樣喜愛收藏木頭、石器等古物的莊明景，純粹以「能否創造美感愉悅」[10] 為其挑選骨董的標準，從中體會並累積美感經驗，他對於攝影取景的美感經驗認知，是一種確認個人凝集心神所框設的景象。[11] 這樣的感知正如瑪奎（Jacques Maquet, 1919-2013）闡述人類的經驗美感時指出，當感受這個景象（view）一旦存乎於心，便能引進沉思默想的狀態，進而藉由冥想，成就了美感的吸收，觀看者即能進入美感經驗的領域。[12] 若比較杉本博司與莊明景影像作品顯現的意象，或許可以說，杉本是站在人類歷史之上，傳達無時間性的概念，莊氏則是矗立於人群之外，象徵在「入世」與「出世」之間的另類出家人，「單純地不再受時間概念的染污」，[13] 傳達超越世間對於時空的概念與淨化出脫俗的心靈。

三、風景攝影神秘他性的內心感受

郭力昕在〈論地景攝影〉一文中分析世界級風景攝影家安瑟‧亞當斯（Ansel Adams, 1902-1984）拍攝美國優勝美地國家公園攝影作品時指出：「照片讓人感染了某種似乎超越物質世界的、先驗的哲學氛圍，進而召喚出一種神秘的『他性』（otherness）。」[14] 這種神秘的他性，筆者借用青原惟信禪師對門人說明修行人圓證菩提的三個次第（階段）：需要經過懷疑、批判、辯證後，才能透徹了解事物的本質，因此，當禪修者達到悟道境界之際：「見山（仍）祇是山，見水（仍）祇是水」，[15] 只是此山已非原有的彼山。換言之，地理景觀攝影不只是一張風景照，亦能「體現為一種具有神秘和精神高度的神話性存在」。[16] 相對於莊明景提出對地景攝影的看法，不僅要表現大自然的實存，更重要是顯示攝影家對大自然的感受，是一種平衡、和諧、人與大自然融合的藝術，同時他表示攝影也有三個次第（階段），從「感性」的見山、水，是山、水；經過「悟性」的見山、水，不是山、水；達到「知性」的見山、水，仍是山、水，甚至是一種「知山是山，知水是水，心物合一，自由自然。」[17] 如此，創作者不僅透過作品象徵內心的感受與思想，若能夠自由自在隨心所欲形成個人風格，進而達到心物合一的藝術境界，[18] 致使地景攝影雖是從現實自然擇取而組成的影像，卻能超越現實中的物質世界，對人召喚神秘他性的精神高度，而進入觀賞神話般的共感之美。

莊明景翻越崇山峻嶺，其鏡頭下西方山景中的黃石、落磯山、優勝美地、猶他州的拱門與布萊斯峽谷等地的國家公園，給予我們宛如身歷其境的臨場感，山勢巍峨、起伏疊嶂的山稜線，產生迷離撲朔的態勢，經由空間透視感表現景物的縱深感，強調奇岩怪石、沙漠紋理（沙痕）與森林樹幹線條等，然此景物已非原地之景物，而是再現（representation）崇高的精神性，產生令人敬畏又驚嘆之美。綜觀亞當斯風景攝影作品內容有山水、月光、岩石、植物等，給人柔軟順暢的視覺感知，而莊明景拍攝同樣的題材，是透過在「大風景中的小細節」，如樹木、石塊或是滾滾黃沙的紋路，給人粗獷中帶點溫柔的印象及神秘難測的意象，他「用自然環境襯托生命曾存在過，表現風景裡平衡美感」，深具崇高與美的合體。

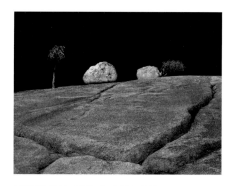

〈優勝美地國家公園〉/ 莊明景攝 / 美國 / 1983
Yosemite National Park / photo by Mike Chuang / the U.S. / 1982

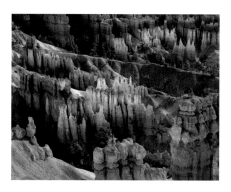

〈猶他州布萊斯峽谷國家公園〉/ 莊明景攝 / 美國 / 1982
Bryce Canyon National Park / photo by Mike Chuang / the U.S. / 1982

筆者引用古希臘羅馬美學家朗吉弩斯（Pseudo-Longinus, 213-273 A.D.）著作《論崇高》談修辭學中提到的崇高（sublime），該書中他同時演繹社會政治生活與自然界的崇高。他表明崇高除了使人驚嘆，還能夠使理智驚詫而使僅僅合情合理的東西黯然失色，真正的崇高不在華美或雕琢，而在思想的高超、強烈與莊嚴，它能提高我們的靈魂，產生一種激昂慷慨的喜悅。[19] 如果沒有產生愉悅、欣羨或崇敬之情感，則不是崇高，而只是恐怖。換言之，崇高具有對心理上的影響，不只偉大而已，還給人一種緊張的壓迫感，並擁有某種力量，足以提升我們。觀看莊明景縱橫在高山、大地、峽谷間的地景攝影，「可以知道他是以一種嚴謹得近乎苛求的態度來對待他的作品」，[20] 經由其個人的構圖之眼或說構圖觀點，表現他內心感受的美，並非僅是透過色彩、線條、明暗、角度等構圖要素，或是高超的技巧加上精細的質感，而是往往讓觀者在震撼 [21] 之餘，還能產生崇拜與欣悅之情。

再觀莊明景表現東方山景的崇高，中國黃山霧靄蒼蒼，峭壁飛流直下，看似萬里雲凌神仙眾妙遊遨之玉宇。有些畫面搭配若有似無的落日或朝陽，有些則是皚皚的雪景，特意與其他景物形成明暗反差，畫面的對比性顯得層次感豐富且具有變化，尤其是雲海在高峰對峙中任遨遊，擬似哲人莊周（約 369-286 B.C.）〈逍遙遊〉文中所描述的氣度與瀟灑心態。筆者從多次訪談莊明景在言談之

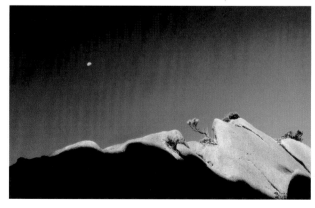

〈黃山〉/ 莊明景攝 / 中國 / 1986
Huangshan / photo by Mike Chuang / China / 1986

〈玉山〉/ 莊明景攝 / 臺灣 / 1986
Yushan / photo by Mike Chuang / Taiwan / 1986

間顯露的神情態度，感受到他就像似一隻大鵬鳥振翅高飛九萬里，憑藉著風（自然給予）之外，還有永不放棄的堅強意志，同時也知道應該順風而飛，隨風而返，沒有適合的氣候天色拍照，他也能淡然接受無功而返或轉移陣地。而面對臺灣玉山雄姿凜凜、獨峙寰宇，莊明景畫面中的玉山，凹凸的山稜脊薄如斧削，山勢高峻突出頭角崢嶸，尖峰相連到天際，狀似攪海翻江直沖九重天，亦呈現雲淡風輕天靜謐，廣袤無垠之氣魄，或是一輪朝日孤傲地高懸，雲霧似有似無，時隱時現，彰顯出神秘的他性在群峰之地，卻教浮世總成謎之意境。

眾多攝影家爭相拍攝這兩座高山，甚至坊間推出給業餘攝影者「黃山旅拍」的路線與景點，蜻蜓點水式地追逐黃山之美，難以呈展獨特的視角與美學觀。臺灣山岳攝影家方慶綿（1905-1972），其一生來回阿里山和玉山之間，達四十餘年，攀登玉山達三千多次，留下許多真實記錄登山路徑與攝影視線之觀察位置的黑白影像。另外，阮榮助（1935-2013）、陳玉峰（1953-）等人拍攝的玉山之美，含括珍異的各種高山植物、奇花異卉、飛禽昆蟲等，在春夏秋冬的節氣裡記錄這座錦繡之地。反觀莊明景不以記錄為其拍攝目的，而是在峰嶺蒼山、雲霧茫茫渺渺充滿靈氣之間，追求與大自然「知性」（前述攝影第三階段）的對話。

四、結語：遨遊無盡的繪影乾坤

從大學時代便迷戀上攝影的莊明景，強調攝影需要「忠於自己的思想，修練內涵，追求個人理想，不管從事業餘攝影或商業攝影，對著攝影藝術，全力以赴，永久、深遠，無止境。」[22] 他經歷過年少攝影比賽常勝軍的輕狂時期；為精益求精 1971 年負笈紐約，初到時曾流浪街頭，所幸經柯錫杰引薦至商業攝影公司當助理的學習時期；靠著自身的勤奮以及早年自學的攝影基礎，獲得老闆賞識升任攝影師的出頭時期；嚴格精準的自我要求，在美國商業攝影界闖出名氣的高峰時期之後，也許是冥冥中受到「藝術」之召喚，毅然決然拋棄他已扎下根基穩固的商業攝影，開啟壯遊於萬里路，翱翔於天地間的風景攝影。

回顧莊明景的攝影生涯，終其一生「專注於心靈美感的探求，找尋生命價值的終極」，[23] 自詡是另類的出家人，在修行的旅程裡他看盡千山萬水，早已參透「見山仍是山，見水仍是水」的奧妙禪境。根據攝影器材與技術、個人喜好與美感經驗等，選擇表現他獨具的視角，拍攝極天際地氣勢博大的景觀，繪影出獨有見地的乾坤，表達他對自然近乎崇拜之情。眾所周知，美感涉及對象有限的形式，崇高卻是涉及對象的無形式，正如我們得以觀視海浪的美，卻無法掌控浪潮無限的力量。同時，因風暴掀起的海潮本身尚不能稱之崇高，它只是令人感到可怖的景象，唯有當我們心靈之中有美感，對自然賦予崇拜之情，在觀賞海潮時才能激發出崇高之感。

綜上所述，莊明景無論是經由傳統大型或中型相機所拍攝的高質感照片，再現氣勢壯闊的風景攝影，或是1990 年代因底片意外發霉導致奇幻色彩的無盡影像，甚至近期運用電腦數位繪圖軟體，企圖在虛擬的數位抽象世界裡進行蒙太奇的影像處理，皆能落實他對於「心靈美感的探求」，尋找另類出家人出世的生命價值。

1. 引自莊明景，〈「出世」山水——莊明景的風景攝影哲學〉，採訪林添福、撰稿朱淨宇，《秘境》雜誌第9期（2013年2月），雲南：雲南美術社，頁5。
2. Landscape Photography亦可翻譯為景觀攝影或地景攝影。
3. 游本寬，〈風景攝影導論〉，《自然與人為的對話——風景攝影學術論文集》，中華攝影教育學會1995年專題學術研討會文集，臺北：中華攝影教育學會，1996年，頁10。
4. 參閱肯尼斯・克拉克（Kenneth Clark）著，廖新田譯，《風景入藝》，臺北：典藏藝術家庭，2013年，頁126。
5. 書名繁體字應為《黃山誌》，莊明景被編列為〈游山名人〉其中一名，參閱《黃山志》編纂委員會，《黃山志》，安徽：新華，1988年初版，頁265。
6. 玉山國家公園發行，《玉山之美》，南投縣：玉山國家公園，1987年，頁18。書中收錄數幅莊明景的作品。
7. 莊明景對美感經驗的說法：「攝影是美感經驗的累積與展現。這種美感經驗，可以說是一種享受、一種感受、一種純淨無染的愉悅。」參閱本書〈口述訪談〉。
8. 同註1。
9. 杉本博司，林葉譯，《藝術的起源》，新北：大家，2014年，頁42。
10. 本文加上引號內的引言，若未載明出處，則是摘自本書〈口述訪談〉的內容。
11. 在老梅採訪莊明景時說：「依據直覺經驗，看『視框』範圍美不美？這時候純粹主觀直覺、不會想太多（理念或企圖）。」
12. 參閱賈克・瑪奎（Jacques Maquet）著，武珊珊等譯，《美感經驗：一位人類學者眼中的視覺藝術》，臺北：雄獅美術，2003年。
13. 宗薩蔣揚欽哲諾布著，姚仁喜譯，《近乎佛教徒》，香港：皇冠，2019年，頁185。
14. 郭力昕，《再寫攝影》，臺北：田園城市，2013年，頁33。
15. 瞿汝稷編撰，《指月錄》，宜蘭：如來，1996年，頁1591。
16. 郭力昕分析愛德華・威斯頓（Edward Weston）的作品，同註14。
17. 摘錄莊明景回答張敬德的說法，參閱張敬德，〈訪我國旅美攝影家莊明景先生：談攝影應走甚麼路？往哪裡去？〉，《攝影天地》第72期（1981年10月），頁33。
18. 莊明景認為「把你的內心感受，用你高超的技術表達出來，便是『藝術』」，同註17。
19. 參閱李醒塵，〈朗吉弩斯的《論崇高》〉，《西方美學史教程》，臺北：淑馨，1996年，頁87-88。
20. 秦情，〈木匠的鉛錘：攝影家莊明景的自然之眼〉，《時報周刊》第151期（1981年1月18日－1月24日），頁42。
21. 張敬德寫道：「作品清新純淨，精密活潑，親切熱情，但不失莊嚴雄偉，充滿震撼力，實為藝術與技術的結晶……讀者非常著迷……」，同註17，頁32。
22. 同註17，頁34。
23. 莊明景於天使美術館展出「莊明景藝術影像特展」的感言，展覽時間為2020年10月10日至11月15日。

From A "Clear View" to Metaphorical Scene:

Looking through the Brocade Screen Woven from "Reflection of Meaning" and "Portraiture"

Author / Hu Chao-kai

1. Preface

For a sense of beauty, no turning of corners is required.

When we face a subject and intuitively find it breathtakingly beautiful, or when it causes us to form associations or stimulates our imagination, we will respond with compassionate feelings, or with pleasure and joy. These feelings, in response to beauty, are often a kind of instinctive emotional reaction aroused by the distinctiveness of the objects themselves. When this self-evident "clear view" [in Chinese, "clear view" is "ming jing," the same characters as the photographer's given Chinese name] meets the composure, the eye for composition, and the intuitive hand of Mike Chuang (Chuang Ming-jing), what kind of images and what kind of aesthetic experience and value will be created? That is the subject of this essay.

According to Susanne K. Langer's view of art, put forward in her "signification theory," a work of art does not express emotions personally experienced by the artist, but can only express the artist's understanding of the form emotion takes, and that is where the actual "meaning" of the artwork is found. Chuang has stated that for him, the meaning of photography is "the accumulation and presentation of aesthetic experience." This point of view indicates that his thinking on how "the feeling of beauty" can be displayed through the "form" of the photographic medium echoes the views of Langer on "the artist's understanding of the forms of emotion."

For Chinese artist Xu Bei-hong, being "remarkably true to life" was his criterion for aesthetics in painting. With respect to photography, the innate realism of the medium means it easily meets the aesthetic criteria of being "true to life," provided the photographer ascertains the light source on site and the needed exposure, whereas pursuing what is remarkable involves imbuing a work with an impressionistic sense of an idea. Whether the scene is considered a simile or a metaphor all depends on the photographer's ability to observe, face, and grasp the innate nature of the subject and the character of his medium, to frame a particular layout, make the correct settings, and await opportunity… these are the criteria by which we will understand the "clear views" of Chuang and his metaphorical works.

This essay will begin by discussing Chuang's photography career, and then explore his concept of photography and analyze how his work conveys the essential beauty of nature (including in humanitarian photography). It will thus summarize the nature of his photographic "fingerprint," and the hundreds of ways in which the "impressionistic clear view of what is in the heart" and the "realistic projection of a clear view on a screen" intertwine in his work.

2. Both in the World and Apart from It

Creating a photograph is a ritual, a kind of game, and also a kind of experimental, ceremonial process: One begins by preparing the equipment for the game, understanding the rules by which it is played, considering the setup, and taking action. Then, depending on the response, adjust the setup and the next action. Each setup, each action, is a way

of "challenging the unknown," and the main player in the game obtains a kind of addictive pleasure and happiness, completely unconnected to any utilitarian ends.

In his repeated efforts to master this photographic game, Chuang's life has been spent in a free journey between pragmatism and forgetfulness of self, between photography's realistic demands and the obliviousness of its ritual. In general, his photographic journey through life can be divided into four slightly overlapping phases: First, the period of self-study of photography in high school and individual travel prior to leaving for the U.S. (approx. 1958-70); second, the period spent in commercial photography in the U.S. and his grand tour through North America (approx. 1971-83); third, his return to Taiwan to publish his work and settle down, and his photographic travels on both sides of the Taiwan Strait (approx. 1981-2012); and finally, the stage (from 2008 to the present) in which he began to use digital cameras and computer post-production, combining photography and image-making, and using software to produce derivative works.

In the first phase, Chuang displayed an inborn aptitude for photography with apparent ease; with no formal or professional training in the photography or the visual arts, he nevertheless was able to enter photography competitions and win awards, with nothing but the straightforward and uncomplicated desire to make photographs.

This did not make him complacent, however, and with his intense and adventurous nature, he decided to give up the stable, steady income of a job with his family's business and enter into the second stage of his photography career. In 1971 he bravely set out for New York and the world of commercial photography. Beginning as a photographic assistant, he worked until 1980, adapting to the more materialistic aesthetic values of the profession, until he acquired the rank of first junior photographer and then senior photographer.

Another turning point in Chuang's career came in 1981, the year he quit his job and set out on a grand photographic tour. He also received an invitation to go to Beijing, where he would photograph cultural artifacts and the Forbidden City to provide photos for documentary materials in The Palace Museum. The photographic "karma" that led to Chuang to work in both China and the U.S. once again set him on a parallel, two-track course in which he roamed between the worldly and a more transcendent, extra-worldly realm.

Chuang returned to Taiwan to live a more settled life in 1984, but continued his photographic work on both sides of the Taiwan Strait. He photographed Taiwan's national parks and the landscapes in China's Anhui (Huangshan), Sichuan (Jiuzhaigou), Guangxi (Guilin), and Qinghai-Tibet region, while also engaging in humanitarian photography. After this point, the third phase of his photography career began.

Beginning in 2008, Chuang engaged with digital technology as he pursued his photographic work. During this phase of "creative roaming," the original external appearances of his subjects were made more ambiguous, and his photographic medium, translated into digital bits, revealed the beauty of pure form and color.

Looking back at Chuang's life, between living in the world and apart from it, we see how in his photographic works, based on a "universal (perfect) theory of forms," he was able to discover the beauty and form of things that might at first seem unremarkable. He once said that there were really only three aspects of human life: "Being alive, making a living, and living your life." In his own life, being single and unburdened by family, he nevertheless does not feel lonely, but instead regards that state as a kind of personal cultivation. Such cultivation is not an ascetic practice, but reflects instead his innately optimistic, carefree, and uninhibited life. It makes light of the problems of making a living, turning his life into an expansive, free-spirited life in photography.

3. Harmony between Subject and Object

As the person who controlled the viewfinder of the camera, Chuang often said, half-jokingly, that his mood when "inspecting" nature to frame a scene was the same as when looking at a beautiful woman. We will use not the word "stare" in this context, nor claim that there was no projection of personal thoughts by the photographer when framing a scene, but rather, that he let go of any highly speculative subjective ideas, and consistently viewed the world with a more direct, pure, and uncomplicated frame of mind.

For Chuang, the relationship between photographer and nature was one of mutual absorption and exchange of "meaning." When photography first appeared, the picturesque photographers adopted the aesthetic values of painting, producing photos that, by contrast with the vision of the human eye, featured low-level softness or blurriness in an attempt to totally rewrite nature with soft-focus beauty. But Chuang "attends to the self-evident elements in time and space," letting aspects of his subjects take on their own firmness or softness, which he refers to as "elemental photography."

Beyond mutual absorption and being on an equal footing with nature, Chuang also maintains a kind of "I advance, you retreat, and vice-versa" relationship, like a game of chess, transforming the relationship between the self and the outer world into a kind of tug-of-war. He advises new photographers facing nature to "view the scenery," rather than being "viewed by the scenery." We should not stand above the world like conquerors, looking down at the world beneath our feet, but neither should we be intimidated by its majesty or power. Rather, we must adopt a feeling of respectful union, with the "things in themselves" of the natural world, which here thus refers to the concept of inter-subjectivity.

4. The Dance of the Color Scale and Template

The forms (or techniques) developed in the West based on faithful imitation of reality reached their maturity during the Renaissance (15th to 16th centuries). Their perfectly rational principles, based on linear perspective and the golden ratio, enabled artisans to create a grand style and produce gorgeous decorative pieces for the royal court, the aristocracy, and merchant families. But artists, such as Leonardo da Vinci sought transcendence through a regeneration of the classical: da Vinci took the notion of the theory of ideal forms from the classical period as derived from observation and contemplation of universal nature, or "the first nature"; but he believed we must extract what is most beautiful from nature, using selection and concentration to create a "second nature." Thus, the concepts of "pure beauty" and "dependent beauty," in binary opposition, nevertheless obtained some degree of reconciliation through da Vinci's attempt to transcend, by seeking this "second nature" on the foundation of the "first nature."

In the works of Chuang, we can see how he used the former form (technique) to present the surface beauty of things, while the latter appeals to the beauty of content (selection) in the essences of those things. The two together form an appropriate union of form and substance.

Chuang, for example, does not use wide-angle lenses to exaggerate the distance between deep background and foreground, but uses standard or micro-telephoto lenses to reduce the perspective effect of the third dimension (depth). Further, by moving the vanishing point of the perspective beyond the dividing point of the golden section, he elongates the vector force distance to produce greater tension, with implied visual movement.

Chuang also excels at creating "energy fields and spaces," helping him break from the formula of the traditional "giant monument style" of landscape compositions featuring great swaths of territory or towering central peaks. He evolved three layouts for depicting physical appearance: (1) a central medium-sized shape surrounded by a basin-shaped

concavity, like an inverted dome of the sky; (2) randomly distributed medium-sized shapes and various distances from each other, standing at peace and waiting for the mists arrive; and (3) a split shape, from which mountain rocks recede at left and right, forward and back, with stars and moon encircling a central element.

Linear gradients are also a feature of Chuang's photography. He often takes advantage of transitions between sun and moon to radically increase or decrease the gradient, so that the concentrations change from an arithmetic progression to a geometric progression. The result enhances distances, or can help alleviate the reduction in three-dimensionality in the foreground or middle distance due to backlighting.

5. Synergy between Clarity and Vagueness

Lin Wen-yue (Chuang's university professor) once used the notion of "a cold pen to describe space, a hot pen to describe time" in his analysis of the *Luoyang Qielan Ji*: A Record of Buddhist Monasteries in Luoyang by Yang Xuan-zhi. He noted how the author combined the narrative styles of "rational (geographic) accounts" with "emotional (historical) plots" in the same work.

Chuang's landscape photography also features examples of mirroring that embrace a duality of character in one work, as interesting in itself as the modes of contrast in Western art. The difference between mirroring and contrast is that the latter tends toward the management of things or plot elements in a binary distinction; the former tends toward a comparison time and space before and after some particular development, and the synergistic responses between ternary (or greater) elements. Chuang's works exhibit greater participation of the temporal dimension, allowing for movement between mirroring and contrast.

Clearly, one aspect of basic photographic knowledge is the use of physical, optical effects to produce clarity and blurring, either within the depth of field region where the point of focus is, or with the interference from the circle of confusion outside of it, to create a dependent relationship between the image and the place itself. But the key lies in how to transcend the scientific, analytical calculations regarding the absolute relationships between image and place, or between distance, subject, and foreground, and add a more romantic outlook that involves concentration, flow, speed and slowness, and merging – so as to resolve the extreme opposites of science and romance.

Originally, the terms "clear" and "blurry" represented two emotional families. The former can be bracketed with the terms concrete, clear, sharp, close, distinct, and delicate feelings, while the latter can be grouped with abstract, misty, chaotic, distant, ambiguous, vague, and other feelings. It's often difficult to find the two together. However, we find that Chuang is able to make clever use of shutter time and timing, combined with sunlight conditions and lens framing, to bring clarity and blurriness together in a single photograph.

Edward Bullough believes that psychological distance is a necessary condition for the production of aesthetic experience, which exists "between the self and the object that causes emotion." "Space-time distance," on the other hand, is (among) the two forms of psychological distance. Superficially, there might seem to be a contradiction between the blurred system of forms of distance, which are "fluctuating, uncertain, misty, and vague" and the aesthetics of the "clear system," which advocates that which is "distinct, bright, and clear." But now, in Chuang's works, there is no contradiction between the two. His inborn wisdom makes him a matchmaker, and in the ceremony of photography, he makes a match between the "clear" and the "blurred" based on mutual feeling and compatibility.

6. The Mystery to be Found between Reality and Fantasy

Chuang's ability to use the lens preview allowed him to intuitively judge, under certain sunlight conditions, whether the changes he saw in the frame would meet the aesthetic expectations he had in mind. But because circumstances are always changing, to avoid accidents he made use of multi-sampling methods such as bracketing exposure or "burst mode" to obtain a "package" of photos that were similarly framed, then reviewing the results.

This process is like a scientific experiment—manipulating the independent variables to see if the dependent variables respond as expected under a given research framework. Photography itself can be considered an experiment, a process of experimentation with a game-like character.

With a spirit of adventure, Chuang often attempts, within the mathematical framework of an already established algorithm, to see what different possibilities arise as he tries setting different parameters until he obtains an aesthetically pleasing result. He called this series of works, in which he undertook "creative roaming" through second creation or post-production with his own photographs, *Painting Images, Soaring Imagination*, a title indicating free creativity without preset positions or conscious goals. The control program for "soaring imagination" inputs commands and unexpected "new visions" are output as a result.

The development of these new visions, even though most are taken from pre-existing master films of landscapes, possess meta-implications in terms of inter-textuality. Yet this moves beyond the realism of the original master film text and into incubating unknowns, in fantastical scenes that while not real, still possess "a vague sense of nature in its original state."

On the whole, Chuang attempts to liberate the archetypal primary colors of our real visual memory, continuing to follow the spirit of selection in his elemental photography, as he attempts destructive creation. He either changes the original shapes of things or blurs their outlines, or he causes their colors or color scales to deviate from reality, or reverses colors, or makes use of solarization or posterization effects... and so on. But although the original shape or color of things is liberated and reality is transformed, he rarely destroys the original shape or alters the original color at the same time, so that the result is not completely abstract. Qi Baishi emphasized that the meaning of painting "is the subtlety of the space between likeness and dissimilarity." The "soaring imagination" of Chuang's image-painting, whether in a change from low-level ambiguity to stronger vagueness, or from tonal gradations to layered color scale degrees… the mystery that lies between those degrees of likeness and dissimilarity, and the pleasure of unexpectedly encountering beauty, all result from experimental probing without pre-set conscious goals.

In addition, these effects, which transform the original forms of things, turn the works into decorative pictures, giving them increased possibility of commercial application, for example, in designs for clothing patterns, or wrapping paper, wallpaper, posters or magazine covers. The effect is like antique collector's items or decorative parts of buildings in the way that the layouts of their textures, colors, and lines produce enjoyment through their likeness (reality) and dissimilarity.

7. Final Thoughts: Sorting out Mike Chuang's "Heart/Hand/Eye" Approach to Photography

As Chuang "writes" through the medium of his camera lens, his great theme is the life within nature. He eschews deliberately manufactured scenes, attaching strained interpretations, and forced emotions, nor does he seek sudden, surprise gifts of inspiration. He understands that life and death are in the nature of things, and that there is no need to struggle against innate nature. With his outstanding observational ability, his eye for composition – anticipating, placing oneself on an equal footing with nature, and grasping the nature of the elements, he has created numerous series of autonomously created photographic works.

In terms of content, visual arts begin by imitating reality and nature. Nature includes things that are naturally (not artificially or deliberately) produced, and the laws that govern their production. The principal content captured through Chuang's lens is a reflection of the meaning of the state of nature and the conditions under which it thrives - the sweep of the wind, surging clouds, rising waves, the ebb and flow of tides, and sunset and moonrise. He visually spells out the meaning of power, of appearance, of concentration, of slowness, of sharpness, of steadiness....

In terms of form, traditional Western painting, like Chinese landscape painting, began by imitating reality, but because the two use different media, they developed different forms and approaches: Western oil painting developed sfumato, linear methods, and frottage, while Chinese ink painting developed "chapped" texture strokes, the "boneless" painting method, and line drawing. Regardless of the vehicle, whether wall murals or canvases, Western painting imitated reality (with perspective) in limited spaces, while Chinese painting, whether on cloth, vertical screens, silk, or rice paper, sought to take picturesque scenery, with beautiful mountains and rivers, and make them into scenic pictures of mountains and rivers.

In the photographic medium, which is also graphic visual art, the optical perspective of the lens and the photosensitive film may seem fated to project objective reality. Yet Chuang's strategy of subtracting space and adding time creates a more generous, open kind of space. Time takes on new colors, nature is touched up with light mascara; the picturesque portrait style of photography that the larger public enjoys is skillfully fused and interwoven with content of a more natural essence, which is to say, Chuang's reflections of meaning.

Chuang's creative work continues even today, like the cycles that are constantly renewing themselves in nature. Even a work completed yesterday may tomorrow evolve into an image with a new and different (impressionistic) meaning. In this essay I therefore propose that you use a natural state of mind, like "sitting and watching the rising clouds" to intuitively experience the beauty in each of Chuang's works, the union of form and substance that informs each of his beautiful "brocade screens!"

Painting Images of Grandeur:
The Mysterious Otherness of Mike Chuang's Landscape Photography

Author / Chiang Li-hua

In photography, "feng" (wind) means a change in atmosphere, a change in the light, and so we call it "fengjing" (wind / scenery) – "landscape." "Wind" is in motion, but the "scenery" of the land does not move – this blend of movement and stillness is the most important element of landscape.

<div align="right">Mike Chuang</div>

1. Introduction: The Depth and Breadth of Landscape Photography

Perceptions vary widely today with regard to what "landscape photography" actually means. Scenic photography is often lumped together with landscape photography, whereas here we want to emphasize that there is a difference between landscape and scenery – in particular, in contemporary landscape photography, "'landscape' is no longer merely shorthand for 'beautiful scenery' or 'pleasing views,' but instead, a true return to the much larger and broader realm of 'landscape.'" This includes both primitive and man-made landscapes, landscapes of both the natural world and of culture and society. Rather than merely directed at the pursuit of beautiful, dreamy landscape scenes, landscape photography is rich with our humanistic heritage and a sense of shared aesthetic experience. While landscape painting and landscape photography make use of different mediums, their depiction of natural scenery in each case is aesthetically pleasing, and the concepts behind their artistry are similar. Thus we have the expression "landscape into art," and I believe both can be viewed as "selected and composed from nature, just as the words of a poem are selected from everyday language. That is, 'painting is poetry.'" This quote, from Kenneth Clark (1903-1983), would certainly seem to be confirmed in the work of Mike Chuang (1942-), one of the first generation of Taiwanese landscape photographers. Chuang exceles at the use of high-contrast tonalities to present degrees of contrast between black and white, or very fine, high-resolution color to produce grand, imposing photos of unusual, spectacular landscapes, rather than gaudy, pretty scenery photos. We cannot help but be curious, how did he hope to photograph the nature that he saw? How did he make these marvelous, poetic, picturesque images?

With his booming voice and strong, sturdy frame, Chuang easily impresses as a bold, fearless figure. In 1983 he traveled hundreds of miles to reach Anhui, where he took in Huangshan's rows of towering peaks and personally glimpsed the 1683-meter-high Shixin Peak (considered the most spectacular sight in the range, its miraculous appearance like a painted scene). He became determined to conquer these mountains, and in the course of photographing the region throughout the four seasons, he climbed the peak a total of 26 times over a ten-year period, earning the moniker "celebrity hiker" in the *Huangshan Chronicles*. Through his lens, Huangshan is presented in high-contrast black and white, a lofty, floating peak seen in unusually imposing views. Having already found success as a commercial photographer in the U.S., the trick of "creating something from nothing" in that kind of photography was easy for him, whereas confronting a natural scene and preserving its essentials, in order to communicate his personal idea of beauty, was more difficult.

Invited to photograph Taiwan's highest peak, Yushan, in 1986, Chuang chose a panoramic view like a horizontal scroll painting to depict this sacred mountain, the crowning peak of Northeast Asia, with its high, steep peaks like the scales of a dragon cavorting among the peaks and valleys. Confronted with the unique geological features and rocks of Taiwan's coastline (at Kenting, Nanya, Guihou, Wai'ao, or Taroko), he was skilled at using small apertures and slow shutter speeds to highlight the lines of the terrain and beautiful strands of mist floating above the waters. Amid the natural settings of mountains, sea, and sky, he captured fleeting landscape scenes through a unique personal eye for photographic composition. He often self-deprecatingly said it was nature that had chosen him, allowing him to press the shutter, or that, because he had developed artistic perception through aesthetic experience, he could create poetic, picturesque landscapes by "selecting and composing from nature." Chuang's comments resemble very much the way that "art" is spoken of by Martin Heidegger (1889-1976) in his book, *The Origin of the Work of Art*. Although a work of art derives from the activity of the artist, only a work of art can turn a creator into an artist, and it is the art work that calls upon the artist to create. Without the previous existence of art as a source, there would be neither the work of art nor the artist. In a word, the images of landscapes in Chuang's work present a sensation of lofty aloofness, the grandeur of looking down upon the world from above. His landscape photographs have entered the realm of art, becoming a form of artistic expression. They are no longer merely beautiful scenes or pleasing views, but can produce the psychological effect of being apart from the world, of something that touches upon aesthetic philosophy.

2. Landscape Photography: Vital Energy and Power

Chuang, a graduate of the National Taiwan University Department of Philosophy, takes a linguistic approach to parsing the meaning of the Chinese word for "landscape" (which is made up of two Chinese characters, "feng," or "wind," and "jing," or "scenery"): "'Wind' is in motion, but the 'scenery' of the land does not move – It is this blending of movement and stillness that is the most important element of landscape." Because the wind is in motion, it has vital energy ('qi'), and while the land does not move, it has power ('shi'). I believe that that Chuang's landscape photography is a combination of the two. This imposing sense of energy and power can refer to the feeling of power in the image, or it can refer to the power in the changing state of the scenery throughout the four seasons. His landscape photography conveys the miraculous artistry within nature itself, its imposing grandeur, and its lofty mountains and deep waters. In his work, the energy may appear as a kind of power, or an atmospheric feeling; the power of nature may appear in its poise, or the sense of imminent motion, and these different kinds of energy and power create musical rhythms and emotional ambience. In particular, when we see how, after more than 100 visits to the Laomei Green Reefs in the Shimen District on Taiwan's north coast, he presents the unique and highly varied topography of the area: we can almost imagine that he was working not with a camera, but instead wielding a paintbrush with all the flair of an artist. Sea and sky, mountain and cloud emerge with a deft touch, while strong contrasts of dark and light appear, producing a poetic and musical effect and a mysterious, surging power. Whether in the erosion clefts carved by the sea, which look (as Chuang describes them) like groups of whales or alligators swimming in unison toward the sea, or in the lonely hulks of volcanic reefs, the rising and falling lines of the background and the roughness of the textures and forms express the crashing of the surrounding waves. Or he may show a sea as smooth as silk, in a scene that is ethereal, airy, and misty, almost illusory. Some of these photos show terrain at the same site, but shot from different angles, in different weather, or at different times of day; Chuang's forms of expression all have a rhythmic cadence and energy deriving from their movement and stillness, yet they vary from each other – just as the violin in each movement of Vivaldi's *Four Seasons* varies in tempo from allegro to andante, presto, and adagio molto. We feel the rich variety and change of everything in nature through the different seasons.

Chuang further finds a final touch of enlivening color in the green seaweed, sometimes known as "sea lettuce" or "hair of flat boulders" that grows on rock surfaces over the years with moisture from the ocean waves. Against large washes

of black and white in the background, the embellishment of these touches of bright green creates the wonderful atmosphere of this photograph. Or, he might be waiting for the moment when the bright sun rises, spreading its reddish tints throughout the sky and shining on the bright waves and dark stones of the beach, when we can hardly tell if we are in the sky above or in this human world, as the colors saturate all we see. Nature, it seems, has given him colors with which to paint, and with his perfect control he creates a kind of grandeur and atmosphere that embraces both movement and stillness.

Japanese photographer Hiroshi Sugimoto (1948-), an avid collector of antiques, also deals in antiques as an avocation; as a part of the contemporary art world, he frequently comes into contact with the modern art of the West. His *Seascapes* series tends to be static rather than dynamic, and his landscape photography "places you within the unending flow of time, flowing toward the infinite distance. Through the eternal presence of water and atmosphere, his photographs project a mood of great distance from the mundane world. Chuang also enjoys collecting antique objects such as wood and stone tools, and bases his choice of antiques purely on "whether they can create a sense of aesthetic pleasure." From this practice of collecting he has gained much experience and a greater understanding of aesthetics. He perceives the aesthetic experience of selecting photographic compositions in terms of framing an image that confirms the concentrated attention of the individual. Chuang's understanding of this issue is similar that of Jacques Maquet (1919-2013). Maguet pointed out, when discussing the human experience of beauty, that once a feeling for a particular scene enters our heart, it can induce a state of quiet contemplation, and through meditation on it, we absorb its beauty. As a viewer, we enter into the realm of aesthetic experience. If we compare the imagery in Sugimoto Hiroshi and Mike Chuang's photographs, we can perhaps say that Sugimoto stands above human history to convey a sense of timelessness, whereas Chuang stands apart from the crowd. He symbolizes "an alternative kind of monk," somewhere between engaging with the secular world and withdrawing from it, who is "simply no longer polluted by the concept of time." He conveys a concept of time and space that transcends our world, purifying the soul and freeing it from baser feelings.

3. The Inner Feeling of 'Mysterious Otherness' in Landscape Photography

In his essay *On Landscape Photography*, Kuo Li-hsin analyees the work of the world-class landscape photographer Ansel Adams (1902-1984) in photographing the Yosemite National Park in the U.S. He notes: "Photographs infect us with a sense of transcending the material world, an innate philosophical feeling, thereby summoning a mysterious kind of 'otherness'." To explain this mysterious "otherness," I borrow the explanation given to his disciples by Zen Master Qingyuan Weixin regarding the three sequences (stages) by which a devotee achieves enlightenment: Only after the stages of doubt, criticism, and dialectics can you thoroughly understand the essence of things. Thus, when an adherent of Zen reaches a state of enlightenment, "The mountain is (still) just a mountain, and the water is (still) just water." It's just that this mountain is no longer that original mountain. In other words, landscape photography does not mean just landscape photos, but "embodying a mythological existence of great mystery and spiritual elevation." By contrast, Chuang puts forward a view of landscape photography that not only expresses nature's essential existence, but more importantly, points to the photographer's subjective experience of nature; it is an art of balance, harmony, and humanity's integration with nature. At the same time, it also involves the three sequences (stages), from perception – seeing the mountains and waters as mountains and waters, to realization – seeing that the mountains and waters are not mountains and waters, to knowledge – seeing that the mountains and waters are still mountains and waters, and even, a further state of "knowing that mountains are mountains, that the waters are waters, that mind and matter are one, free and natural." In this way, a creator not only symbolizes his or her inner thoughts and feelings through their works; if they achieve the freedom and facility to follow their heart and create a personal style, they can attain an artistic

realm in which "mind and matter are one." This means that while landscape photography consists of images drawn and composed from the real natural world, it can transcend the material world of reality and summon the spiritual height of that "mysterious otherness," and we can enter into an appreciation of that mythical beauty and rapport.

Chuang has climbed many mountains and ridges, capturing the mountain scenery of national parks in Yellowstone, the Rockies, Yosemite, and the Arches National Park and Bryce Canyon in Utah, immersing us in the startling immediacy of the scenes he captures. We see lofty, towering shapes that move in undulating folds and ridges, arrayed in bewildering complexity; Chuang conveys depth through his grasp of spatial perspective, while emphasizing the strangely shaped rocks and cliffs, the textures of the desert (sediment ripples in sand), and the lines of tree trunks in the forest. But these scenic elements are no longer merely themselves, in their original setting, but have become a representation of sublime spirituality and reveal an awe-inspiring beauty. In the landscape photography of Ansel Adams, the visual presentation of the moon, rocks, and plants often seems soft and smooth. When Chuang shoots the same subjects, however, his presentation of the small details within the larger landscape, such as the trees, stones, or the flowing ripples in yellow sand, show a touch of gentleness within roughness, in images that are mysterious and difficult to fathom. He uses the natural environment to suggest the life that once existed there, expressing the balanced beauty within the landscape, creating a union of beauty and the sublime.

I would like to cite the ancient Greco-Roman aesthetician Longinus (c. 213-273 A.D.) and the concept of the sublime he discussed, in relation to rhetoric, in his work *On the Sublime*. In that book, he simultaneously derives the notion of the sublime in both social and political life and in the natural world. He makes it clear that what is sublime, beyond causing us to feel wonder, is also capable of astonishing us intellectually, overshadowing whatever is merely ordinary and rational. True sublimity isn't merely gorgeous or ornate, but involves lofty, intense, and solemn thought. It elevates our souls and produces a kind of impassioned and expansive joy. Without the emotions of delight, admiration, and reverence, there is no sublimity, but only fear. Put another way, the psychological effect of the sublime is not just a sense of greatness; it also brings tension and pressure, and has a certain kind of power to raise us above the ordinary. Viewing the photographs Chuang has taken among the mountains, the plains, and the valleys, one will understand that he approaches his work with a rigorous, demanding attitude. Through his individual eye for composition, a unique compositional viewpoint, he expresses what he feels inside. It is not just a matter of elements such as color, line, brightness, or vantage point, or the combination of outstanding technical skills and fine textures, but instead, the ability to startle the viewer while also inspiring feelings of joy and awe.

Returning again to Chuang's expression of the sublime mountain vistas of the East, China's Huangshan appears in mist and haze, its cliff faces plunging straight down, like the vast mountain chains of the "jade realm" of the immortals. In some images, a rising or a setting sun may appear, faintly discernible, or in others, a heavy blanket of snow, deliberately contrasting in brightness relative to other scenic objects. The contrasts within his photographs creates rich layering and variety, particularly in the drifting banks of clouds set off against high mountain peaks, recalling the free and easy air described by the Warring States Period philosopher Zhuang Zhou (c. 369-286 B.C.) in his writing in *A Carefree Excursion*. Observing Chuang's expressions and attitudes as we talked during numerous interviews, I couldn't help but feel that he is like the roc, the great bird of Chinese mythology, soaring high above the vast landscape, partly floating on the wind (what nature gives), but also with a powerful will that never wants to give up. But he knows that he must fly with the wind and return with the wind; if the weather or the light aren't right, he will calmly return or find another place to work. Photographing Yushan's majestic peak, standing alone in Taiwan's landscape, Chuang shows a protruding ridge as thin as an axe blade, raising its head into a lofty peak that reaches into the sky, as if the oceans had been stirred up until they rose up into the heavens. A light wind blows among the thin mists in a tranquil scene; above this vastness a

round disc of the morning sun hangs proudly in the sky. Hazy, insubstantial clouds and vapors add to the "mysterious otherness" in this land of mountain peaks, in an artistic conception of the mystery behind our material world.

Many photographers have been eager to photograph these two mountains, and Huangshan Travel Photography guides have even been published to point amateur photographers toward the best routes and scenic highlights, although such a cursory approach makes it difficult to present a unique perspective or aesthetic view. Taiwanese mountain photographer Fang Ching-mian, who has traveled between Alishan and Yushan for more than 40 years and has climbed Yushan more than 3,000 times, has left many black-and-white photos documenting the paths on which he climbed and the locations that afforded him a particular line of sight for photography. Other photographers, such as Juan Jung-chu and Chen Yu-feng have also captured the beauty of Yushan, including its rare alpine plants, exotic flora, and birds and insects as they change through the various seasons. Chuang, however, did not engage in photography for documentary purposes; instead, amidst the spiritual energy of the ridges of blue mountains wreathed in mist and haze, he sought a dialogue of knowledge and understanding (the third stage of photography, as set out above) with nature.

4. Conclusion: Roaming the Endless World of Photography

Chuang has been infatuated with photography since his college days, and he emphasizes that photography requires "being true to your own thoughts, cultivating implicit meaning, and pursuing personal ideals. Whether you are an amateur photographer or you work in commercial photography, you must devote yourself entirely to the art of photography, permanently, in every way, without end." As a young man, he had a more frivolous phase in which he often won youth photography competitions, but to further hone his skills, he went to New York in 1971. At first, he just wandered the streets, but he was fortunate to get an introduction from Ko Si-chi and began to learn more while working as an assistant at a commercial photography firm. With his hard-working and uncomplaining nature and the basic skills he had already taught himself, he impressed his boss and was promoted for his first experience of working as a photographer. The rigor and precision he demanded from himself led to a career peak in which he made a name for himself in the American world of commercial photography, but he appears to have felt the secret call of art. He resolutely abandoned his already well-established commercial photography practice in favor of roaming the world, soaring between heaven and earth to pursue landscape photography.

In Chuang's career as a photographer, he has dedicated his life to "focusing on the exploration of spiritual beauty and finding the ultimate value of life." He refers to himself as "an alternative kind of monk," and seeing many mountains and waters during the course of his spiritual journey, he grasped early on the meaning of the profound Zen state in which one "sees that the mountain is still a mountain, and the water is still water." He chooses to express his unique personal perspective with his particular choice of photographic equipment and techniques, on the basis of personal preferences and aesthetic experience. He photographs the imposing grandeur of landscapes reaching to the edge of the horizon, painting a unique vision of heaven and earth as he expresses what is very nearly a worship of nature. It should be understood that beauty relates to the limited, physical form of the artist's subject, whereas sublimity involves aspects unrelated to that form. We can observe the beauty of waves in the ocean, even if the tides and their vast power are beyond our control. But a great ocean wave thrown up by a storm cannot be called sublime if it is just a sight that causes terror. It is only when our spirit is moved by a sense of beauty, and we feel inspired to worship nature, that a sense of the sublime is engendered as we watch the great wave.

To sum up, whether Chuang was using traditional large-format or medium-format cameras to produce high quality photographs, or reproducing views of magnificent landscapes, or whether it was the inexhaustible images of fantastic

colors caused by the mold on his negatives in the 1990s, or even in his more recent use of computer graphics software to produce montages through image processing in the abstract, digital, virtual world – each of these has been a vehicle for carrying out his search for spiritual beauty, discovering the value of life as an alternative kind of monk in this material world.

作品
WORKS

鏡觀的旅程

作品內容：《臺灣》、《黃山》、《青藏》、《北美（洲）》系列

文 / 胡詔凱

從本單元，可以走一回莊明景一生為攝影的「鏡觀」行腳，也可以來一回寂靜的、寂寥的、帶有侘寂意味的「靜觀」體驗；並隨著作者純淨無染的創作心境「淨觀」作品中的「無目的之美」。

總括莊明景的主要攝影足跡，可以分成《臺灣》、中國大陸的《黃山》與《青藏》以及《北美（洲）》四個空間系列。每個系列以自然景觀為大宗（搭配若干人文地景照片），在時間軸上彼此交互穿插，顯示作者曾經多次重複往返同一景點，而非僅有一、兩次足跡的一般旅遊攝影紀錄、或人文紀行所能及。

《臺灣》系列，環照著北海岸、南墾丁、東太魯閣與蘭嶼以及中央山脈玉山頂峰的多元地理形貌，呈現出海島特有的地景多樣性。

《黃山》系列，將「松石雲泉雪」黃山五絕構成的「如畫之景」賦予「如景之畫」的寫意，與黃山腳下「徽派建築」的古意盎然相互輝映。

《青藏》系列，傳達了當地景觀與人文風貌；若與我們的塵世社會做比較，可以感受到那「秘」（神秘氛圍）與「淨」（環境純淨）所蘊含的「秘・淨」風情。

《北美（洲）》系列，匯集了山、水、石、沙、木等不同型態元素，將北美洲的各式風貌，藉由「日月照明」而顯得多彩多姿。

The Journey of "A View through the Lens"

Including works from the *Taiwan, Huangshan, Qinghai-Tibet, and the North America* series

Author / Hu Chao-kai

In this section, you can follow Chuang on his lifetime journey in photography, his "view through the lens." Or you can make it a quiet, solitary, "wabi-sabi" experience of contemplation, as you follow the photographer's pure and unsullied creative outlook, for the clear view his works give us of "beauty free of any other motives."

Chuang's main photographic "footprint" can be divided into series of works from the four main regions in which he traveled: *Taiwan*; *Huangshan* (the Yellow Mountains) and the *Qinghai-Tibet* region in China; and *the North America* continent. Each series focuses on natural landscapes, but with a number of local scenes of humanitarian interest interspersed among them. These two types of photography mingle with each other all along the axis of time, showing that Chuang traveled repeatedly to and from the same scenic spot many times, something beyond the reach of ordinary travel photography records or humanitarian photography that takes place over only one or two trips.

The *Taiwan* series reflects the diverse geographical features along its North Coast, along with Kenting in the south, Taroko and Lanyu (Orchid Island) in the east, and Yushan peak in the Central Mountains, revealing the unique and diverse landscapes of the island.

The views in the *Huangshan* series, of "scenery like a painting," are composed of the "five wonders" of Huangshan Mountain, which are its pines, rocks, clouds, springs and snow. The free, impressionistic treatment of the photographs turns them into something more like "paintings of scenery," which shine brilliantly together with the ancient feel of the Huizhou-style architecture, as photographed by Chuang at the foot of Huangshan Mountain.

The *Qinghai-Tibet* series conveys the local landscape and its cultural and humanitarian features. By contrast with our worldly society, you can feel the "secret and pure" aspects of the region, as Chuang describes it, in its mysterious atmosphere and its environmental purity.

The North America series brings together different environmental elements such as mountains, water, stone, sand, and wood, and under the illumination of sun and moon, reveals the splendor and color in the various landscapes of North America.

《臺灣》系列
Taiwan Series

〈蘭嶼（勢與穩）〉/ 臺灣 / 1968
Lanyu (Power and Stability) / Taiwan / 1968

〈蘭嶼（轉與凝）〉/ 臺灣 / 1968
Lanyu (Turning and Condensation) / Taiwan / 1968

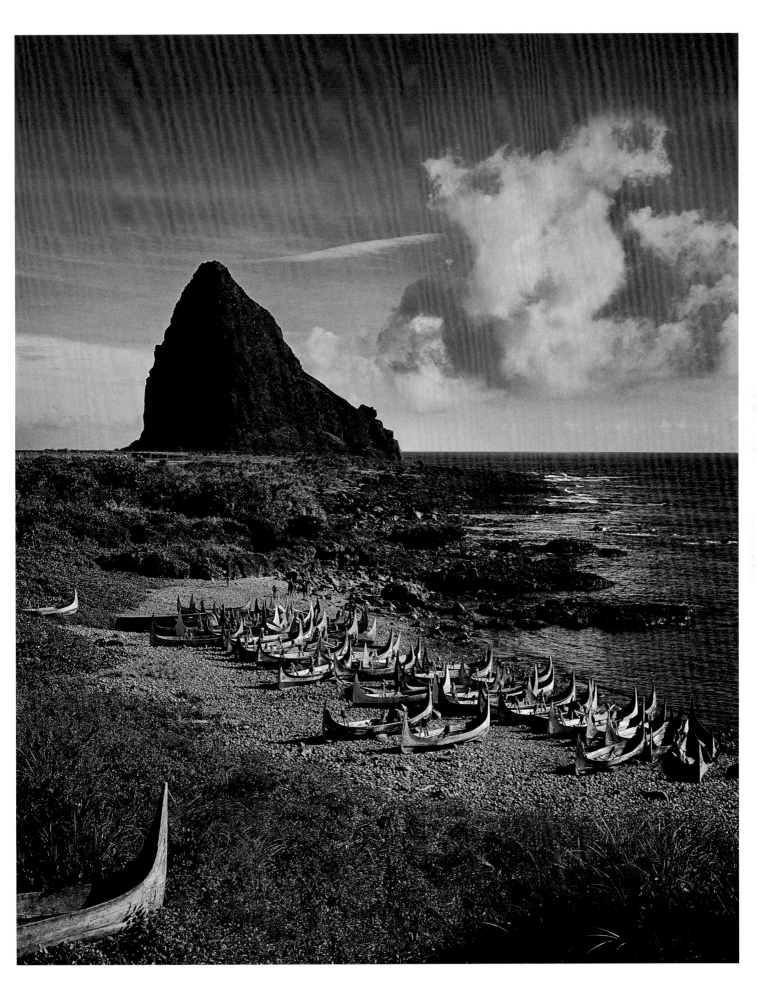

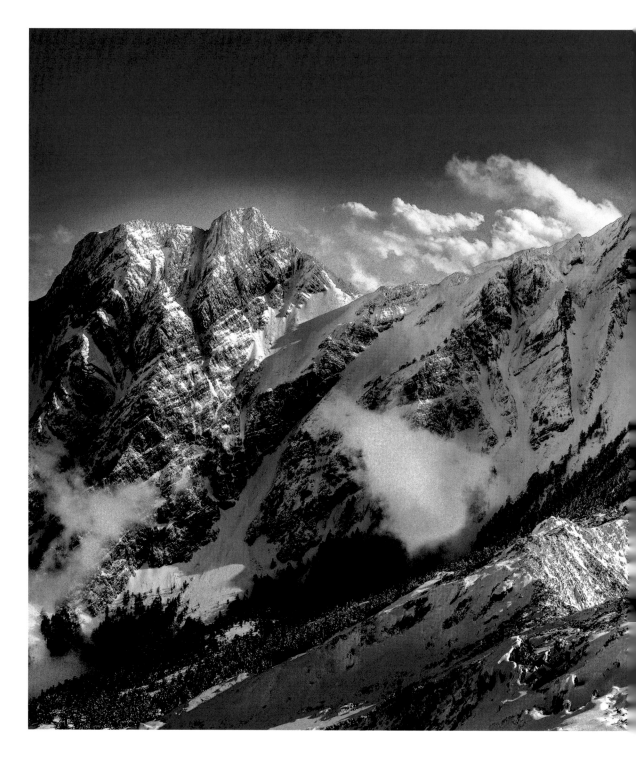

〈玉山（勢與利）〉/ 臺灣 / 1986

Yushan (Power and Sharpness) / Taiwan / 1986

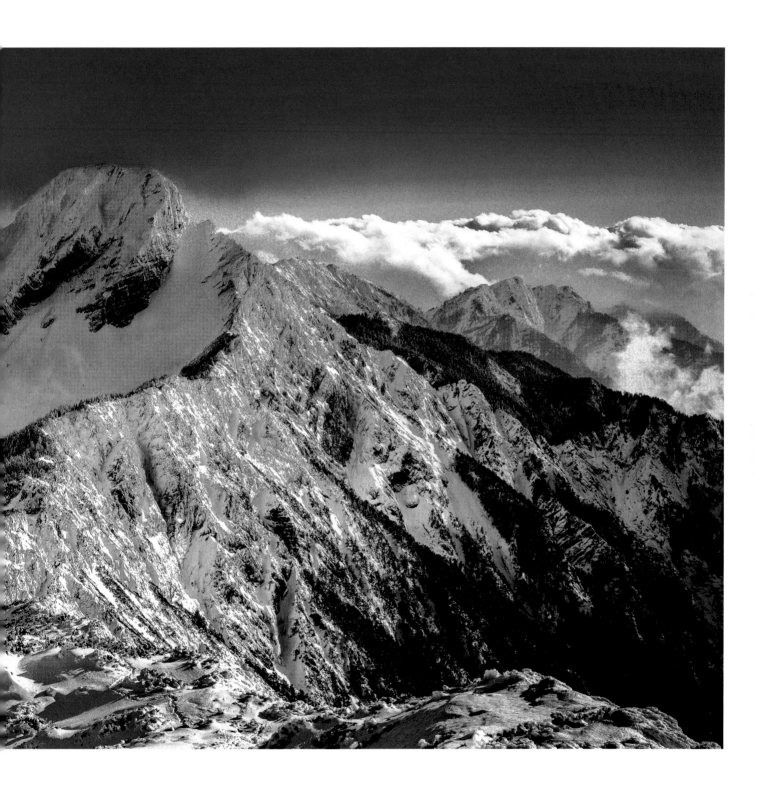

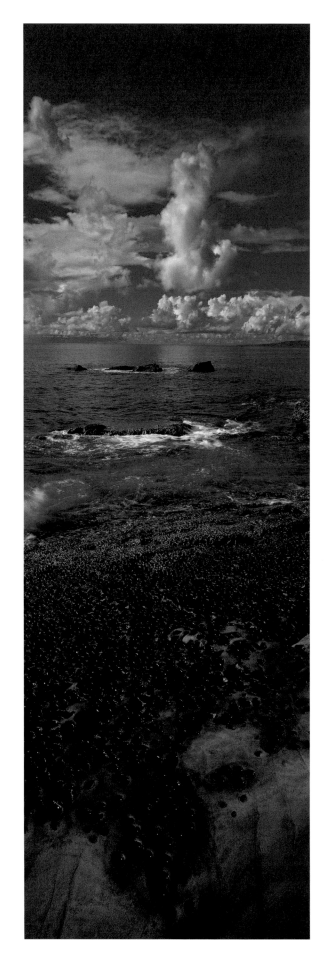

〈墾丁（紛與覆）〉/ 臺灣 / 1986
Kenting (Disparity and Coverage) /
Taiwan / 1986

〈佳樂水〉/ 臺灣 / 1986

Jialeshuei / Taiwan / 1986

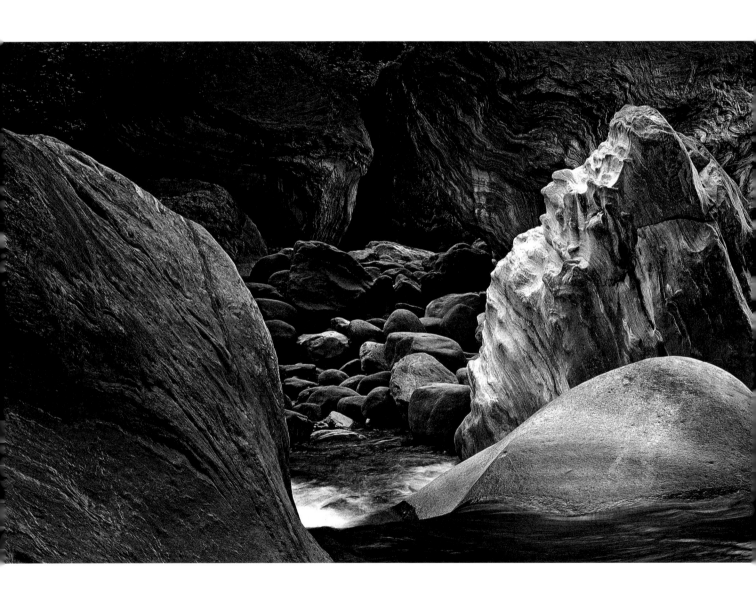

〈太魯閣（容與穩）〉/ 臺灣 / 1988
Taroko (Enfolding and Stability) / Taiwan / 1988

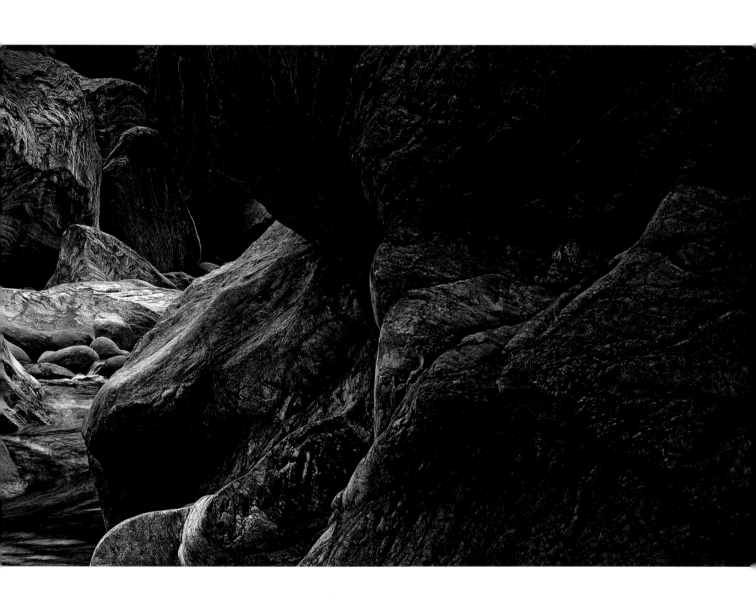

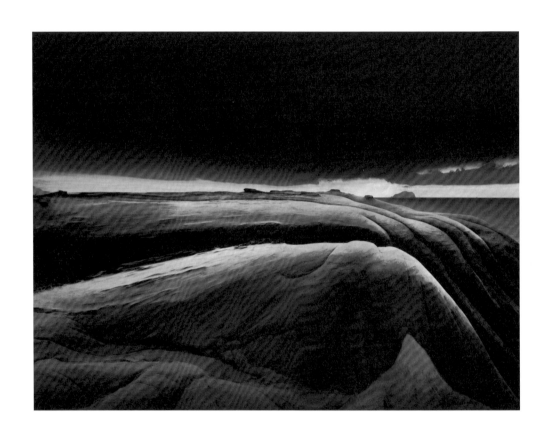

〈南雅（質與點）〉/ 臺灣 / 2005
Nanya (Texture and Focal Point) / Taiwan / 2005

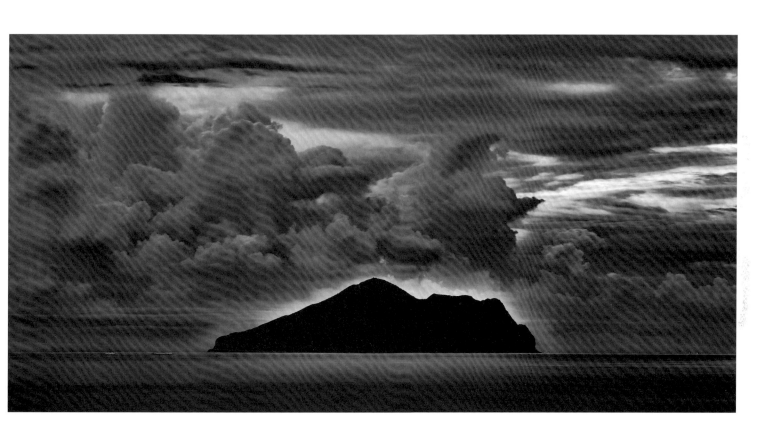

〈龜山島〉/ 臺灣 / 2020
Turtle Island / Taiwan / 2020

《黃山》系列
Huangshan Series

山上天人對弈
山下徽州古意
品「侘寂」！

On the mountain,

A game between man and the heavens

At the foot of the mountain

The ancient ways of Huizhou.

Taste its quiet simplicity!

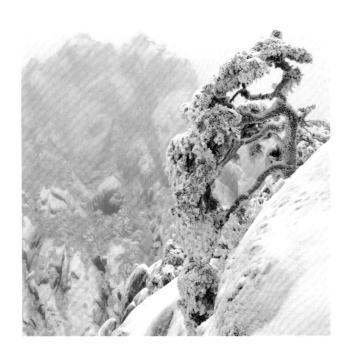

〈送客松〉/ 中國黃山 /1984
The Greeting Pine / Huangshan, China / 1984

〈黃山〉/ 中國 / 1985
Huangshan / China / 1985

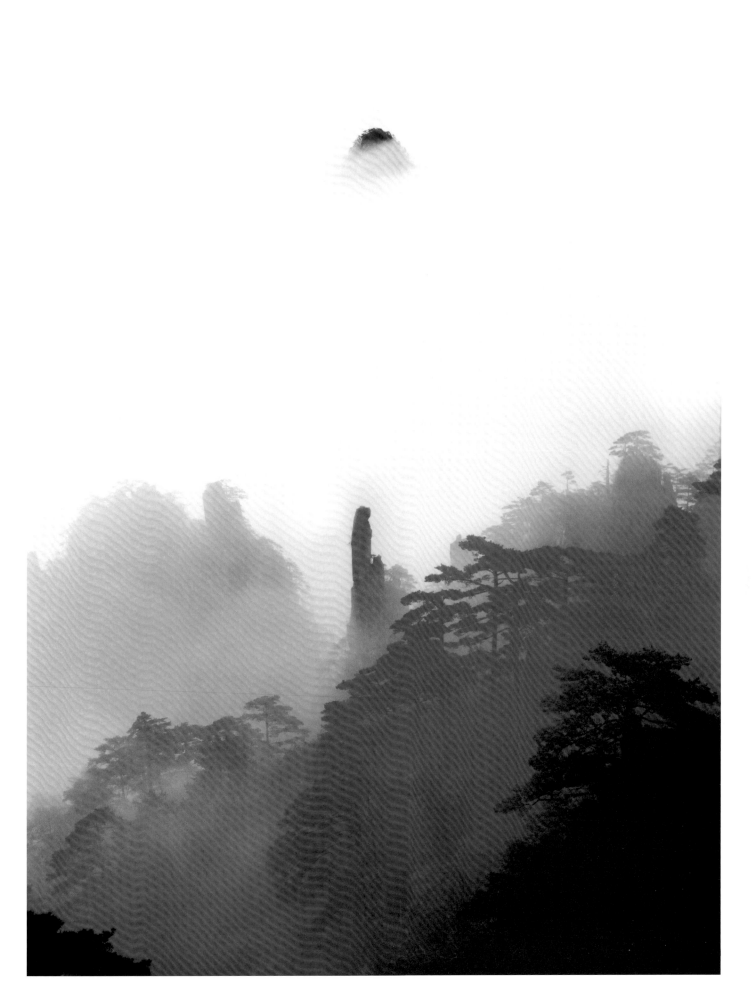

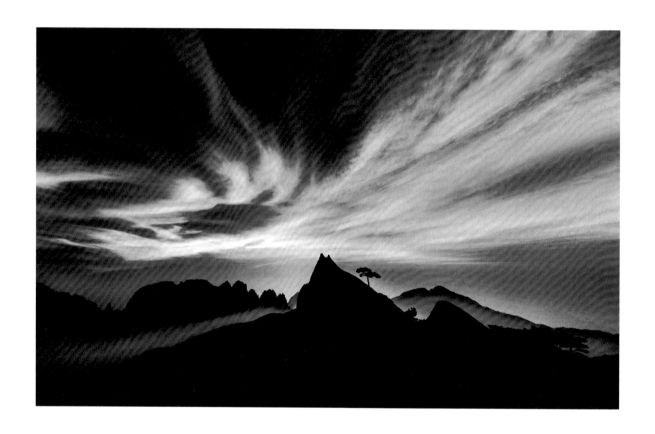

〈黃山〉/ 中國 / 1988

Huangshan / China / 1988

〈黃山〉/ 中國 / 2000

Huangshan / China / 2000

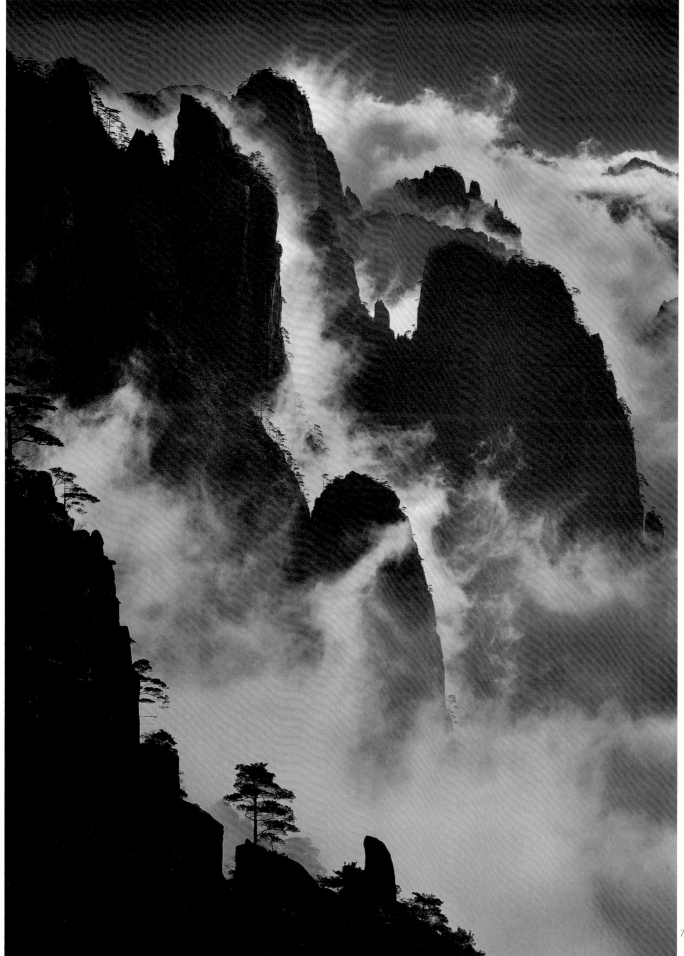

〈宏村〉/ 中國安徽省黟縣 / 1990
Hongcun / Yi County, Anhui Province, China / 1990

〈宏村〉/ 中國安徽省黟縣 / 1989
Hongcun / Yi County, Anhui Province, China / 1989

〈寶綸閣〉/ 中國安徽省黃山市 / 1990

Baolun Temple Pavilion / Huangshan City, Anhui Province, China / 1990

〈西遞村〉/ 中國安徽省黟縣 /1995

Xidi Village (Huizhou) / Huangshan City, Anhui Province, China / 1995

《青藏》系列
Qinghai-Tibet Series

〈布達拉宮〉/ 中國西藏 / 1991
Potala Palace / Tibet, China / 1991

〈青海湖（約與穩）〉/ 中國 / 1989
Qinghai Lake (Restriction and Stability) / China / 1989

〈青海湖（漸與易）〉／ 中國 / 1989

Qinghai Lake (Turning and Change) / China / 1989

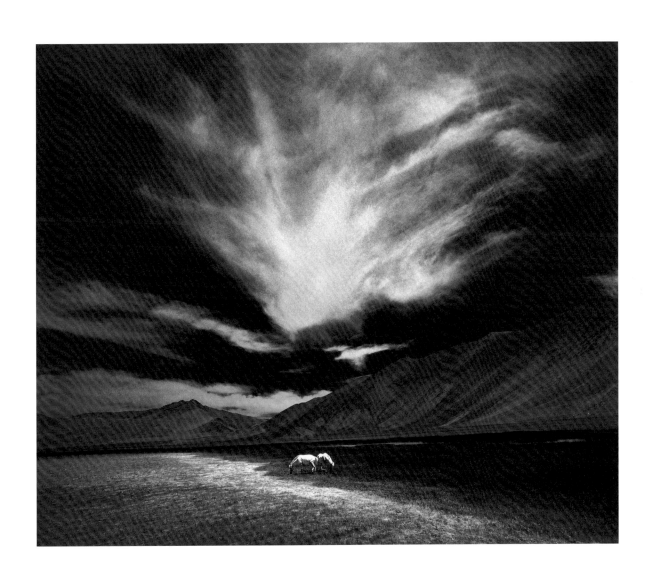

〈青藏高原（揮與點）〉/ 中國 / 1991

Qinghai-Tibet Plateau (Dispersion and Focal Point) / China / 1991

《北美（洲）》系列
The North America Series

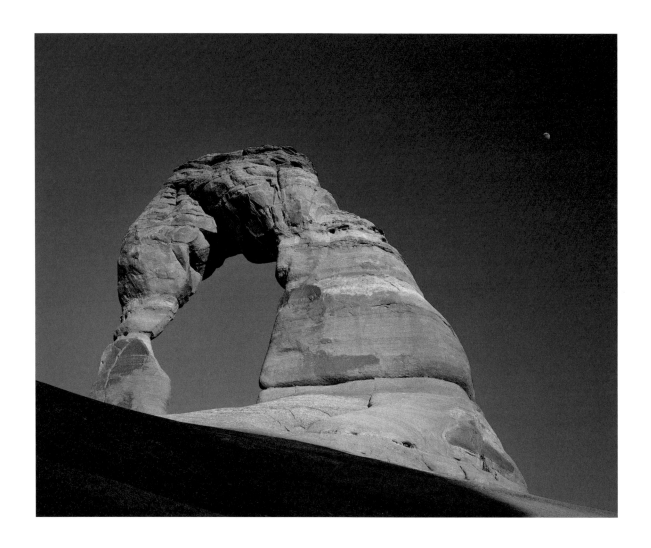

〈拱門國家公園（勢與點）〉/ 美國猶他州 / 1982
Arches National Park (Power and Focal Point) / Utah, the U.S. / 1982

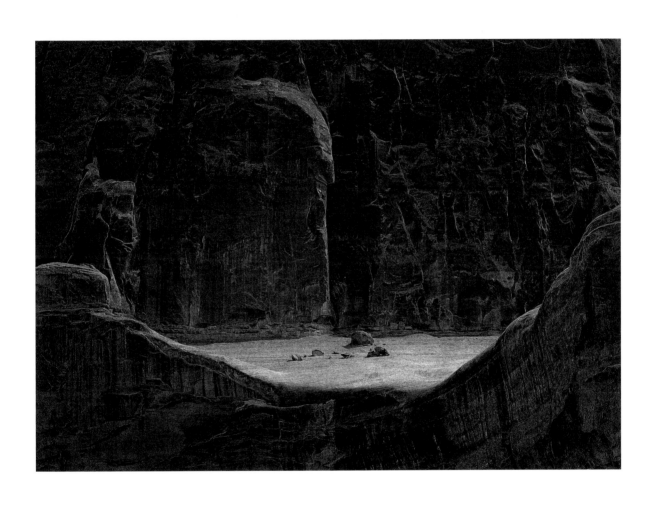

〈拱門國家公園（容與穩）〉/ 美國猶他州 / 1982

Arches National Park (Enfolding and Stability) / Utah, the U.S. / 1982

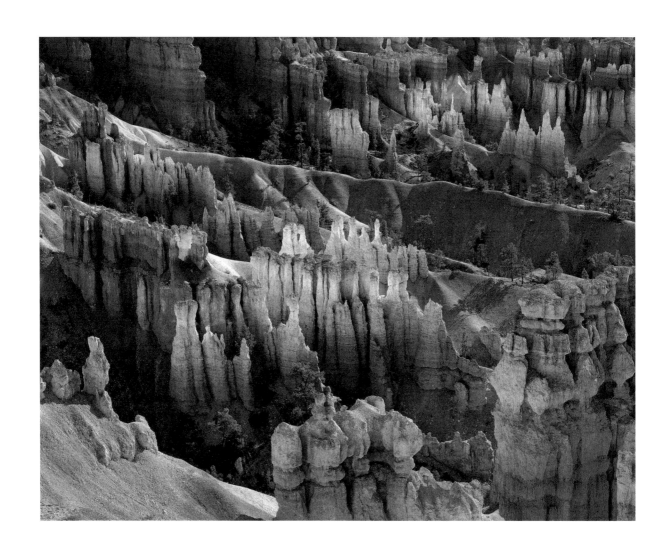

〈布萊斯峽谷國家公園〉/ 美國猶他州 / 1982

Bryce Canyon National Park / Utah, the U.S. / 1982

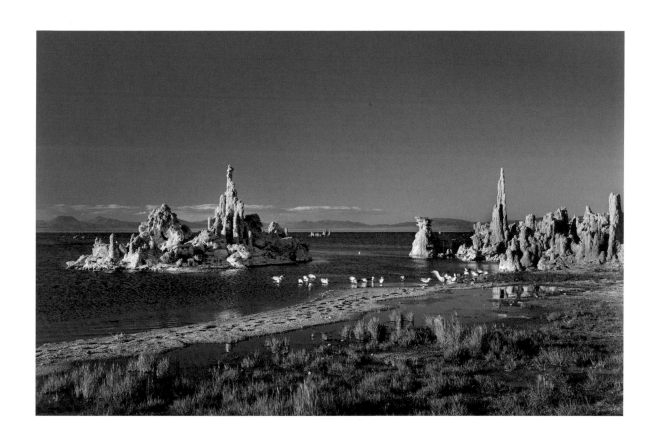

〈莫諾湖〉/ 美國加利福尼亞州 / 1982

Mono Lake / California, the U.S. / 1982

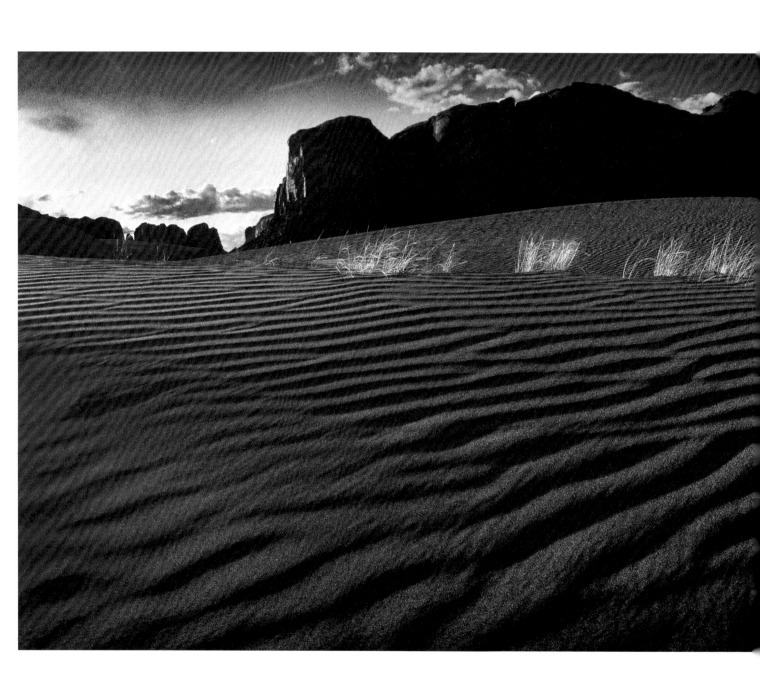

〈紀念碑谷（質與約）〉/ 美國亞利桑納州 / 1983

Monument Valley (Texture and Restriction) / Arizona, the U.S. / 1983

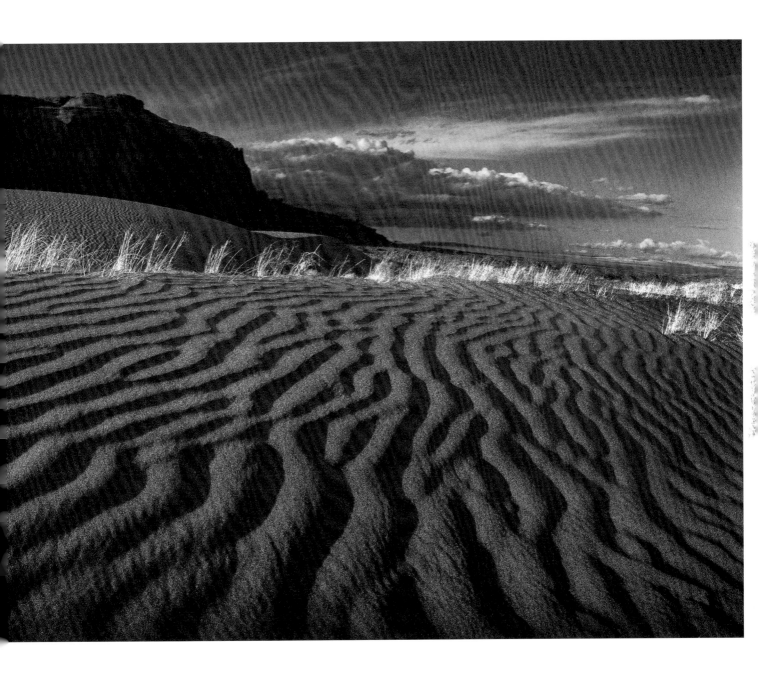

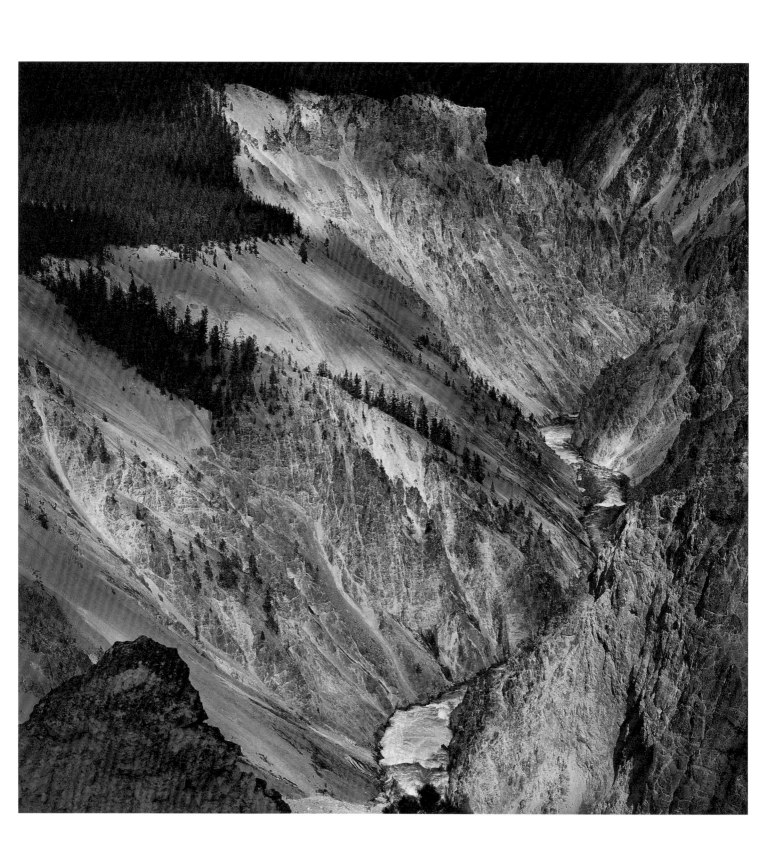

〈黃石國家公園〉/ 美國懷俄明州 / 1983
Yellowstone National Park / Wyoming, the U.S. / 1983

〈新罕布夏州〉/ 美國 / 1983

New Hampshire / the U.S. / 1983

山海經

作品內容：《山脈》、《海岸》、《湖面》等系列

文 / 胡詔凱

「山」與「海」是莊明景重要的創作題材。本單元將臺灣獨具的山海景觀，與國外的山水自然相互對照。

若以海拔高度為縱軸的垂直地理系譜來看，可以看出莊明景在高海拔到海平面的鏡頭視野，如何掌握臺灣山脈與海岸的蜿蜒、雲水變化；相對於境外（中國大陸、美國、日本）的峻嶺與湖面，又是如何掌握高緯度地區山與海的冷峻、沉寂寧靜。

若用「理性形式」和「感性內容」的整合技藝來看，可以看出莊明景如何藉由觀察、取景、操作設定，拍出「勢（力），柔（棉），蜿（蜒），（簡）約，轉（折），容（融），（繽）紛，穩（重），利（糙），點（景）」的形質，除了讓山與海自顯其天然的姿態，也使得唐宋以降文人山水畫的「寫意」之風，更為當代人所親近。

還可以從部分作品，例如「圖地反轉」剪影效果、兩造式構圖之「互為圖地性」、「過牆視域」、「透視點邊緣化之向量動勢」、「巨碑式構圖之變奏與散劈」的經營，看出莊明景如何因時因地制宜的就現場條件，突破既有構圖模組的框架。因而，風起、雲湧、浪推、潮落……各種美感氛圍，值得你我靜下心來坐看與感應！

The Scriptures of Mountain and Sea

Including works from the *Mountains, Seas, and Lake* series

Author / Hu Chao-kai

Mountains and seas are important creative themes for Chuang. This section juxtaposes Taiwan's unique mountain and sea views with foreign landscapes.

If we take altitude above sea level as a kind of geographical genealogy, extending along a vertical axis, we can see how the vision of Chuang's camera, from high altitudes to sea level, captures the meandering of Taiwan's mountains and coasts, as well as its changing clouds and waters. Further, beyond Taiwan's borders, in the lofty mountains and lakes of China, the U.S., and Japan, we see him capturing their stern stillness and serenity.

Looking at the artistry Chuang displays, in his integration of rational form with emotional content, we see how through observation, framing his composition, and manipulating camera settings, he is able to capture the qualities of force, softness, meandering, simplicity, turning and folding, merging, colorfulness, stability, sharp roughness, and scenic focal points in nature. This he does in such a way that the mountains and seas display their own natural poise, bringing the tradition of "freestyle impressionism" of Chinese literati landscape painting, handed down since the Tang and Song dynasties, closer to our contemporary world.

In certain works, we also see how Mike Chuang adapts to on-site conditions and breaks through the framework of established compositional models, such when he uses the silhouette effect of "figure/ground reversal," the "mutual figure/ground relationship" in a dual-subject composition, a visual field seen through a frame of other objects, the vector dynamics created by marginalizing perspective points, or the variations and scattered distributions of the "monument" style of composition. All these make the rise of the wind, the surge of clouds, the push of waves, the falling of the tide... all kinds of beauty and atmosphere available, waiting for us to sit, quiet our hearts, look, and respond!

〈黃山（容與融）〉/ 中國 / 1990

Huangshan (Enfolding and Merging) / China / 1990

〈玉山（點與穩）〉/ 臺灣 / 1986

Yushan (Focal Point and Stability) / Taiwan / 1986

〈玉山（凝與流）〉/ 臺灣 / 1986

Yushan (Condensation and Flow) / Taiwan / 1986

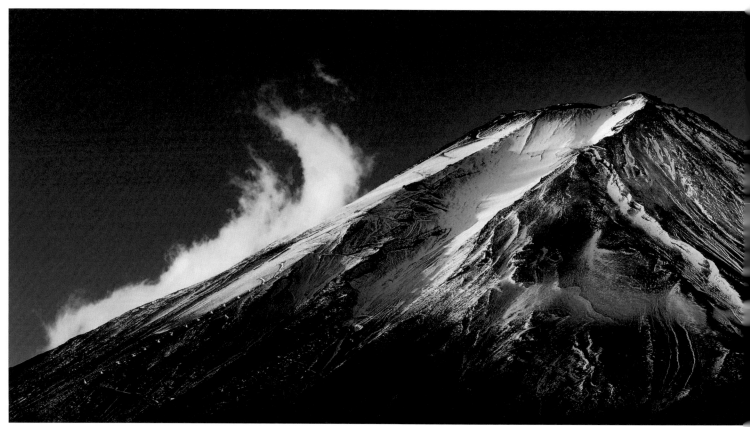

〈富士山〉/ 日本 / 2017
Mt. Fuji / Japan / 2017

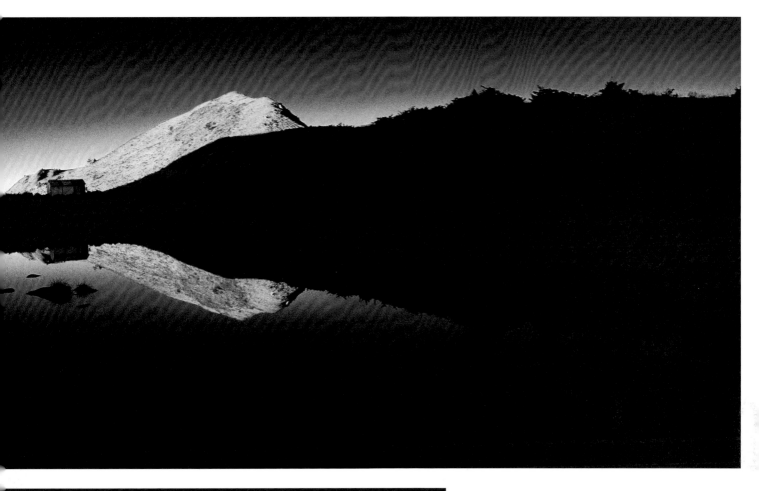

〈大水窟山〉/ 臺灣 / 1986
Dashuiku Mountain / Taiwan / 1986

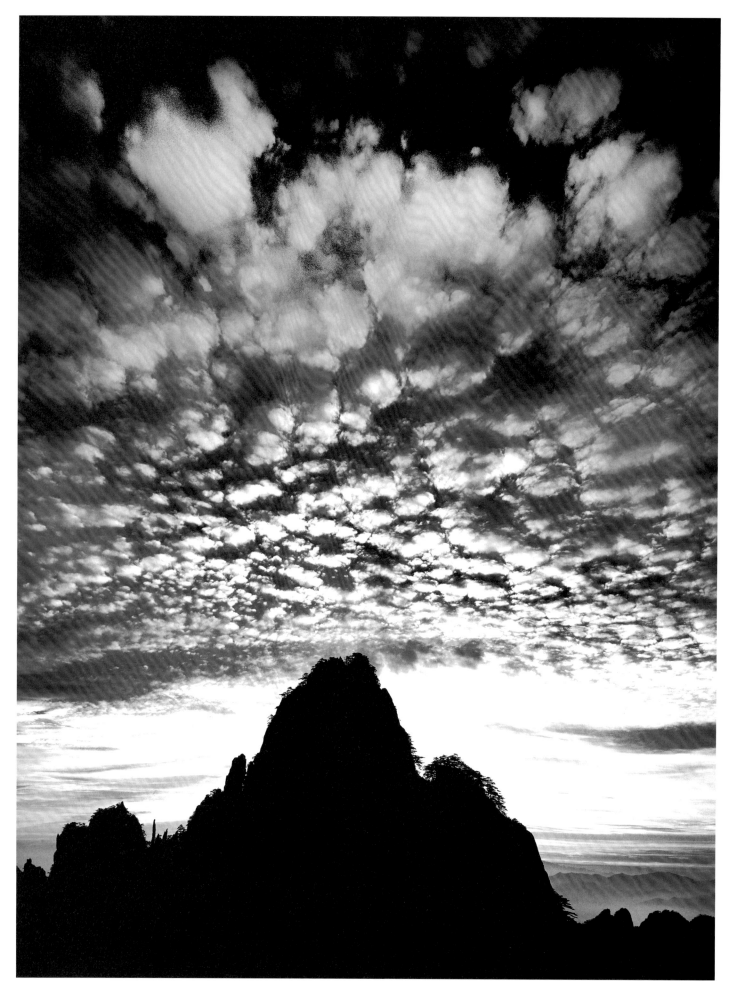

〈黃山（紛與覆）〉/ 中國 / 1984
Huangshan (Disparity and Coverage) / China / 1984

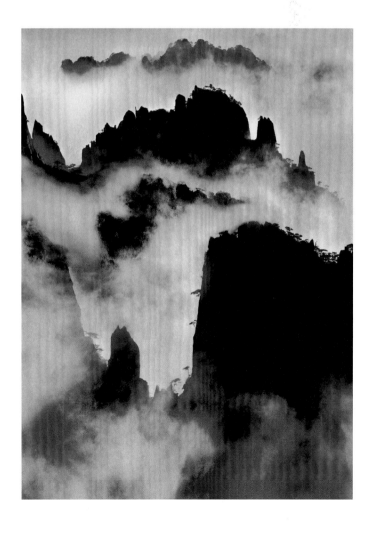

〈黃山（勢與漸）〉/ 中國 / 1989
Huangshan (Power and Permeation) / China / 1989

〈黃山（容與融）〉/ 中國 / 1988
Huangshan (Enfolding and Merging) / China / 1988

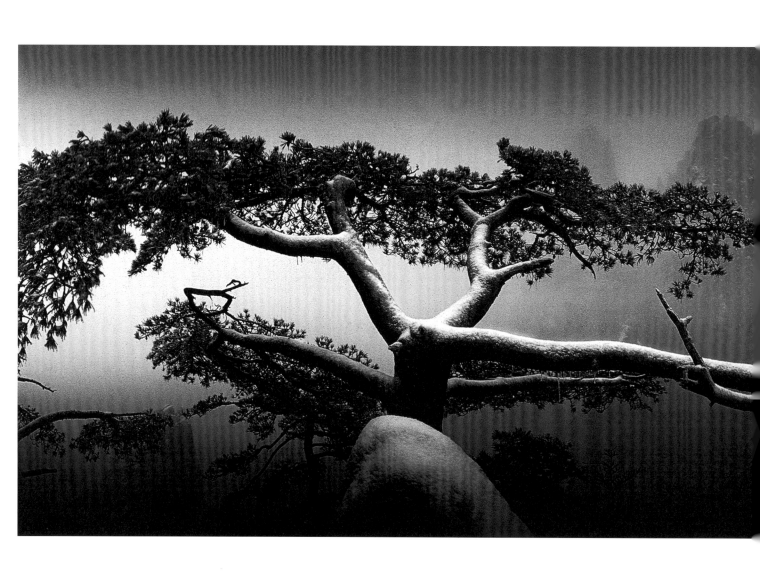

〈黃山（揮與凝）〉/ 中國 / 1991

Huangshan (Dispersion and Condensation) / China / 1991

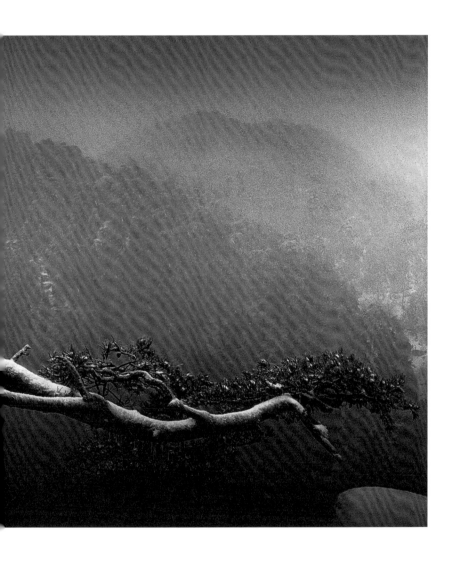

從岩石裂縫中伸展的架勢／
宛若仙人修練太極之姿
——平‧息‧氣

This pose, stretching out from the
cracks in the rock, is like a mountain
spirit practicing Tai Chi

—Calming, Breathing, and 'Qi'

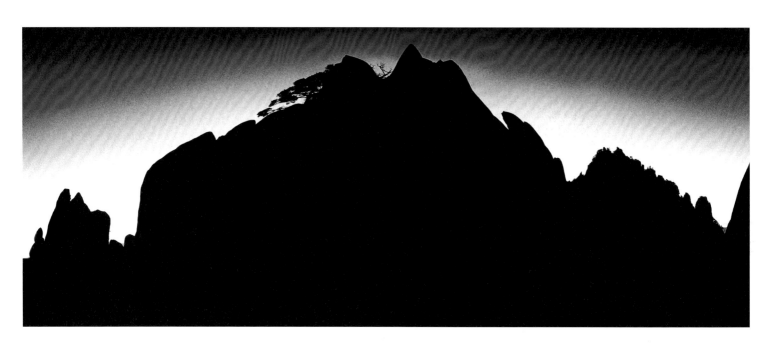

〈黃山（轉與易）〉/ 中國 / 1984

Huangshan (Turning and Change) / China / 1984

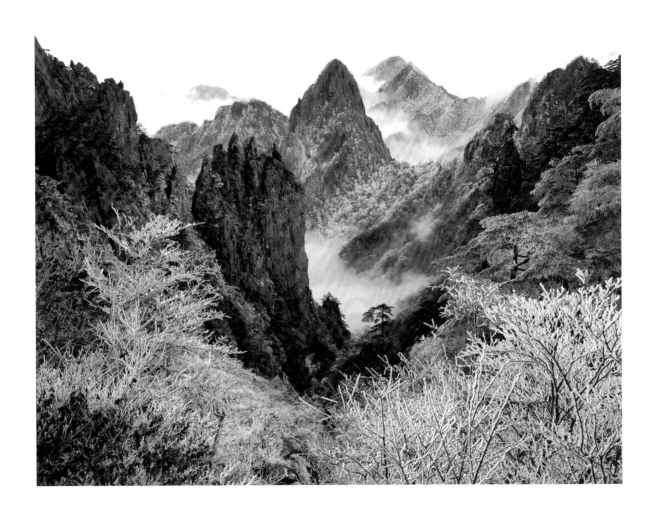

〈黃山（勢與紛）〉/ 中國 / 1984

Huangshan (Power and Disparity) / China / 1984

〈獨秀峰〉/ 中國廣西省桂林市 / 1990

Duxiu Peak / Guilin, Guangxi Province, China / 1990

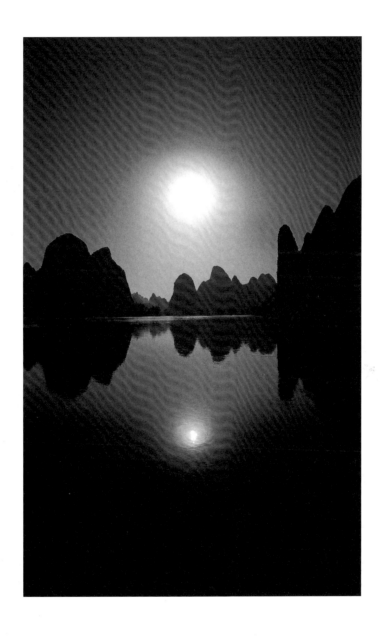

〈陽朔〉/ 中國廣西省桂林市 / 2010

Yangshuo / Guilin, Guangxi Province, China / 2010

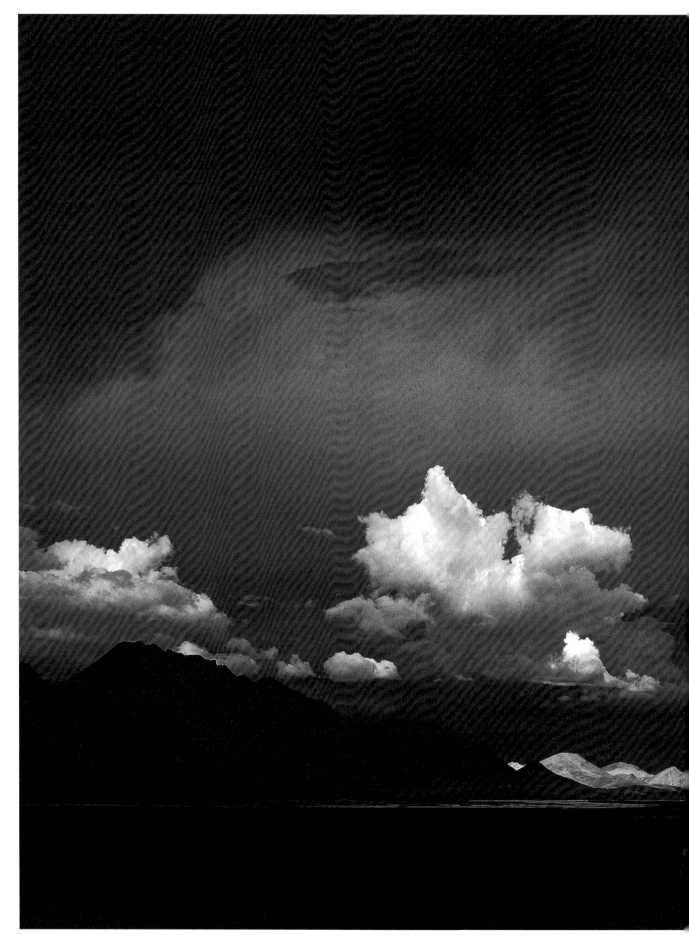

〈青藏高原（揮與凝）〉/ 中國 / 1991
Qinghai-Tibet Plateau (Dispersion and Condensation) / China / 1991

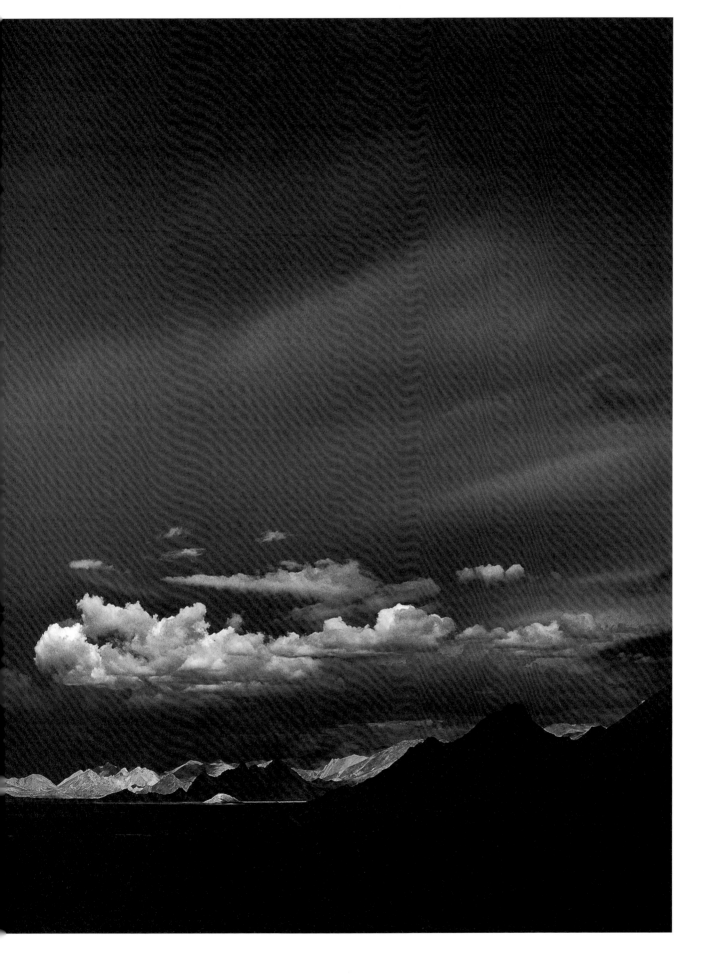

〈最後的鹽湖（西藏）〉/ 中國 / 1993
The Last Salt Lake (Tibet) / China / 1993

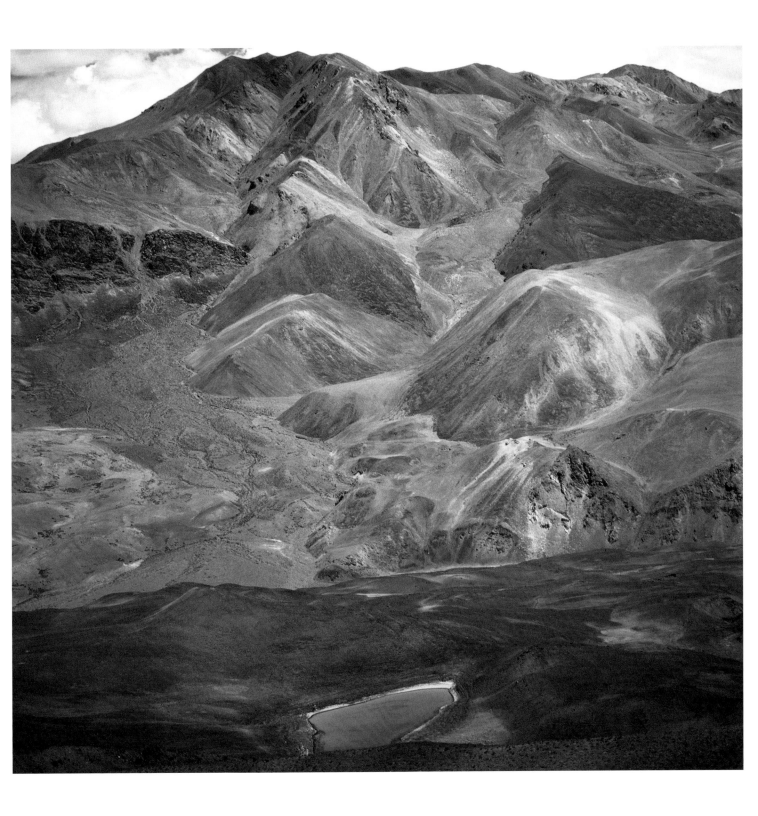

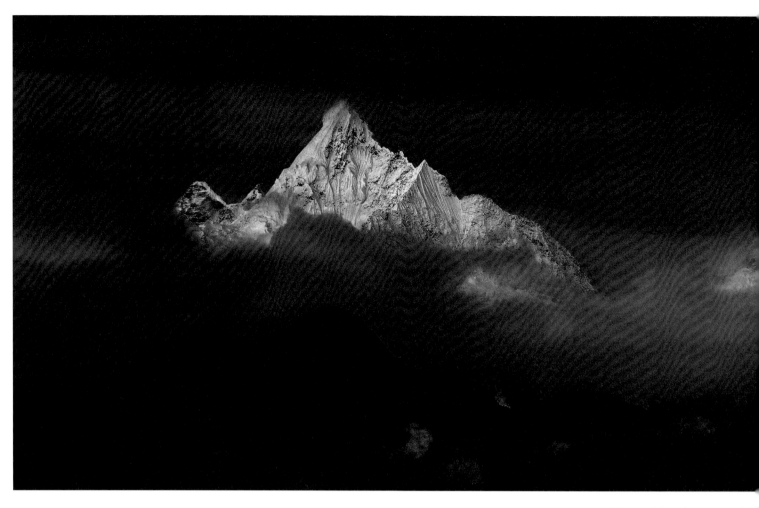

〈梅里雪山〉/ 中國西藏 / 雲南 / 2015
Meili Snow Mountain Range / Tibet, China / Yunnan / 2015

〈阿拉斯加州〉/ 美國 / 1982
Alaska / the U.S. / 1982

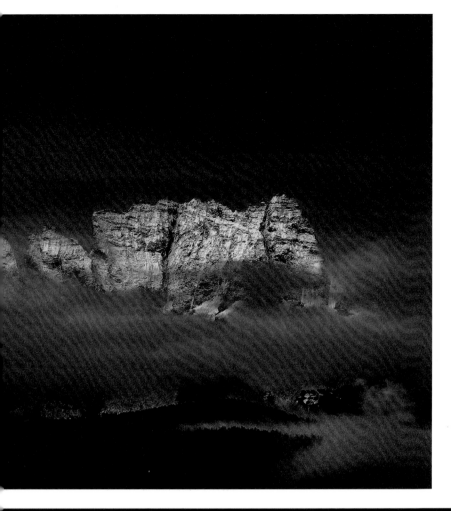
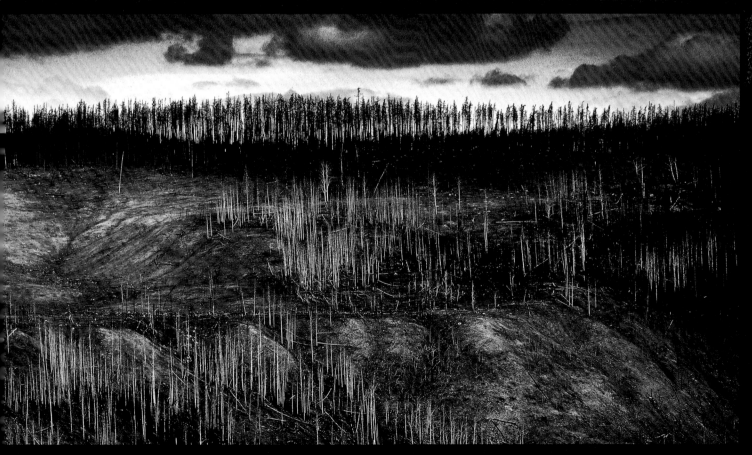

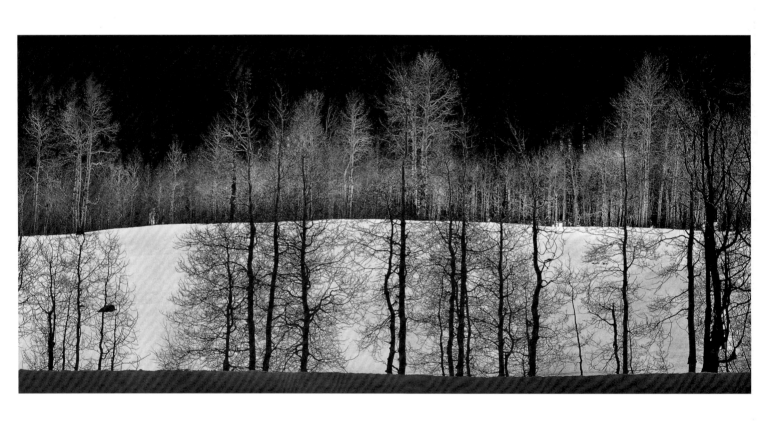

〈落磯山國家公園〉/ 美國科羅拉多州 / 1982
Rocky Mountain National Park / Colorado, the U.S. / 1982

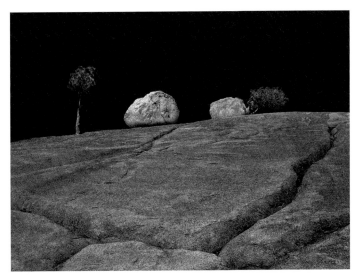

〈優勝美地國家公園〉/ 美國 / 1983
Yosemite National Park / the U.S. / 1983

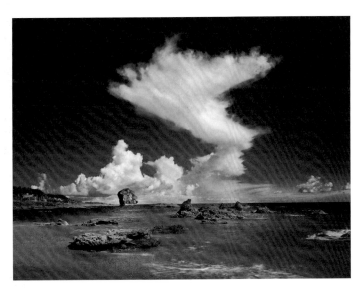

〈墾丁（揮與穩）〉/ 臺灣 / 1989
Kenting (Dispersion and Stability) / Taiwan / 1989

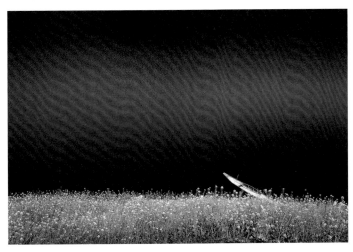

〈新安江〉/ 中國安徽省 / 1991
Xin'an River / Anhui Province, China / 1991

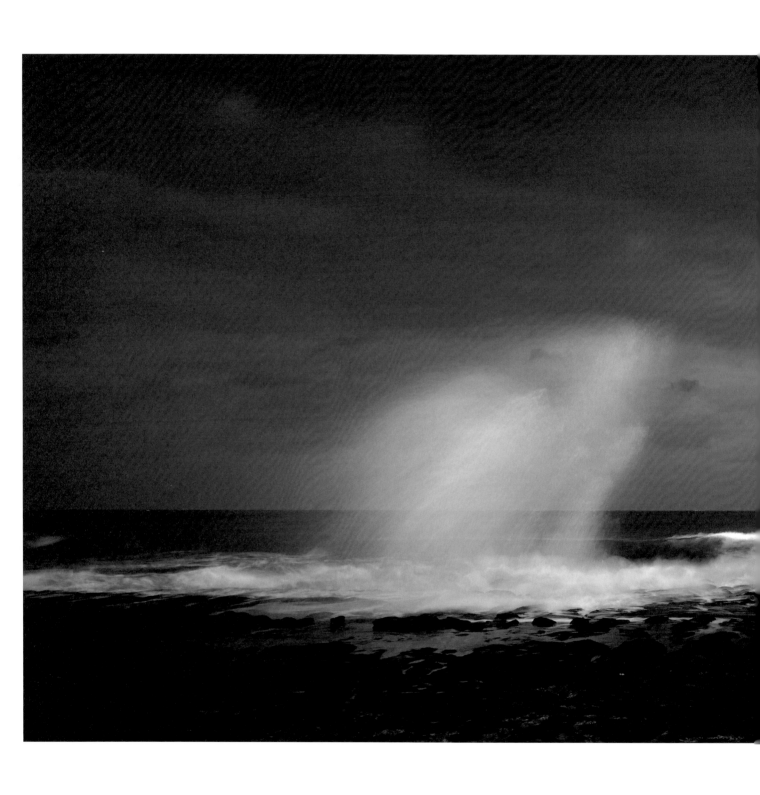

〈老梅（揮與凝）〉/ 臺灣 / 2021

Laomei (Dispersion and Condensation) / Taiwan / 2021

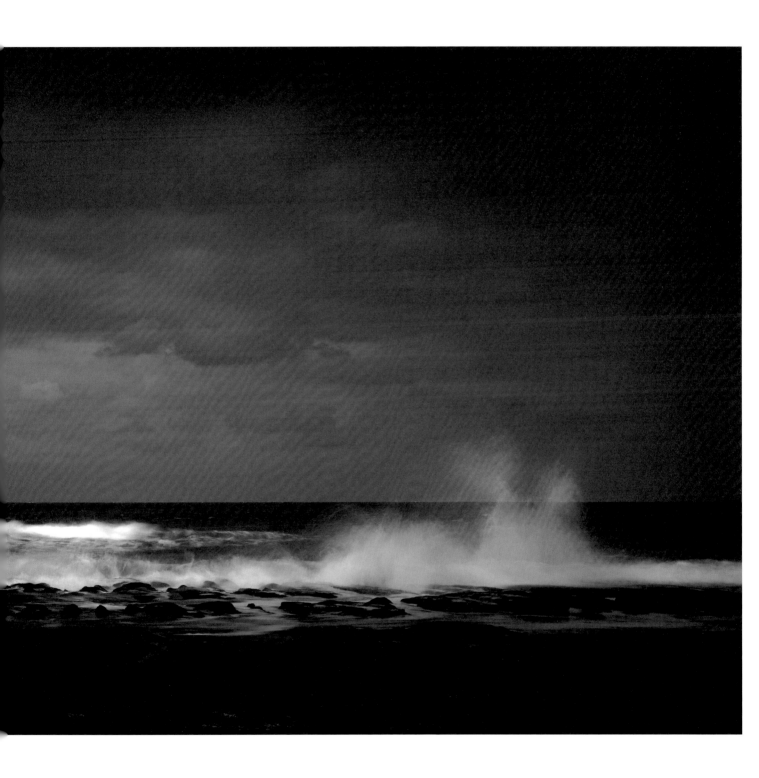

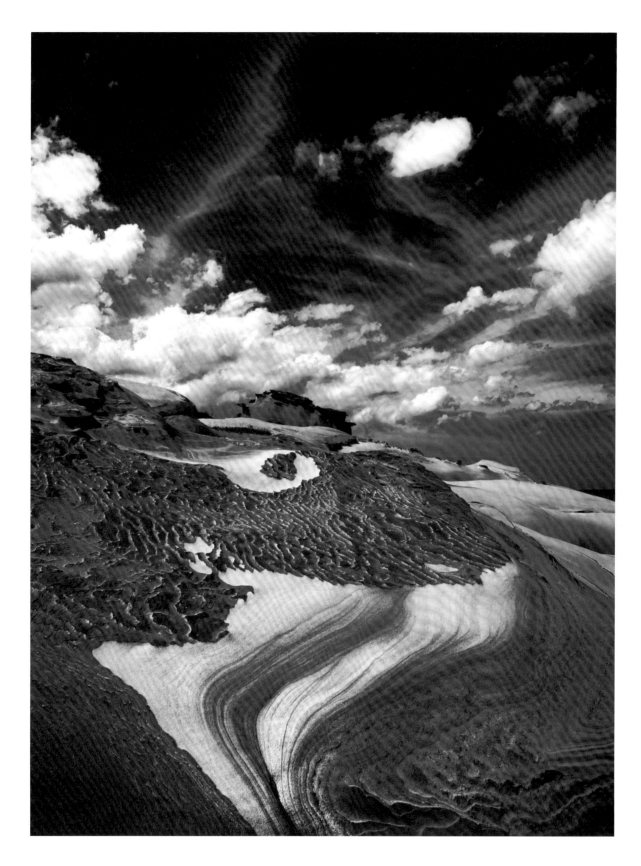

〈龜吼（蜿、覆與凝）〉/ 臺灣 / 2019
Guihou (Meandering, Covering, and Condensation) / Taiwan / 2019

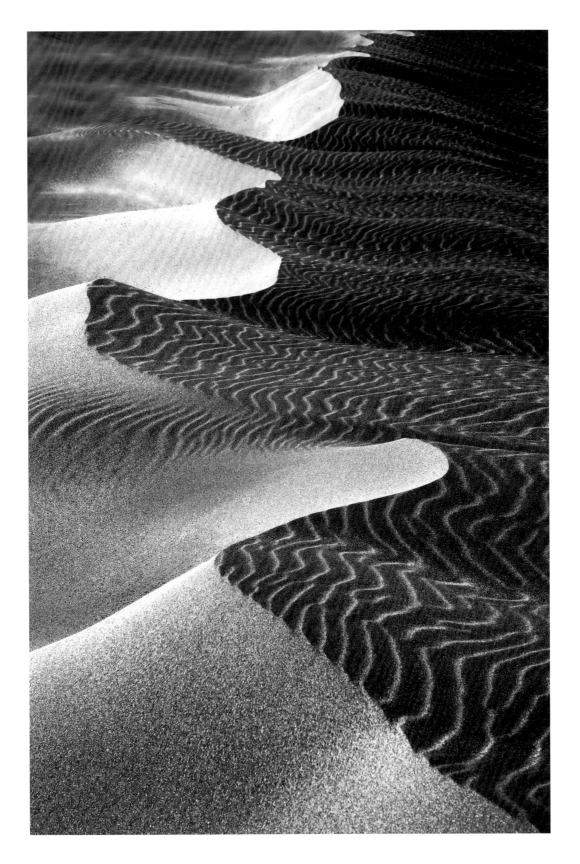

〈老梅（婉與約）〉/ 臺灣 / 2016
Laomei (Grace and Restriction) / Taiwan / 2016

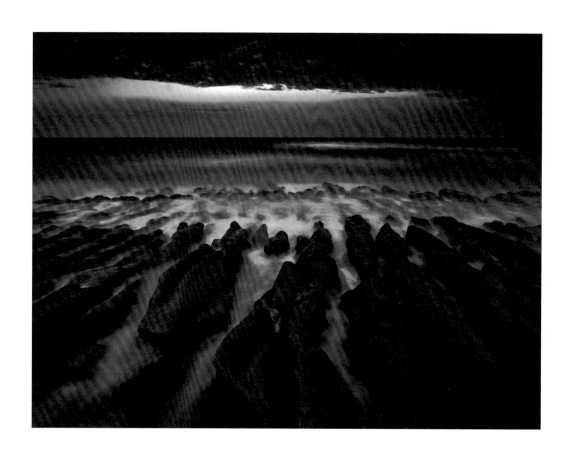

〈老梅（勢與凝）〉/ 臺灣 / 2021
Laomei (Power and Condensation) / Taiwan / 2021

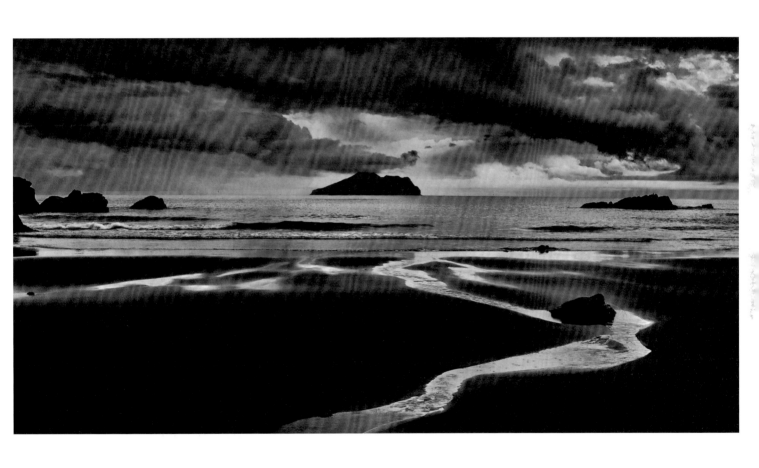

〈外澳〉/ 臺灣 / 2021
Wai'ao / Taiwan / 2021

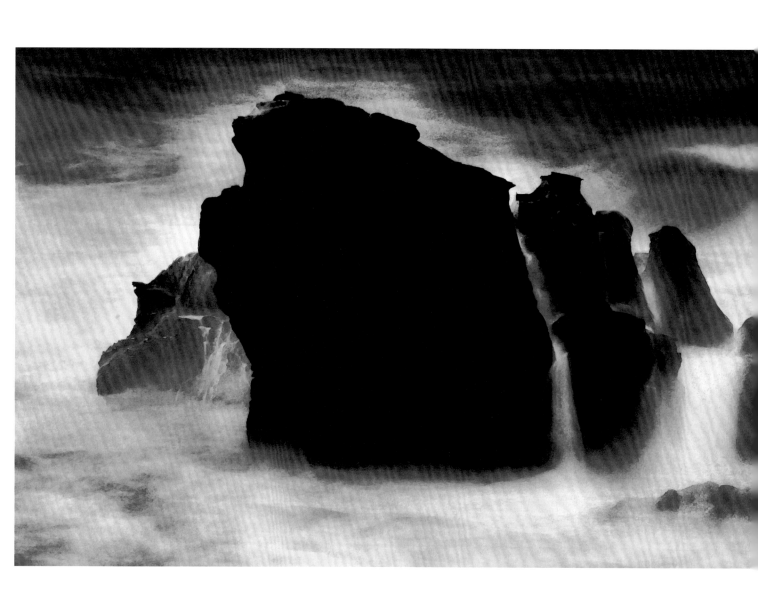

〈龜吼（流與凝）〉/ 臺灣 / 2019
Guihou (Flow and Condensation) / Taiwan / 2019

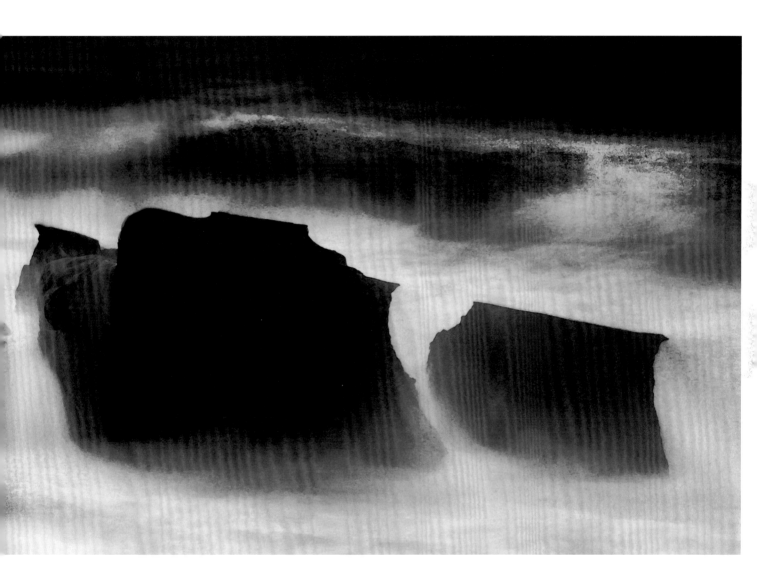

時間的顏色

作品內容：《快門時間》、《季候時間》等系列

文／胡詔凱

攝影創作，除了是空間的截取，也是時間的截取。莊明景除了依據空間中元素的變動，作時間的抉擇（此與「決定性瞬間」概念相通），也會參考時間的規律（例如潮汐、晨昏），作空間的取捨。

本單元將不同時間意識或「時間參與寫作」的作品並列，以觀察作者鏡頭產生的色彩、線面變化與視覺效應。以下分成兩個系列：

快門時間： 以「快門速度」與「快門時機（即按快門的時間點）」兩個軸線，分成「偏高速快門—午後／昏」「偏高速快門—午前／晨」「偏慢速快門—午前／晨」「偏慢速快門—午後／昏」，等四個象限的作品群集，比較朝夕的時間點、與快門速度所交織的色階效果，感受陽光質地、雲水流速所營造的「勁」、「流」、「徐」、「凝」的感受。

季候時間： 以「天候條件」與「季節變換」兩個軸線，分成「晴—秋／冬」「晴—春／夏」「陰—春／夏」「陰—秋／冬」等四個象限的作品群集，比較陰晴天候與季節所交織的光影效果，感受風雨海石在溫熱或涼寒的時候，所營造的色彩情緒。

The Color of Time

Including works from the *Shutter Time, and Seasonal Time* series

Author / Hu Chao-kai

In creating a photograph, the photographer not only intercepts time, but space as well. In addition to making decisions about time based on changing elements within space (similar to the concept of the "decisive moment"), Chuang also makes choices about spatial elements by referring to laws governing temporal events, such as the tides, or dawn and dusk.

This section juxtaposes works with different kinds of consciousness of time — or "time's participation in the creative act" — in which we can observe the changes in colors, lines and planes and the visual effects produced by the photographer's lens. The following is divided into two series of works:

Shutter time: Based on the two axes of shutter speed and shutter timing (that is, the point in time when the shutter is pressed), this will be divided into four groups of works, those with a fast shutter speed at afternoon or dusk; fast shutter speed before noon, or during the morning; slow shutter speed before noon or during the morning; and slow shutter speed in the afternoon or at dusk. This allows for comparison of the time points of morning and evening, the way effects of color gradation intertwine with the shutter speed, the feel sunlight's textures, the rate of flow of clouds and water... and the feelings these create, of vigor, flow, speed, or condensation.

Seasonal time: This will be divided into groups of works in four "quadrants" based on the two axes of weather conditions and seasonal change. Those quadrants are: sunny, in autumn or winter; sunny, in spring or summer; cloudy, in spring or summer; and cloudy, in autumn or winter. This allows for comparison of the effects clear or cloudy weather as they intertwine with the climate and seasons, so that we feel the wind and the rain, and sea and stones, and all the moods of the colors created in warmer or more frigid weather.

「快門時間」的顏色
"Shutter Time" Color

〈黃山（漸與點）〉/ 中國 / 1983（偏高速快門下的黃昏時間）
Huangshan (Permeation and Focal Point) / China / 1983
(Dusk, with a relatively fast shutter speed)

〈老梅〉/ 臺灣 / 2016（偏高速快門下的午後時間）
Laomei / Taiwan / 2016 (Afternoon, with a relatively fast shutter speed)

〈墾丁龍坑〉/ 臺灣 / 2016（偏慢速快門的黃昏時間）
Longkeng, Kenting / Taiwan / 2016 (Dusk, with a relatively slow shutter speed)

〈桂林〉/ 中國 / 2000〈偏高速快門的清晨時間〉
Guilin / China / 2000 (Early morning, with a relatively fast shutter speed)

〈黃山〉/ 中國 /1983（偏慢速快門的清晨時間）

Huangshan / China / 1983 (Early morning, with a relatively slow shutter speed)

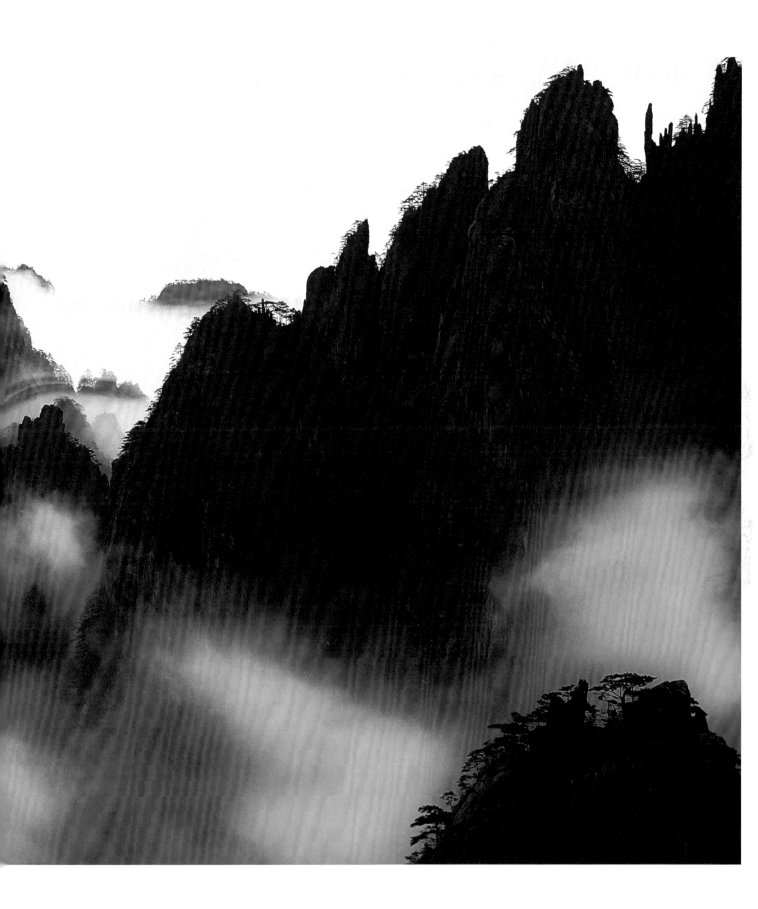

〈合歡山〉/ 臺灣 / 2015（偏高速快門的黎明時間）
Hehuanshan / Taiwan / 2015 (Daybreak, with a relatively fast shutter speed)

〈布萊斯峽谷國家公園〉/ 美國猶他州 / 1982（偏高速快門下的午前時間）
Bryce Canyon National Park / Utah, the U.S. / 1982 (Morning, with a relatively fast shutter speed)

〈老梅〉/ 臺灣 / 2018（偏慢速快門的清晨時間）
Laomei / Taiwan / 2018 (Early morning, with a relatively slow shutter speed)

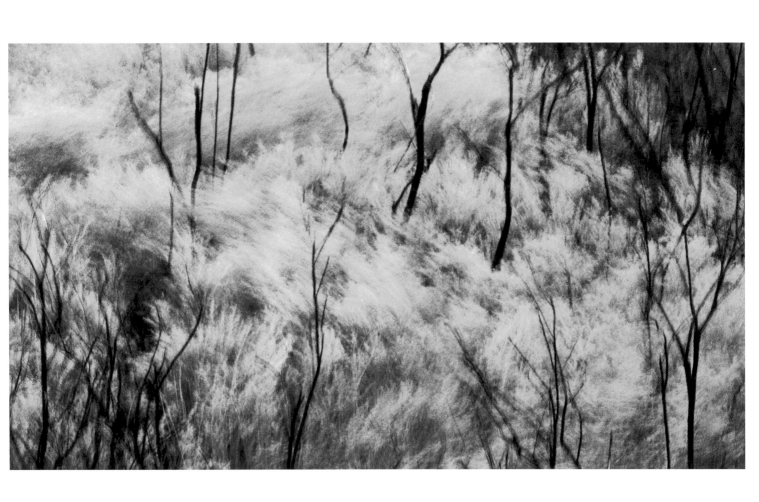

〈亞利桑納州（凝與流）〉／美國／1982（偏慢速快門的午後時間）

Arizona (Condensation and Flow) / the U.S. / 1982 (Afternoon, with a relatively slow shutter speed)

「季候時間」的顏色

"Seasonal" color

〈杭州〉/ 中國 /2010（秋 / 冬天晴時）
Hangzhou / China / 2010 (Autumn/Winter, clear skies)

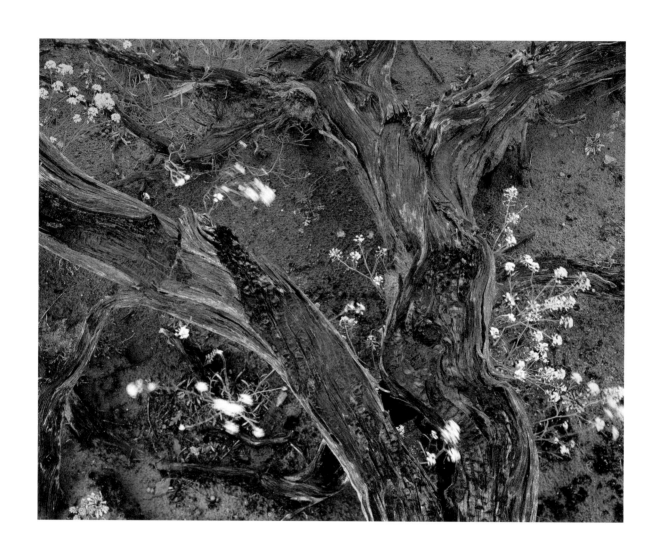

〈亞利桑納州〉/ 美國 / 1983（秋 / 冬天晴時）
Arizona / the U.S. / 1983 (Autumn/Winter, clear skies)

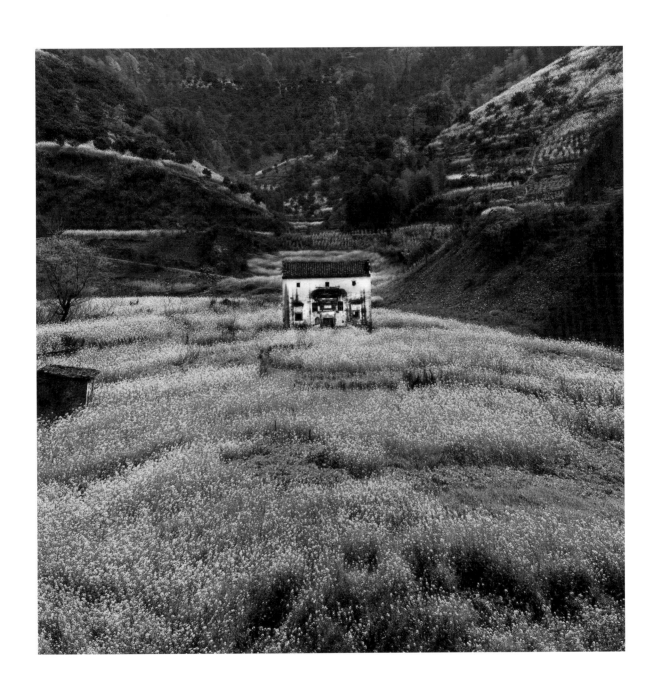

〈安徽〉/ 中國 / 1985（春 / 夏天晴時）
Anhui / China / 1985 (Spring/Summer, clear skies)

〈安徽省歙縣〉/ 中國 / 2015（春 / 夏陰勻時）
She County, Anhui / China / 2015 (Spring/Summer, even overcast skies)

〈京都〉/ 日本 /2016（春 / 夏天晴時）
Kyoto / Japan / 2016 (Spring/Summer, clear skies)

〈紀念碑谷（漸與點）〉/ 美國亞利桑納州 / 1982（春 / 夏天晴時）
Monument Valley (Permeation and Focal Point) / Arizona, the U.S. / 1982 (Spring/Summer, clear skies)

〈黃山〉/ 中國 / 1984（秋 / 冬陰寒時）
Huangshan / China / 1984 (Autumn/Winter, cold, overcast skies)

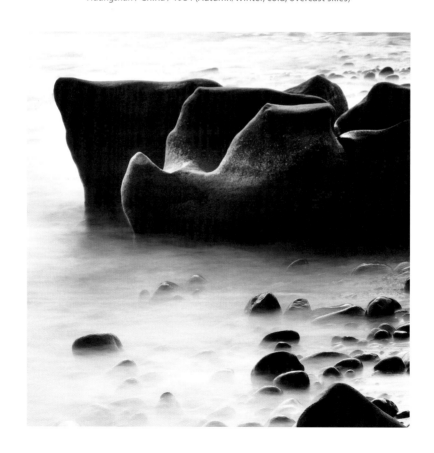

〈老梅〉/ 臺灣 / 2016（春 / 夏陰勻時）
Laomei / Taiwan / 2016 (Spring/Summer, overcast skies)

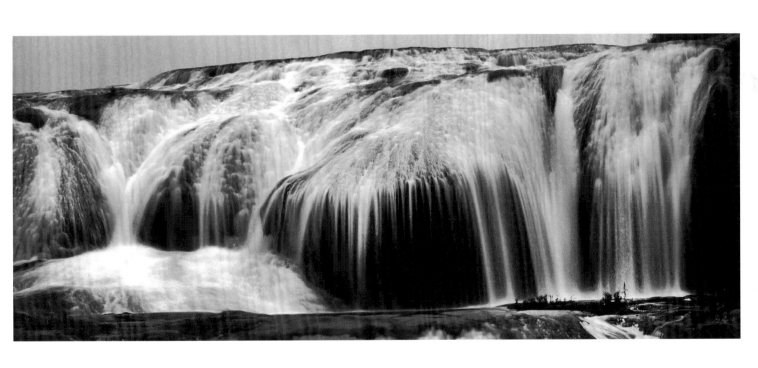

〈貴州陡坡塘瀑布（安順市）〉/ 中國 / 2015（秋 / 冬陰寒時）
Doupotang Waterfall, Anshun City, Guizhou / China / 2015 (Autumn/Winter, cold, overcast skies)

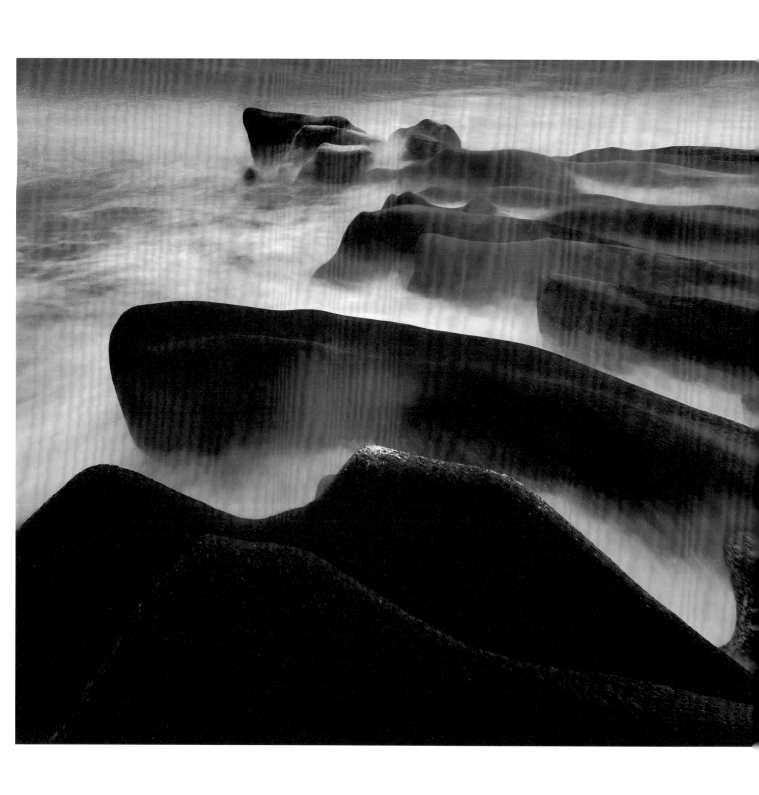

〈老梅〉/ 臺灣 /2020（秋 / 冬天陰時）

Laomei / Taiwan / 2020 (Autumn/Winter, overcast skies)

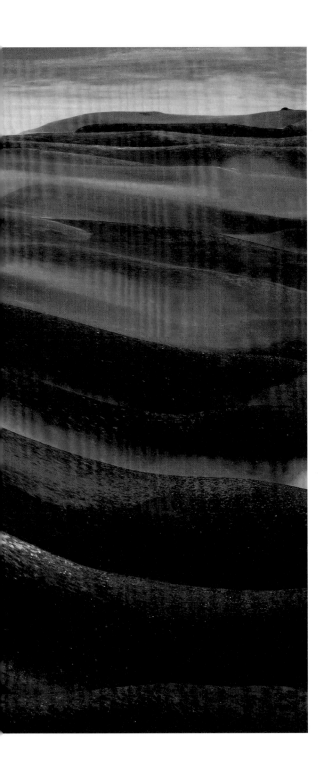

變換與變幻

作品內容：《繪影行空》系列

文 / 胡詔凱

萬象瞬息千變、事物循環生息；沒有生命姿態是永恆不變的。

莊明景的「心／手／眼」猶如一台幻象產生器，藉由電腦程式的演算機制，將現實的具象空間，做實驗性、偶發性的線面挪移或色彩轉換，以賦予抽象化效果，呼應事物無盡演化的現象。

本單元除了兩幅「黴菌滋生」參與改寫畫面的作品外，其餘均為電腦影像處理軟體參與畫面改造之作。在進行變換與變幻的過程中，作者宛如遊戲玩家，沒有強烈主觀意識的介入，純粹為探詢不可預期的視覺可能，做破壞性的創造。例如，將水面倒影做色彩反轉效果、將山石肌理做中途曝光或海報化效果、將事物顏色改變色相，甚至將去背、裁切過的原始現實，做重組、延伸、濾鏡效果之超現實處理。

這一系列作品取名為《繪影行空》，即代表創作過程中是以天馬行空的「無意識」狀態，解構了現實事物的原型或原色。但由於形與色的變造並不完全或不同時一起處理，使得畫面產生既抽象、又不完全抽象的效果，營造出特有「似與不似之間」的玄妙。也由於這樣的作法，削弱了你我對於事物形象的辨認度，更容易讓人直觀現象的本色本質，進而感受無特定形象的純粹裝飾作用，讓這系列作品多了一個觀察面向——即從應用美術的場域，發掘「繪影」與衣服布花、海報、封面設計等，共伴於日常生活中的可能。

Change and Fluctuation

Including works from the *Painting Images, Soaring Imagination* series

Author / Hu Chao-kai

The many manifestations of nature are ever-changing; everything is cyclical, and no aspect of life is eternal.

Chuang's "heart/hand/eye" approach is like an illusion generator, making use of the calculation routines of a computer program to perform experimental, random shifts in lines and planes or produce color conversions, imparting abstract effects to real, figurative things and spaces, in an echo of the phenomenon of the unending evolution of things.

In this section, with the exception of two works in which mold growth contributed to "rewriting" what was on the film, all are works in which computer image processing software was involved in altering the final photograph. In this process of transformation and fluctuation, the photographer is like a player in a game, in which there is no strong, subjective consciousness to intervene, but instead a pure exploration of unpredictable visual possibilities and the production of "destructive creations." Reflections on the surface of water, for example, can be used in a color inversion effect; rock textures can be used in solarization or posterization; the color of an object can be changed in hue; or after background is removed or an original real scene cropped, they can be further reorganized, extended, or filtered for surreal processing effects.

The name of this series of works is *Painting Images, Soaring Imagination*, which means that in the creative process, the original shape or color of a real object is deconstructed in a state of "unconscious," soaring imagination. But because the alteration of the shape or color is not complete, or they do not take place simultaneously, the effect produced is abstract, but not completely so; the result is a sense of mystery in the space between "likeness" and "dissimilarity." This approach weakens our ability to identify the object, which somehow leaves us better able to intuitively see the true nature of the phenomenon, and further, to feel the decorative effect of this non-specific image. This adds another facet to this series of works – exploring the possibility, in terms of the field of applied arts, of the use of these "painted images" on the items such as clothes, fabrics, or cover designs that accompany us in life.

〈荷鏡（南投名間）〉/ 臺灣 / 2015
Lotus Mirror (Mingjian Township, Nantou) / Taiwan / 2015

〈臺北植物園（易與蜿）〉/ 臺灣 / 2016
Taipei Botanical Gardens (Change and Meandering) / Taiwan / 2016

〈臺北植物園（紛與約）〉/ 臺灣 / 2016
Taipei Botanical Gardens (Disparity and Restriction) / Taiwan / 2016

〈臺北植物園（點與凝）〉/ 臺灣 / 2016
Taipei Botanical Gardens (Focal Point and Condensation) / Taiwan / 2016

〈臺北植物園（易與勢）〉/ 臺灣 / 2016
Taipei Botanical Gardens (Change and Power) / Taiwan / 2016

〈京都（流與霞）〉/ 日本 / 2016
Kyoto (Flow and Sunset Glow) / Japan / 2016

〈龜山島（漸）〉/ 臺灣 / 2015
Turtle Island (Permeation) / Taiwan / 2015

〈臺北植物園（凝與約）〉/ 臺灣 /2016
Taipei Botanical Gardens (Condensation and Restriction) / Taiwan / 2016

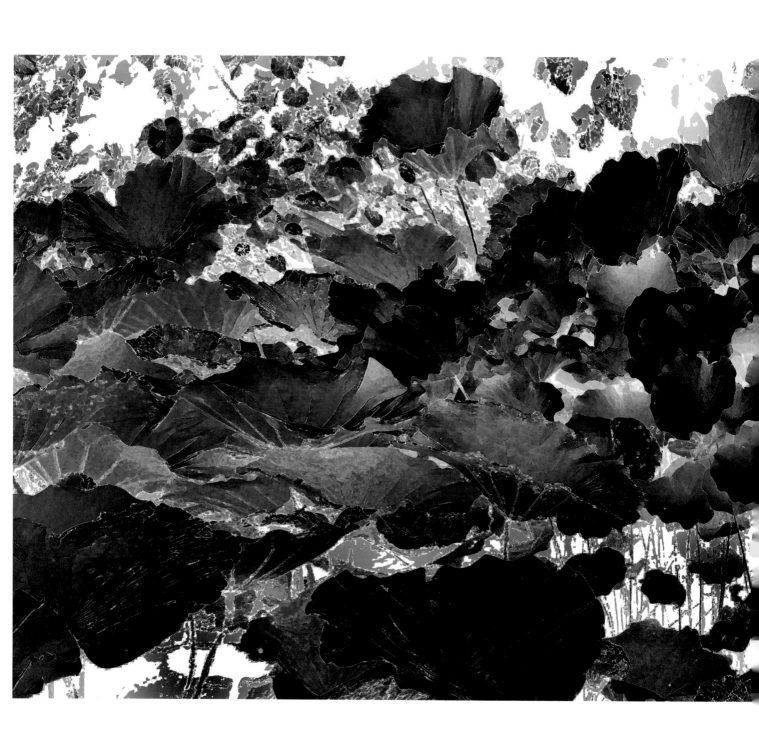

〈臺北植物園（勢與漸）〉/ 臺灣 / 2018

Taipei Botanical Gardens (Power and Permeation) / Taiwan / 2018

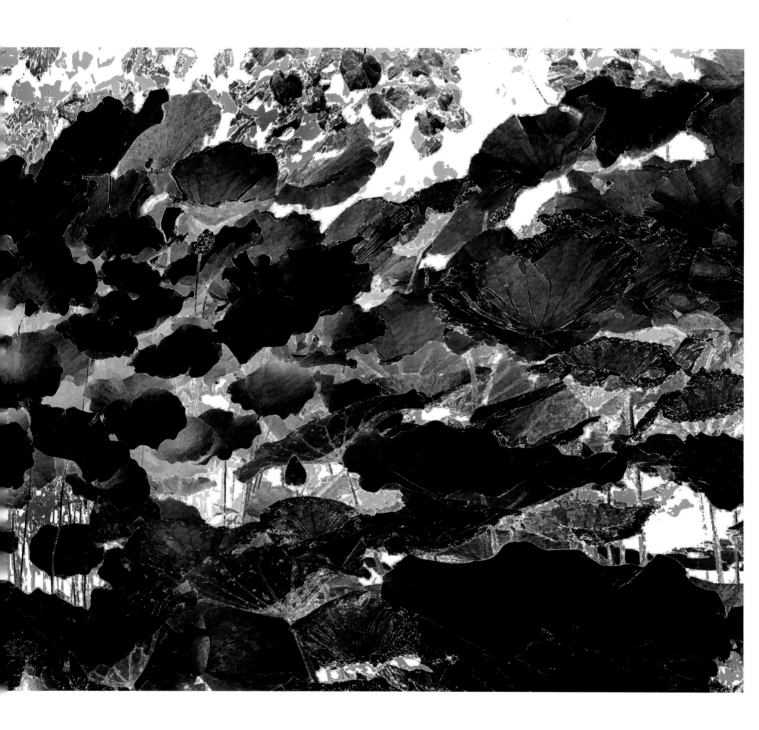

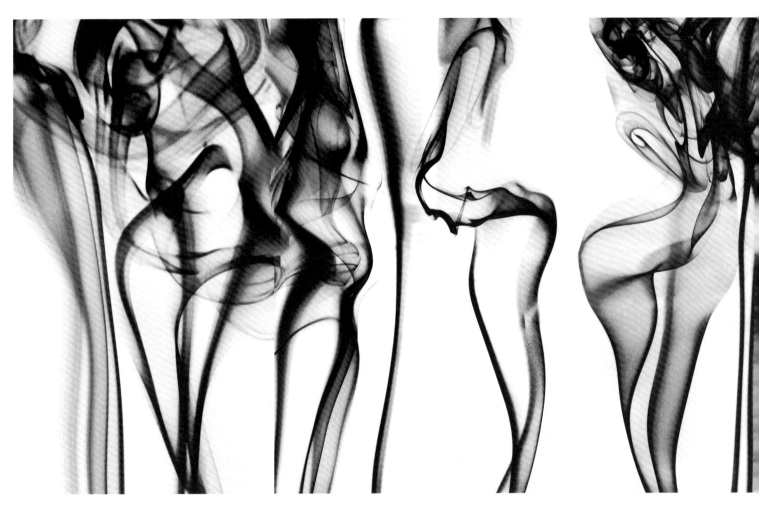

〈隨舞〉/ 臺灣 / 2020
Spontaneous Dance / Taiwan / 2020

〈老梅（融）〉/ 臺灣 / 2017
Laomei (Enfolding) / Taiwan / 2017

〈黴斑弄紋（南門市場）〉/ 臺灣 / 1990

Patterns of Mold Spots (Nanmen Market) / Taiwan / 1990

〈黴之灑綴（北海岸）〉/ 臺灣 / 1990

Embellished with a Spray of Mold (North Coast) / Taiwan / 1990

老梅（流）/ 臺灣 /2022

Laomei (Flow) / Taiwan / 2022

〈桃花系列（西湖）〉/ 中國 / 2005

Peach Blossom Series (West Lake) / China / 2005

〈天后宮（臺南市）〉/ 臺灣 / 2016
Tianhou Temple (Tainan City) / Taiwan / 2016

〈岩利紋〉/ 臺灣 / 2022
Yanliwen / Taiwan / 2022

〈和尚岩（龜吼）〉/ 臺灣 / 2022
Heshang Cliff (Guihou) / Taiwan / 2022

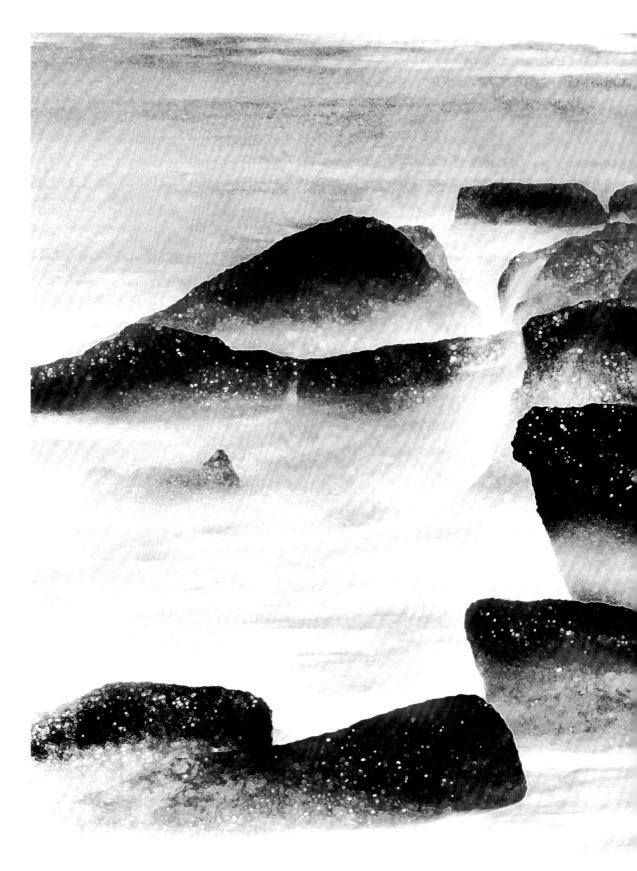

〈老梅〉/ 臺灣 / 2010
Laomei / Taiwan / 2010

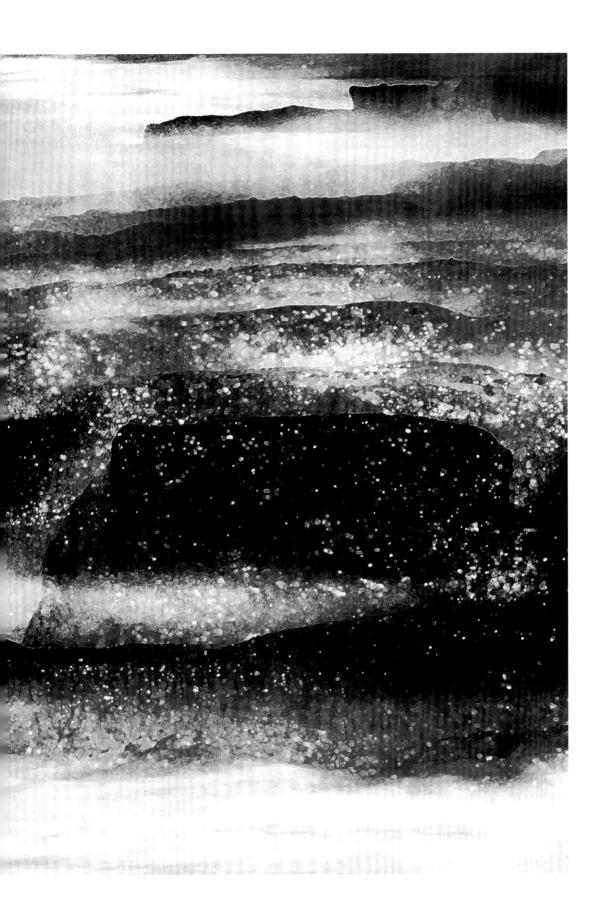

口述訪談
INTERVIEWS

莊明景訪談紀錄 [1]

一、攝影的因緣與早期歷程

胡詔凱（以下簡稱胡）：請談一談您接觸攝影的因緣？

莊明景（以下簡稱莊）：我高中就讀成功中學。在上下學途中，會經過館前路的臺灣省立博物館（今國立臺灣博物館），有機會就到館內參觀攝影展，感受到拍照似乎是一個有趣的挑戰性活動，從此，開始借用家族裡的照相機自習攝影。最初都是參考軟片的包裝紙盒內頁的使用說明，所以算是無師自通。

胡：在臺大就讀期間的攝影學習和創作經歷是如何？

莊：我一進臺大就報名參加臺大攝影社。當時的指導老師主要的有張才、湯思泮兩位，除了傳授攝影基礎知識，大多數的社團活動還是以「外拍」和「作品觀摩」為主。

外拍，通常是「snapshot」，然後就是同學作品觀摩。記得當時每次舉辦作品觀摩會，攤在桌上的照片幾乎全是我拍的，張才老師看到我強烈的創作能量，就鼓勵我把照片拿去參加「台北攝影沙龍」[2] 比賽，因為很多作品獲獎，不到半年就憑累計入選作品的總積分，獲得第一名的「年度優秀作家獎」。

胡：您在臺大攝影社期間，是否也在校外參加攝影比賽或活動？

莊：當時，想試試看自己的實力怎樣，就廣泛投稿到各種攝影比賽，例如愛克發（Agfa）公司為宣傳新興彩色軟片舉辦的彩色攝影比賽、新光大樓攝影比賽、臺北建築攝影比賽、電影公司為宣傳旗下女星所舉辦的「國聯五鳳」[3] 攝影賽……，均獲得比賽前三名、前六名名次或佳作入圍名額的過半席次。

胡：您本身的「哲學系」背景，對於創作理念有沒有甚麼啟發或收穫？

莊：其實，我在哲學系沒有讀什麼書，所以才有時間出去拍照，讓我「長

莊明景在大學時期即已掌握完美構圖，運用彩色濾鏡呈現淡水夕陽風貌 / 莊明景攝 / 淡水 / 1968
Mike Chuang was already producing perfect compositions in college, here using color filters in a Tamsui River sunset / photo by Mike Chuang / Tamsui / 1968

時間」浸淫在特定環境時空中領悟到一點風景哲學──要真誠思考「為何而拍」，也就是「純粹無染」的拍攝動機，我覺得這才是超越表象景觀紀錄的關鍵。

胡： 您在大學期間已經獲得許多攝影成就，畢業後，應該會直接從事攝影工作吧？

莊： 大學畢業後隨即入伍。退伍後，進入家族事業從事染料的貿易業務，後來覺得攝影是最愛的活動，家族貿易業務反而是業餘事務，所以工作不到三年，就辭職打算赴美進修攝影課程。

二、美國商業攝影的職場磨練

胡： 到美國後，一開始做了哪些事？

莊： 我透過柯錫杰當時太太（李諄菊女士）的聯繫與協助，前往美國紐約，先在柯錫杰個人攝影工作室擔任實習助手，觀摩商業攝影的製作模式，同時準備申請紐約攝影學院（New York Institute of Photography）的入學。提出申請時，審查委員從我自備的作品集（portfolio）提出建議，說我已經具備專業的，甚至學校老師的實力，實在無須就學，應該直接投入職場，累積實戰經驗。

胡： 談談在紐約攝影職場的相關經歷？

莊： 後來，柯錫杰介紹我到他曾任職過的《哈潑》（Harper）雜誌專屬攝影師威廉・西拉諾（William Silano）的工作室擔任攝影助理。在美國，

莊明景在紐約從事商業（外景）攝影工作照 / 1972
Mike Chuang engaging in commercial (location) photography work in New York / 1972

商業攝影助理的工作相當沉重、也耗費體力，比如室內地毯的鋪設、汽車廣告攝影的打燈作業，樣樣都來。經過九個月、跟過三位攝影師之後，我升任為正職攝影師（junior photographer）。

能在不到一年時間升任正職，我要感謝擔任助理時，所輔助過的一位擁有牙買加和中國廣東血統的攝影師譚瑞（Ray Tenn），會耐心教我如何打燈以及商業攝影技巧，使得我在升格正職攝影師之初，即使沒有助理，也可以獨當一面，所以再經過一年多就成為資深攝影師。

莊明景拍攝珠寶的商業攝影工作照 / 1978
Mike Chuang photographing jewelry for his commercial photography work / 1978

胡： 所以，以您三十多歲的年齡，能在競爭激烈的紐約商業攝影圈熬出頭來，真的很不容易！

莊： 其實，壓力真的很大，對於體能消耗也很大。當時紐約的商業攝影師超過一萬五千人，且各行各業都有不同領域的專門攝影師，比如專拍昆蟲的、鳥類的，要在頂尖人才濟濟的市場競爭中存活下去，我們必須高度配合客戶與公司團隊需求，設法克服各種問題。也因為過去三年來高度耗費體力的拍攝，所以當譚瑞自立門戶創立Photo Conception Studio挖角我時，我就轉換跑道離開原來公司。

胡： 轉換跑道以後，和原來的攝影工作有什麼不一樣？

莊： 我在Photo Conception Studio承接商品攝影（幾乎什麼都拍），訂單數量多，壓力自然也重；接著換到規模較大的Ted Pobiner廣告攝影公司，拍攝以珠寶、鑽石、手錶為主，屬於table top的精緻商品，但由於公司規模大、制度健全，每一件case都有嚴格的SOP，我必須依循藝術指導（art director）的需求、設計師的意見，還要體會美感流行趨勢、考慮小體積物件的細節與反光，拍攝難度與壓力並未減輕。

於是，從1971到1980年，我從實習助手、攝影助理，到正職攝影師和資深攝影師，一直處在工作量大、壓力大、體力消耗也大的情境，沒有時間去拍攝自己想拍的東西，難免會思考要不要離職，好去拍攝著名的美國自然景觀！

三、踏上攝影壯遊之路

胡： 談談您為何離職、走上壯遊之路？

莊：在紐約熬了十年，覺得年齡已近四十歲，不再適合做消耗體力的工作。所以，我決定離職，想以自由接案者（freelancer）的身分，一邊遊歷美洲大陸，一邊拍攝自己想記錄且兼能讓照片出售的題材。

所以我找了圖片租片公司（FPG International）合作，擔任特約攝影師。先以賒帳方式向FPG預借軟片購買與必要開銷之費用，帶著相機遍遊北美拍攝景觀，再將作品版權出售所得，扣除預借現金之後的餘額，做為酬勞收入。就這樣，遊歷北美期間，除了為租片公司拍照，我也能同時「完全自主」創作，依個人理想拍攝風景。

胡：請問您壯遊的路線足跡？使用哪些器材？

莊：我用的相機主要是Ansco的8×10相機（view camera），但相機牌子不是重點，關鍵是要搭配好的鏡頭。至於路線足跡，我會先查資料，看租賃片商需要哪些地方、同時自己也有興趣的景點，來規劃路線；通常是以國家公園為主，搭配有景觀可取的地方公園，比如緬因州有一充滿英格蘭風味、佈滿秋天楓葉的景致。

最長的一次路線，是開車從紐約到舊金山、沿路拍公園，再從舊金山搭渡輪到加拿大維多利亞島（Victoria Island）、經過溫哥華、到阿拉斯加的安克拉治（Anchorage）和蘇厄德（Seward），再經過加拿大洛磯山脈（Rocky Mountains）的傑士伯國家公園（Jasper）、班夫國家公園（Banff）、沃特頓湖國家公園（Waterton）、冰河國家公園（Glacier），然後南下回到美國黃石公園（Yellow Stone），再回紐約，全程花了兩個月的時間。

胡：您是由於怎樣的因緣，到中國大陸拍照？

莊：1981年我算是比較忙，先從美國回臺北，舉辦我的首次風景攝影個展。回美國後，接著受翁萬戈[4]先生推薦，隨同他（時任中美友好協會會長）前往北京拍攝故宮風貌及文物，當時是為北京故宮博物館英文專書[5]出版所需插圖圖片而去拍照，在北京拍了兩個月，將攝影器材全部捐給故宮[6]之後再回到美國。

莊明景拍攝北京故宮外景的工作照 / 1981
Mike Chuang location shooting at the Forbidden City in Beijing / 1981

胡： 後來為什麼想到要去黃山拍照？

莊： 那是在1983年，北京方面招待中美友好協會（翁萬戈為會長）的會友到中國觀光旅行，我也隨隊同行，從北京到絲路，參觀莫高窟（一天看四十多個窟）、高昌古城、交河故城、新疆一帶。行程結束後，協會會友回美國、我獨自留在北京。因為久聞郎靜山作品有許多取材自黃山，所以計劃過去拍照。

那是第一次去黃山，我先到杭州、包車開了兩天抵達山腳下過了兩夜，當時黃山還未開發成觀光景點，路況不佳、人煙稀少，我請了兩位挑夫（當時費用每人每天約十元人民幣）揹著裝備爬山，走六小時（經過白鵝嶺）才到北海賓館；在抵達賓館前二十分鐘腳程有一個據點「始信峰」，是以「行到此處『始』相『信』黃山之美」而得名。

我在北海賓館住了一個月（時為秋天），評估此處像「優勝美地」（Yosemite），若在寒冬下雪必為可觀的景致。於是，隨即在1984年1月6日第二次登黃山。此後，我平均每年去黃山一次、每次停留的時間大約一個月，到2012年最後一次上山為止，前後累計登山次數達二十六次。

四、遊走於兩岸的下半場攝影生涯

胡： **1984年回臺灣定居之後，除了持續前往大陸拍照之外，您在臺灣有做創作或發表嗎？**

莊： 回臺灣之後，陸續出版攝影集、發表作品。1986年，受當時的營建署長張隆盛邀請，特約拍攝玉山、太魯閣、墾丁國家公園自然景觀，作品以8×10底片拍攝為主，部分使用617相機[7]拍攝。因為作為觀光宣傳之用，所以要兼顧務實需求與理想。

胡： **您為何會拍徽州的題材？**

莊： 去黃山的路上，會經過黃山市（1987年以前名為徽州地區），那是一個文化古城，有許多歷史建築（比如屯溪老街建築群），所以後來就

莊明景參觀嘉峪關留影 / 1983
A photo of Chuang visiting Jiayuguan / 1983

早年黃山人煙罕至，莊明景身處如化外之地的住宿條件，怡然自得 / 1983
Early on, Chuang was content to live simply in the remote Huangshan area, which was sparsely populated then. / 1983

會連帶一起拍攝徽派建築和在地人文環境，足跡包括歙縣、紅村、西遞村、新安江、婺源（1949年改隸江西省）。

胡： 談談您的西藏攝影之旅？

莊： 我在1989年原訂要從四川上去西藏，但剛好遇上六四天安門事件，不便前往，就留在四川成都拍攝（青藏高原邊緣），足跡包括九寨溝、海螺溝等自然景觀。到了1991年，走青藏公路 [8] 深入西藏拍攝，從烏魯木齊出發，穿過準噶爾、塔里木等盆地、沙漠地帶抵達青海，再銜接青藏公路到拉薩。1993年，走新藏公路，從烏魯木齊出發，沿著喀什、葉城、中印邊界到青藏高原，並深入西藏阿里（前古格王朝統治）地區拍攝。1994年、1995年，則受林添福之邀，走滇藏公路進入西藏拍攝，從昆明出發，沿途經過虎跳峽、德欽，拍攝梅里雪山山脈（含主峰「卡瓦格博峰」）。

在四川、西藏的一路上，非常辛苦，除了是沿途上坡、地勢險峻（一度被馬摔落至斷崖邊、差兩公尺即為溪谷斷崖）、高山空氣稀薄，唯恐天黑前無法抵達住宿點，行程總是連拍帶走、連跑帶拍。這和黃山的「以靜制動」條件完全不同，我必須「以動制靜」，所帶的器材以機動性高為原則（如120哈蘇相機、135的Nikon及Canon相機），還有每趟近二百捲Kodachrome底片（需寄送美國沖片）也是一大負擔。

但是新疆西藏仍是值得前往拍攝的地方，我之所以稱之為「秘‧淨」，一方面以「秘」代表相對神祕（因為我們對當地所知有限），同時以「淨」表示純淨（相對於我們都會環境的污染），兩字疊加正代表一種「自然」的風情。

胡： 您什麼時候開始拍攝北海岸老梅系列？是怎樣的因緣或動能，促使您不厭其煩的去了上百次？

莊： 我在2006至2008年間開始的。那個地方原本是海防管制區，對外開放之後，經過攝影同好推薦，以及我親自觀察發現，那裡是潮間帶，海平面升降期間的水石交流景致特殊，值得留下紀錄。從此，我把攝影重心轉回臺灣，連帶東北角岩岸，拍攝水、石、陽光互動交會出的色彩與形狀景觀。

我之所以會去那麼多次，主要是為了反覆觀察、反覆體驗（美感）。當攝影與生活融為一體，去再多次也不會疲乏，好比一般人要過生活，而我要攝影。在臺灣，有些攝影社團把「風景」當成「模仿（臨摹）」技巧的對象，以致使用的器材、構圖、技巧過於制式，在到此一遊、完成預設的模樣之後，再換一個題材複製前人成功的模樣來自我滿足，如此以旅遊為主、攝影其次的本末倒置，容易形成走馬看花，不能專注，實在可惜。

胡： 您什麼時候開始創作荷花、以及各種花草「繪影」系列？

莊： 我是2012年起開始嘗試的。其實，荷花照片很早就拍了，只是花雖漂亮、但一直無法突破，就都擱著沒有發表。直到後來電腦影像處理軟體問世，發現這些工具真是海闊天空、無限可能，可以滿足、摸索、重現花卉美感，從此開始發展一系列的「繪影」（後製）創作。

五、攝影觀、時空觀與美感經驗

胡：　我們先來談一談您的攝影理念。請問，對您而言「攝影」是什麼？

莊：　攝影是美感經驗的累積與展現。這種美感經驗，可以說是一種享受、一種感受、一種純淨無染的愉悅。在大自然中，這些美感無處不在，但攝影師的職責，就是要了解並在掌握「天時地利人和」的條件下，將美萃取與留存下來。

胡：　您收藏骨董的因緣為何？有沒有為了激發攝影靈感而依循的典藏骨董標準？

莊：　我我本身對於生活中的美感事物比較有興趣，因此對於「經得起時間考驗」被流傳下來的骨董（家具），會想去發掘其中蘊含的工藝之美；這些古文物「長期大量累積起來即為（審美）文化」。

　　　至於典藏的標準，我基本上不會跟著收藏熱潮走，比如黃花梨、紫檀木製作的（骨董）家具有一陣子很搶手，但我不為投資獲利，不會追高買這類昂貴家具，只會純粹以「能否創造美感愉悅」為收藏標準。

胡：　您一個人「單身」生活，對於您的創作有沒有什麼正面或負面上的影響？

莊：　「單身」最大好處，就是擁有完全自主的時間和空間，能夠專心做自己想做的事，過完全屬於自己的生活（full time life）。有人會問單身會不會有孤獨感，我反而覺得「孤獨是一種修養」——在北美洲一個人流浪，是對自我成長最有用的時候。

胡：　風景攝影家與探險家是一線之隔，都須承擔一定風險。有些紀實攝影師也冒著風險拍攝戰爭、難民，或是落後地區的景象，因為在媒體發表（比如《國家地理雜誌》、《LIFE》雜誌）而獲得矚目。您是否想過拍這類入世的題材？

莊：　這類雜誌有訂閱率、銷售量的壓力，圖片內容必須顧慮到讀者的期待，因此刊登奇風異俗引起話題、訴諸苦難引起悲憫的照片，所在多有。一張非洲饑荒的照片在歐美攝影圈或許會引發重視，但是對於非洲飢民而言，這是他們的日常，對他們沒有什麼意義。如果照片只是

莊明景收藏的清式骨董家具 / 孫耀天攝
Qing-era antique furniture in Chuang's collection / photo by Porsche Sun

為了（讀者）共鳴、為了掌聲，這代表拍攝者的動機並不純粹。人生課題，不外乎「生老病死喜怒哀樂」，我並不想繞著這些人之常情來博取同情，這樣拿別人的人生來譁眾取寵，這也說明了我何以選擇出世，記錄大自然的純粹與美感。

胡： 您在面對大自然時，有什麼體悟？

莊： 大自然是無限的，人卻有極限，從廣袤的空間中能夠帶出時間之無限。對我來說，人與自然的交流是一種相互吸收，而不是單向利用。這種相互吸收，是「意」的交流、精神的交流──人類的生老病死，表面上似乎代表生命的有限，卻如同大自然日出日落、春夏秋冬周而復始的輪迴循環。這一種意境，如同國畫（山水畫）裡講究的「氣」（生息循環），讓我從看得見的事物，體悟到生生不息、無限循環的大自然規則。

胡： 您前面提到國畫，可否談談「寄情山水」、「禪修放空」，或者中國繪畫思想中的概念，對您的創作有沒有什麼影響？

莊： 其實，除了禪修的概念，我很少去做這些連結。我就是很直覺地想記錄自然的美感，站在天地間觀察，看天候、看陽光、看景物、選角度，掌握「天時地利人和」的條件來拍照，不會連結到這麼多外加的東西。

禪修是一種過程、一種方法，讓自己放下、放空的修行，如果一個人（像小孩一樣）本來就沒有雜念，何來放空？對我而言，創作（或工作）好比是禪修，是放下的過程，在過程中會悟到自己（拍照）的錯誤，並加以修正，也就是學習如何將污染（不好）的事物拿掉、達到純淨無染的方法。

〈臺北植物園〉/ 莊明景攝 / 臺灣 / 2016
Taipei Botanical Garden / photo by Mike Chuang / Taiwan /
2016

胡： 在國畫的題材裡有「梅蘭竹菊」四君子的題材，您選擇荷花作為創作題材，是否有什麼意涵？

莊： 「梅蘭竹菊」是因為生長在四季的環境背景所具備的特質，被用來比喻人的品格，那是作者強加給植物的意念，不是體會花朵的美。我看荷花，會考慮在什麼背景與光影條件下、以什麼視點或構圖來拍攝會最美，然後搭配後製（比如reverse效果，再調整色相復原局部色彩），來製造「再生美感」。

胡：國畫的創作中有所謂的「傳神／寫意」的概念，可否就「黃山意境」這個題材來談談您想要傳達的象徵意義？這中間有沒有哪一座山（峰）讓您有所感悟？

莊：對我而言，「傳真／寫實」是一種紀錄，「傳神／寫意」是內在精神與意境體驗的傳達，兩者似乎是分開的，但我是同時在記錄美，也在分享美感體驗——既傳真，也傳神，既寫真，也寫意。以黃山為例，它就是一個空間，我並不會特別去連結什麼象徵意義，這個空間中有「天地人」——看天有雲、看地有石、看松就直接想到（形象近似）有生命姿態的人，所以從「雲石松」的觀察，我們可以看到「天地人」——人（松）在天地間、人（松）與自然共生的樣貌。

胡：康德曾經提出「崇高」美學觀，將「壯美」分成數學上的和力學上的崇高。這兩種崇高的美，皆具足於您的作品（構圖）中，這是否與現實生活的空間體驗或經歷有關？您登上黃山高達二十六次，這麼多次的親身體驗是否對於創作有所影響？

莊：我是在臺北城市長大的，所以在我的現實成長經驗中，並沒有開闊空間的視覺體驗，也沒有刻意去培養美感或接受構圖訓練（課程）。如果我的作品有一種力量，或許是我天生對美的事物比較敏感吧！

所以，我去黃山之前（甚至去美國之前）對一般人習以為常的東西，會產生某種「直覺聯想」（這不是指形而上的精神或概念）——「留黑」（比如山的剪影）會產生一種「重量」感，「留白」（比如風／雲的互動）會產生一種「分量」感，這種對美的敏感度，和我去黃山幾次沒有關係，去這麼多次，是要經由「反覆觀察」，掌握到天候與季節變化的常態規則，然後選擇景致變換的時機去拍照。

胡：相較於國畫中的自然主義山水、郎靜山的集錦攝影的「圖層式模板框架」，所建構的平遠、深遠、高遠透視效果。您的作品（構圖）還兼具「光影營造」的透視感，請問您如何透過觀察、取景與鏡頭選擇，營造視覺心理學所謂的向量張力？

莊：從故宮典藏、翁萬戈先生與各地骨董展示的字畫形制可以看出，國畫的構圖（加上點景物）之所以會形成（前景／中景／遠景三層）「八股（制式化）」的表現，受到文人（從官方到民間收藏者）的偏好，也可說是典藏風氣（就像骨董家具偏好紅木）的影響極大。

〈黃山（穩與約）〉/ 莊明景攝 / 中國 / 1988
Huangshan (Stability and Restriction) / photo by Mike Chuang / China / 1988

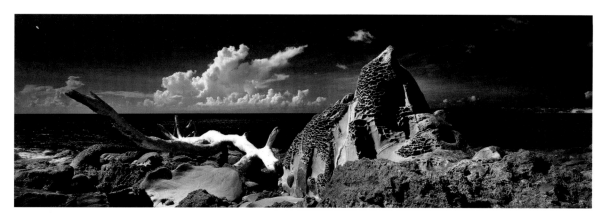

〈佳樂水〉/ 莊明景攝 / 臺灣 / 1986
Jialeshuei / photo by Mike Chuang / Taiwan / 1986

當攝影術傳入中國，這種平面構成框架的影響依然存在，郎靜山先生率先利用銀鹽媒材「再現」（複製）文人山水畫的構圖形態而得名，從他們將攝影社團取名「光社」就可以理解，其作品主要是利用攝影來從事繪畫。他們在攝影觀察前，已經預設一個構圖模式、一種「沙龍調」，卻忽略攝影能夠營造光影變化的特質，他們是「為繪畫而攝影」，是模仿構圖、複製技巧的「記憶攝影」，而我是「純粹為風景而攝影」，是「元素攝影」，吸收好的元素（如一片質感、一個視點、一種光影／剪影效果、一個時間點配合快門速度）化為創意，而非全盤模仿。

我在取景時，會專注用「構圖眼」來觀察——每一個角度都有不同的景物構成，我看的則是「入鏡的範圍」能不能滿足心中的美感效果（尤其是立體感）。每到一個地點，除了觀察陽光、雲霧的規則與走向，我是在（以構圖眼）「看」風景，而不是「被風景看」，當觀察經驗累積久了，自然就可以判斷出適當的取景。

當然，人都會有「美感疲乏」的時候，對於美好事物的感受有時間性、有數量性（會飽和），當這種美好感受變成習慣的時候，我通常會轉換對象，比如改拍近物，或機動變換角度，或觀察其他對象，讓情境的變換來刺激新的觀察能量。

六、心手眼：整備、面對、觀察、選擇與後製

（一）面對現實挑戰的扎實功夫

胡： 能不能說明一下，在美國從事商業攝影期間的工作情形？在那段高壓的工作環境中，您最大的收穫是什麼？

莊： 商業攝影沒有隨性的空間（雖然我為人比較隨性），必須滿足多人的要求，不能擅自變更已經和客戶討論定案的設計，且要有相當的敏感度，一看到設計圖平面配置（layout），腦海裡必須馬上浮現出完成品的畫面，知道需要怎麼打光、用什麼鏡頭和距離來呈現，這是專業和業餘的攝影最大的差別。

我在Studio期間的收穫，一個是這種專業「預視」能力的強化，另一個就是「應變的技術」。前者和我在風景攝影的觀察時，腦海裡能夠「預知」一幅圖像的想像力相輔相成；後者，則是如何打光（包含避免反光）、如何調校色溫（包含如何配合後製調色、修片或變形）、如何對商品「動手腳」的技巧。

胡： 能不能說明一下，在故宮如何進行拍攝工作？

莊： 拍外景（宮殿建築）的部分，都是在清晨還沒開放遊客進來的時間，利用自然光，以「搖頭機」[9]或4×5相機拍照。拍文物部分，以4×5大型相機，打持續光源為主（圍觀的員工很多、擋住外來光線，勉強構成一個標準光的攝影棚環境），拍攝地點在奉先殿。當時殿內還沒有供電系統（為了防範火災），故宮員工特別拉一條電線到殿裡，由於鹵素燈泡溫度很高（怕傷到字畫），又必須打均勻光，所以燈光保持在遠距離、用長時間曝光來拍照。

胡： 您如何規劃風景攝影行程？是依「季節變換」與「天候條件」做決定？還是隨性出發？

莊： 我會先收集資料，了解我計畫前往目的地的四季景致，選擇春夏秋冬適合的時機，這是「天時」的掌握。比如優勝美地四季分明——春夏的花開、秋天的楓葉、冬季的雪景，四季循環各有特色（如同生老病死）；黃山則是在冬天有松有雪（其他季節比較沒有區別），美國日本都有秋天楓葉，秋冬變換期間花葉凋謝留下樹枝的蕭瑟美感；臺灣

莊明景同時使用大型、中型、小型專業相機拍攝玉山 / 1986
Mike Chuang photographing Yushan with large, medium and small professional cameras / 1986

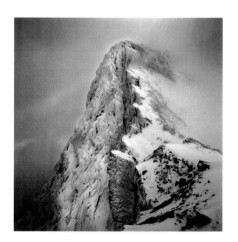

〈玉山〉/ 莊明景攝 / 臺灣 / 1986
Yushan / photo by Mike Chuang / Taiwan / 1986

則是看「秋老虎」陽光十足（但不像7、8月那麼炙熱），秋風落葉與樹影的景致（像臺南天后宮結合後製拉長「紅牆」那張作品）。所以，都是選擇景觀可取的季節、天候前往的。

胡： 您拍攝黃山路線為何？

莊： 拍照路線，是以「北海、光明頂、玉屏樓（景區）」三個景點為主，進行「機動調整」的拍照：先到一個定點拍照（如北海賓館），如果遇到「變天」，比如說天候不佳、雲霧太多、遮蔽了山景，我判斷這種能見度太低的狀況，短時間內不會排除，就會就移師到下一個定點住下來繼續拍。再遇變天，就換到下一個定點（如玉屏樓）住下來再拍……如此循環下去。三個據點之間的距離，以腳程計算各約三小時，如果中途不停留，三個點繞一圈大約需要半天。

胡： 關於「快門時間」，包括「快門速度」、「按快門的時刻」兩個變因的抉擇，您是否有什麼依循標準？此標準背後，有隱含什麼特殊（象徵）意義嗎？

莊： 快門時間決定事物運行效果（也影響後製的線條舞動或拖曳效果），是針對會移動的物件狀態，比如水流、隨風搖動的樹枝、潮水，但對於靜止的或光影構成沒有影響。所以，當我到一個地點，選擇天時、地利條件吻合（通常選擇晴天晨昏、陽光入射角有利凸顯立體感）的定點，感受鏡頭中景物與光影布局能否滿足美感經驗，接下來就是觀察水流的漂移流速、高潮水位，從中推想想要的效果，再決定快門速度。當然，水流慢適合慢速快門，但快門時間過久反而讓水面一片模糊；水流快適合高速快門，但快門時間過短反而讓水花太過鋒銳。所以，都要以經驗來判斷，端視（水花、海浪、雲霧）的凝結效果來決定——就是反覆觀察！至於時機點則是選擇浪花最高那一刻按下快門，如果遇到浪花很明顯、抓到內在中心焦點（intra-center）的狀況，也不一定要連拍。

胡： 國畫中表現石頭質感（texture）的皴法有各種變化，您在石頭質感的表現上，會做什麼觀察與操作設定？您如何掌握拍攝條件來控制畫面的明暗階調、光影布局？

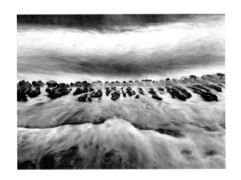

〈老梅〉/ 莊明景攝 / 臺灣 / 2015
Laomei / photo by Mike Chuang / Taiwan / 2015

莊：石頭、木材都有原始質感，我會用大底片（或高畫素機背）、高解析度鏡頭，等待側面光營造立體感，若是黑白攝影，偶爾會掛紅色濾鏡調整反差。但是石頭的造型、山的稜線千變萬化，木材也有厚薄的差別，我會透過框取範圍的調整，在亮暗之間、厚薄之間、曲直之間、遠近之間取得平衡感。

在冬天的黃山，天候導致環境本身的亮部、暗部之間只有五級的明暗比，這時候我不想用黑卡或後製擴大濃度域，我會順應現場雲霧的質感、降低曝光量，形成一大（板）塊純黑效果，以「剪影」勾勒山的稜線，也同時製造出一種重量與分量並陳的平衡效果。

（二）現場即席示範觀摩 [10]

背景描述：莊明景與胡詔凱、姜麗華、洪世聰、呂筱渝、莊哲祥、李宗洋等一行人，於**2022年3月20日**午後，驅車前往北海岸進行現場即席攝影示範觀摩活動，並於傍晚回到工作室電腦前，即席示範後製操作。整個行程有四個據點，依序為「**1.龜吼海岸→2.老梅海岸咖啡廳**（對談「觀察、取景」之心法）**→3.老梅海岸→4.長春路住處工作室**」

1. 龜吼海岸

(1) 一行車輛先進駐停車場。

(2) 停好車後，莊明景對著車窗外面（乍看不起眼）的「岩壁觀察」許久，接著引導一行人，並提示觀察重點。

(3) 莊明景挑選一座岩岸，架設器材、調整鏡頭、完成設定，手持快門線、「看著海浪起伏」、「連拍」了十餘幅影像。

2. 老梅海岸咖啡廳（對談「觀察、取景」之心法）

龜吼海岸一整片不起眼的岩石（圖左），在莊明景心／手／眼裡，浮現了常人視而不見的紋理連結（圖右〈和尚岩，2022〉）
Left, a photo view of an inconspicuous rock on the Guihou Coast in its entirety. Right: The mind, eye, and hand of Mike Chuang finds textural details that escape the ordinary eye. (*Heshangyan*, 2022)

〈加州海岸〉/ 莊明景攝 / 美國 / 1982
California Coast / photo by Mike Chuang / the U.S. / 1982

胡：　您來老梅這地方已經超過百次，今天面對這個海岸場面，請問您心中
　　　的藍圖是什麼？您會怎麼觀察、取景？

莊：　首先，看光線，觀察眼前的石頭，在陽光照射下，明暗分布、陰影位
　　　置。然後，早上陽光、下午陽光，都會觀察，還有潮汐、水位高度
　　　（潮間帶），再做拍攝的選擇，比如左邊那裡像「鱷魚群」的地方，
　　　我就會選擇。接著就依據直覺經驗，看「視框」範圍美不美？這時候
　　　純粹主觀自覺，不會想太多（理念或企圖）。

胡：　那海水是動態的，您又如何抓快門時機？您曾經有過「意外」瞬間，
　　　突然拍到一張機會難得的作品嗎？

莊：　等浪花來的時候，我會連拍很多張，將連續移動的每一瞬間都記錄下
　　　來。然後，趕快換角度，或換位置再拍，因為動作快，所以一個場景
　　　拍起來不下兩、三百張檔案。

　　　對我來說，攝影沒有「意外」。如果到一個地方拍照突然天候改變，
　　　就像是樂透「槓龜」，我會選擇下次再來。基本上，我會先收集資
　　　料，看天氣、看何時漲潮、何時退潮，先把大自然的規律掌握在手上
　　　再出發，到了現場的每一個取景，都是依照經驗，根據腦海的預感想
　　　像來拍照！

　　3. 老梅海岸
　　　(1) 莊明景先選擇遊客較少的位置，架設器材、調整鏡頭、完成設
　　　　　定，手持快門線、「看著海浪起伏」、「連拍」了十餘幅影像。
　　　(2) 莊明景移動器材位置，到原先選定、後來遊客散去的攝影視點，
　　　　　調整鏡頭、完成設定，手持快門線、「看著海浪起伏」、「連
　　　　　拍」了十餘幅影像。

　　4. 長春路住處工作室
　　　(1) 莊明景開啟電腦、啟動Photoshop軟體。
　　　(2) 挑選一張「美感姿態」花卉照片檔案。
　　　(3) 以「反轉」效果處理。
　　　(4) 讀取「色彩控制」功能，以「色相／色彩平衡」滑軸（拉bar），
　　　　　嘗試變換各種可能的色彩效果？

(5) 再一次做「反轉」效果處理，試試看是否產出「再生美感」？

(6) 重複上述動作，不斷嘗試，直到合乎心中美感效果為止。

七、其他訪談：與莊哲祥[11] 對談莊明景作品

胡： 對您而言，您覺得莊老師作品（以黃山為例）的特色是什麼？

哲： 我覺得莊老師經常利用黑白陰影，來改變畫面的透視感，就像李可染作品經常呈現劈面而來的大塊面，莊老師會用簡單的大黑塊，掌握每一塊面的線條，利用主次、疏密，建立部分與整體的關係。常有人拿黃山與文人畫連結，可惜這些文人畫的構圖過於僵化，就像很多攝影構圖學所說的三角形構圖、黃金比例、S形構圖之類的典型，往往「框住」了我們面對現場的觀察與體驗。

莊明景將臺灣海岸風景照進行二次創作的「繪影」作品
A derivative work by Mike Chuang in his *Image Painting* series, based on a photo of Taiwan's coastal landscape

莊： 不一樣的場景，有不一樣情境，自然就會有不一樣的觀察。剛才提到的構圖學，我覺得就像英語的文法課──學了一堆規則，碰到老外還是無法開口。如果現實環境只有兩座山，何來「三角構圖」的建立？所以，我不會硬套，一切都應該回歸到現實觀察再做決定。而且我也不會像有些心象攝影，硬套主題（作者主觀聯想）在拍照對象上。曾經有人建議我的攝影專集裡，應該為每一張照片賦予題名，雖然我會從善如流，拿李白的詩來搭配照片，但其實在舉辦展覽時，大多不做事後的作品命名，這樣很容易框住讀者的想像。

胡： 可否整體說明您對於莊老師創作的總結？

哲： 對我來說，莊老師的作品總是超越時間限制，他三、四十年前的創作，今天看來還是有現代感（不退流行），相對於安瑟・亞當斯（Ansel Adams）、愛德華・威斯頓（Edward Weston）過度追求形式上的極致（指細膩的畫質）照片，拿到現在有精密科技支援的攝影時空裡，反而讓人覺得司空見慣。

莊老師的心，是自由開闊的，沒有世俗拍照者想要「擁有（某景／物）」或「贏得（某名／利）」的企圖，很多風景攝影照片拍得很漂亮，但正因為太漂亮，反而看不到作者的「內裡」。這種在抽離人群後的自由──追求精神的自由開闊，使得他的創作同時有雄渾、空靈、沉蘊又飄逸的感覺，也讓我（們）重新詮釋「風景」這個概念！

1. 本訪談紀錄，係依據《臺灣攝影家口述影音保存計畫（第三期）──莊明景》影片，及2022/02/23、2022/03/16、2022/03/30於長春路住宅訪談和在北海岸、工作室之示範攝影與後製操作紀錄，彙整編輯而成。

2. 「台北攝影沙龍」既是活動名稱、也是攝影觀摩砥礪的平台，其前身為「台北攝影月賽」，原係1956年成立的「台北市攝影會」所主辦每月一次的攝影評選與徵件比賽；次年（1957年）更名為「台北攝影沙龍」，以陳雁賓經營的「美而廉藝廊」（位於臺北市博愛路，於1970年前後結束營業）做為展出地點，內容分為入選展與邀請展，作品題材不限，從沙龍風格（藝術攝影）到紀錄風格（紀實攝影）皆有。主辦單位為鼓勵創作，1961年設立了「年度優秀作家獎」機制，累計每一位參賽者在同一年度的12個月賽獲選作品之得分（特選作品六分、優選五分、佳作三分、入選一分），以總積分最高之前三名頒發證書。參閱胡詔凱，〈端詳「美而廉藝廊」開枝散葉的風情〉，收於莊靈等撰文，《風華再現：臺灣第一家攝影藝廊「美而廉藝影家》，臺北：台灣國際視覺藝術中心，2007年，頁28-33。

3. 1963年，香港導演李翰祥來臺創立「國聯影業」公司，設立片廠與訓練班、推動明星加盟制度、發行電影畫報；並為五位女明星（含甄珍）組成「國聯五鳳」，可謂當時的偶像團體。參閱盧非易，《台灣電影：政治、經濟、美學（1949-1994）》，臺北：遠流，1998年，頁119-120。

4. 翁萬戈生於1917年的上海，為清末大臣翁同龢玄孫，於1938年自北京赴美留學後定居於美國。在美國期間，亟需一位專業攝影師，將過去繼承自翁同龢收藏的大批骨董字畫，進行翻拍與建檔。恰逢莊靈在1972年隨團報導亞東籃球隊訪問美洲活動期間前往拜訪，將莊明景引薦給翁萬戈，於是莊每逢假日空檔會到翁府整理資料，協助建置暗房、翻拍與沖印骨董字畫（如沈其昌、文徵明作品）的檔案照片，以提供給大學教學、波士頓博物館交流之用。翁萬戈也以當時正籌資拍攝「中國十三朝代」動畫電影、需要專業人士之緣由，為莊明景申請綠卡、取得永久居留權。

5. 該書原文書名*Palace Museum: Peking, Treasures of the Forbidden City*，作者為Weng Wan-go（翁萬戈）、Yang Bo-da（楊柏達，時任故宮副院長）。

6. 莊明景有4×5相機四、五十部，大多是從美國二手市場買來的。1981年的拍照之行，也讓當時沒有文物攝影經驗的北京故宮同仁，觀摩到一整套專業攝影的流程與技術。

7. 617相機為片幅6×17cm的1:3超廣角（Panorama）全景相機。相機裡面裝120軟片可拍攝四格畫面、裝220軟片可拍攝八格畫面。

8. 在青藏鐵路開通之前，前往西藏有四條主要的公路，分別為青藏公路、川藏公路、滇藏公路、新藏公路。

9. 「搖頭相機」是攝角140度、片幅為135底片兩倍寬度的「環景相機」，莊明景拍玉山、太魯閣也有用到這台相機。

10. 為了解莊明景在面對景物時，如何透過「心手眼」的運作來完成創作，本訪談系列之一，即特別邀請他到北海岸現場、並回到電腦桌前「即席揮毫」，以供分析觀摩其觀察、取景、設定、拍照到後製的影像創作歷程。
 此處引用「即席揮毫」一詞，除了要避免與英文「snapshot」（譯成即席攝影、即興攝影、或抓拍）產生混淆，也用以比喻「現場示範、動態觀摩」（提供教學研究功能）之意，甚至可以進一步呼應「語意因語境影響而轉換」的語用學（Pragmatics）概念──「即席揮毫」所代表「表現技藝之示範或觀摩」之意，在當代視覺藝術的傳承和研究中，正可象徵攝影本質論「攝影是光之繪畫說」、「攝影是自然的鉛筆說」、「攝影機鋼筆論」，或是日語將攝影翻譯為「『寫』真」，乃至當前數位科技已介入攝影創作的情境中，以滑鼠或觸控筆控制線條與階調濃淡等所指涉的「現場運筆」概念。以上，為了避免讀者望文生義而造成語言和閱讀上的疑慮，謹於此說明。

11. 莊哲祥為世新大學（前世界新聞專科學校）印刷攝影專業人士，受教於攝影家陳炳元、胡毓豪，主要創作題材以人文景觀、自然風景（包括大陸黃山）為主，最高曾有一年八次登上黃山的紀錄。曾於2018年與張松政在臺北市爵士藝廊舉辦「屋漏痕」藝術攝影展，另於2021至2022年在臺北市銀河94藝文空間舉辦「莊明景、郭英松、莊哲祥藝術攝影聯展」。

Interviews of Mike Chuang

1. Getting Started and Early Experience with Photography

Q (Hu Chao-kai): Could you please discuss how you became involved with photography?

A (Mike Chuang): I attended Taipei Municipal Chenggong High School, and on the way to and from school, I would pass by the Taiwan Provincial Museum (today's National Taiwan Museum) on Guanqian Road. When I could, I would go in and look at the photography exhibitions, and I felt photography offered interesting challenges. I had the feeling that "anyone can emulate the success of the great," and I intended to give it a try. That was the turning point. After that, I started borrowing cameras from my family and relatives to teach myself.

Q: **What kind of experience did you have studying and practicing photography at National Taiwan University (NTU)?**

A: As soon as I entered NTU, I signed up for their photography club. At that time, the main instructors were Chang Tsai and Tang Sz-pan. They taught us basic knowledge, and our main activities were outside photo shoots and studying each other's work.

At the photo shoots we mostly took snapshots, and we would then study and critique each other's work. When we had one of those sessions, virtually all of the photos on the table would be mine. Professor Chang realized I had this strong creative energy, and encouraged me to enter some photos in the Taiwan Photography Salon competition. A lot of my photos won awards, and with half a year, I had accumulated enough points based on my selected entries to win my first "Outstanding Photographer of the Year" award.

Q: **Were you developing all the photos yourself at this time?**

A: Yes! The NTU Photograpy Club was one of the university's major clubs, and not only did we have our own offices, there was also a darkroom on the campus. That was why we had more than a hundred members.

Q: **When you were in the NTU Photography Club, were you also participating in outside competitions or activities?**

A: At the time, wanting to test my abilities, I submitted to a wide variety of competitions, such as the color photography competition held by Agfa to promote their new color film, the Shin Kong Building photography competition, the Taipei architectural photography competition, The Five Phoenixes competition held by the Grand Motion Pictures Company to promote their five female stars… I always placed in the top three or the top six, and I was nominated for outstanding work at least half the time.

Q: **Did the fact that you majored in philosophy provide inspiration for your creative concepts or any other benefits?**

A: In fact, I didn't really study all that much in the Philosophy Department, and that was why I had time to go out and take photos. This aided my long-term immersion in the environment of certain specific places, helping me understand something about landscape philosophy – and to think seriously about why I was doing photography, that is, to find a "pure and unsullied" motivation for photography (not just for prize money, or applause, or to please others). I think that was the key to moving beyond just superficially documenting landscapes.

2. Workplace Training in Commercial Photography in the U.S.

Q:　**What did you do at first after you arrived in the U.S.?**

A:　Through contacts and assistance by Ko Si-chi's then wife (Ms. Li Zhun-ju), I went to New York and worked as an intern assistant in Ko's personal photography studio, learning about commercial photography production methods. At the same time, I was preparing to apply to the New York Institute of Photography.

When I submitted my application, someone on the admissions committee made the suggestion, based on my portfolio, that I already had the abilities of a professional or perhaps even a teacher, and that I didn't need further study. He said I should directly engage in work and accumulate practical experience, so I continued to work as an intern assistant.

Q:　**Could you talk about your experience working in photography in New York?**

A:　Later, Ko introduced me to William Silano, the exclusive photographer for Harper's Bazaar Magazine, where he had previously worked. I worked there as a photographer's assistant; after nine months, working with three photographers, I was promoted to junior photographer.

As a full-time photographer, I had a chance to take a case that one of the older senior photographers had refused. I felt this was both good luck and a challenge, so I accepted the heavy responsibility. I handled it with no major problems, so after another year, I became a senior photographer. Later, the physical demands of the job became too much, and when Ray Tenn founded his Photo Conception Studio he asked me to come on board, so I left the original company.

Q:　**After you changed tracks, was your work different?**

A:　I took over photography for all kinds of products at the Photo Conception Studio. There was pressure due to the large volume of orders; I then switched to an even larger advertising photography company, shooting mostly fine "table top" items like jewelry, diamonds, and watches. It was a large company with an established system and strict operating procedures. My work had to satisfy the art director and the designers' requirements, and I had to develop a feel for aesthetic trends, and how to capture the details and reflections of very small objects. There was no reduction in the difficulty or the pressure of the work.

3. Setting Out on a Grand Photographic Journey

Q:　**Could you tell us why you left and began your photographic travels?**

A:　Working in New York for ten years, with heavy workloads, high pressure, and tight schedules, I couldn't even be bothered to go to Central Park in my off hours. I just wasn't in the mood. And at age 40 I felt I wasn't fit for physically demanding work anymore. So I decided to quit my job, and I traveled around the Americas as a freelancer, photographing things I wanted to document and that I thought might sell.

I went to the FPG International stock photo company (a photo bank) and got on as a contract photographer. I borrowed the fees for film and other expenses on credit, then traveled around North America shooting landscapes. My income was whatever remained of the proceeds from selling the copyrights after deducting the money I had borrowed.

Q:　**What factors led you to photograph in China?**

A:　In 1981, I first returned from the U.S. to Taipei for my first solo landscape photography exhibition. On my return to the U.S., Weng Wan-go (then president of the China-America Friendship Association) recommended I accompany him to Beijing to capture the look of the Forbidden City and its cultural relics in photographs. Those photos

supplied images for the English-language book Palace Museum: Peking, Treasures of the Forbidden City. I shot photos in Beijing for two months, donated all the photographic equipment to the Palace Museum, and then returned to the U.S.

Q: Why did you later think of going to Huangshan for photo shoots?

A: It was in 1983, when Beijing hosted members of the China-America Friendship Association on a sightseeing trip to China. I accompanied the group from Beijing to the Silk Road area. After the trip, the Association's members returned to the U.S., while I stayed in Beijing.

Because for so long I had heard that many works by Lang Jing-shan were drawn from Huangshan subjects, I had planned to go there to shoot.

That was the first time I went to Huangshan. I stayed at the Beihai Hotel for a month (it was autumn), and I judged that Huangshan was like Yosemite in that there would be great views if it snowed. On January 6, 1984 (during winter), I set out from Taiwan (for my second trip) to climb Huangshan. After that, I went to Huangshan about once a year, staying for about a month each time. My last climb in 2012 made it a total of 26 times in all.

4. The Second Career Phase, Roaming between Taiwan and China

Q: After settling back down in Taiwan in 1984, did you do more photography or publish in Taiwan, aside from your continuing work in China?

A: After I returned to Taiwan, I continued to release new works and publish photo collections. In 1986, I was invited by Chang Lung-sheng, then Director General of the Construction and Planning Agency, to photograph the natural landscapes of Yushan, Taroko and Kenting National Park.

Q: Why did you take photos of Huizhou?

A: On the way to Huangshan, you will pass through Huangshan City (known as the Huizhou area before 1987), which is an ancient cultural city with lots of historical buildings (such as the buildings along the Tunxi old street), so on my later trips I would also take photos of the Huizhou architecture and the local humanistic environment.

Q: Could you tell us about your trip photographing in Tibet?

A: In 1989 I shot in Chengdu, Sichuan (at the edge of the Qinghai-Tibet Plateau), including landscapes around the Jiuzhaigou and Hailuogou valleys. In 1991, I took the Qinghai-Tibet Highway and went deep into Tibet to shoot. In 1993, I took the Xinjiang -Tibet Highway and went deep into the Ngari area of Tibet (once ruled by the ancient Guge kingdom) to shoot. In 1994 and 1995, I was invited by Lin Tianfu to shoot in Tibet, entering via the Yunnan-Tibet Highway.

Q: When did you start shooting your Laomei series on the northern coast?

A: I started between 2006-08. Laomei was originally a restricted coastal defense area, but after it was opened to the public, I found, based on advice from other photographers and my own observations, that it was very special and well worth photographing in the intertidal zone as the water washes over the rocks with the tides coming and going. From that point on I returned my focus to Taiwan, and along the rocky coast in the northwest, I photographed the landscape of colors and shapes created by the interactions of water, boulders, and sunlight.

Q: When did you start to produce the lotuses and various flowers and plants in your "painting" series?

A: I started experimenting with those in 2012. In fact, I took the lotus photos quite early, but while the flowers were beautiful, I never made any breakthrough with them and didn't release them. When image processing software became available and I discovered the great possibilities it offers, that was when I could feel satisfied, explore, and

reproduce the beauty of flowers. It was after that that I began to develop my "painting " (post-production) series of works.

5. Concepts of Photography, Time and Space, and Aesthetic Experience

Q: **Let's talk about your concept of photography – what does "photography" mean to you?**

A: Photography is an accumulation and presentation of aesthetic experience. We can say that aesthetic experience is a kind of enjoyment, a feeling, a pure and untainted delight. In nature, these aesthetic pleasures are everywhere, but the photographer's responsibility is to understand how, through the right combination of time, place, and circumstance, to extract and preserve that beauty.

Q: **Why do you collect antiques? Do you have standards for antique collecting that you follow to help inspire your photography?**

A: I am most interested in the aesthetic things in life, so I want to discover the beauty of craftsmanship in antiques (furniture) that have been handed down that let them "stand the test of time." These relics "accumulating in large numbers, over a long period of time, are what constitute (aesthetic) culture."

As for standards of collecting, I basically don't follow popular trends. Antique furniture of aged rosewood or red sandalwood was in demand for a while, but I don't buy for investment purposes, and I'm not going to buy such expensive furniture. "Does it create aesthetic pleasure?" is my one standard for collecting.

Q: **What insights have you gained in contact with nature?**

A: Nature is infinite, but people have limits. In a vast space we find the infinity of time. For me, communication between man and nature is a kind of mutual assimilation, not one-way exploitation. This mutual assimilation is an exchange of meaning, a spiritual exchange – the birth, aging, illness and death that humans experience on the surface seem to represent the limitations of life, but instead they resemble the reincarnational cycle of sunrise and sunset, and spring, summer, autumn and winter. This kind of artistic conception, like the "qi" (the cycle of life) that is accentuated in Chinese painting (landscape painting), allows me to gain insight into the laws of nature and its unending cycles in what is visible before me.

Q: **You mentioned Chinese painting. Can you talk about "projecting feeling into landscapes," "emptying the mind in meditation," or whether other concepts in Chinese painting have influenced your creativity?**

A: In fact, aside from the idea of meditation, I rarely make those connections. I just intuitively want to record the beauty of nature, to stand between heaven and earth and observe, watch the weather, see the sun and the scenery, pick an angle, and find the right combination of time, place, and circumstance for my photographs; I don't connect them to so many external ideas.

A: Meditation is a kind of process, a method for letting go and clearing the mind. If a person (like a child) had no distracting thoughts, then where is the need to clear the mind? For me, creation (my work) is like meditation, a process of letting go. In the process, I will realize what my own (photographic) mistakes are and correct them, that is, I learn how to remove the things that contaminate them, in order to achieve a method that is pure and untainted.

Q: **Chinese painting has the concept of "expressive" or "freehand" painting. Can you talk about the symbolic meaning you want to convey in your artistic conception of Huangshan? Do you have a special feeling for any particular mountain peak there?**

A: For me, "true to life" or "realistic" photography is a kind of documentation, whereas "expressive" or "freehand" photography involves inner spirit and an understanding of artistic conception. The two seem separate, but I both

document beauty and share my understanding of it – it is both true to life and expressive, and both realistic and freehand. Huangshan, for example, is just a space, and I don't attach any special symbolic meaning to it. In this space are "heaven, earth and people" – in the sky you see clouds, on the earth, rocks and pines, and you mentally link the pines with the demeanor of living people (the image is similar). So, observing "clouds, rocks, and pines," we see "heaven, earth, and people"; people (or the pines) stand between earth and heaven, and people (like pines) coexist with nature.

Q: **Kant once put forward the aesthetic concept of "the sublime," and he categorized "sublime beauty" as either mathematical or dynamic. Both of these are present in your work, compositionally. Is this related to your experience or understanding of the spaces of real life? Did your personal experience of climbing Huangshan as many as 26 times influence your creative work?**

A: I grew up in the city of Taipei, and I had no real experience of broad, open spaces at that time, nor did I deliberately cultivate aesthetics or have any training in composition. If my works have some power, is it possibly because I am naturally sensitive to beautiful things?!

So, before I went to Huangshan (or even the U.S.), I would have some kind of "intuitive association" (I'm not referring to a metaphysical spirit or concept) about things that ordinary people are accustomed to – " dark areas," such as a mountain in silhouette will produce a sense of "weight"; "empty spaces" such as the mixing of wind and cloud, will create "volume." My sensitivity to beauty had nothing to do with how many times I went to Huangshan; I returned so often because only through repetitive observation could I understand the typical weather and seasonal changes, and then choose the best time for taking photos.

Q: **Compared with the "level distance," "deep distance," and "high distance" perspectives in the naturalistic landscapes of traditional Chinese painting or in the "layered template frames" of Lang Jing-shan's composite photographs, the compositions of your works also possess a sense of perspective that is structured through light and shadow. How do you use observation, framing and different lenses to create what is known as vector tension in visual psychology?**

A: It can be seen from the forms of expression in the calligraphy and paintings in the collections of the Palace Museum, Weng Wan-go, and antiques around the world, that the "ba gu" (stereotyped) style of the three-layered foreground, middle ground, and distant perspectives in the composition of traditional Chinese paintings has been greatly influenced by the preferences of the literati, from official to private collectors, or what we could call fashions in collecting, like the preference for mahogany in antique furniture.

When photographic art came to China, the influence of this planar composition frame still existed. Lang Jing-shan took the lead in using silver salt photography to recreate, or duplicate, the compositional style of literati landscape paintings, and from the name of his photography group, the Light Society, his goal can be understood as using photography to engage in painting. They have already decided on a compositional style, a "salon" tone, before even beginning to observe their subject, and they ignore the aspects of photography that create changes in light and shadow. It is "photography for the purpose of painting" and "nostalgic photography" that imitates earlier compositions and reproduces their techniques. What I do is "photography purely for landscape" and "elemental photography," where I absorb useful elements into my creativity (a texture, a viewpoint, a light and shadow or silhouette effect, a point in time with appropriate shutter speed), rather than complete imitation.

When framing a scene, I will focus on observing with my "compositional eye" — every angle includes different scenic elements. What I look for is whether "the scope of lens capture" will be psychologically, aesthetically satisfying (in particular, its three-dimensional effect). Whenever I go to a place, I observe the direction and the patterns of the sunlight and the clouds, and I am "looking" at the scenery (with my compositional eye), rather than having "the scenery looking at me." After accumulating enough experience with observation over time, I naturally make appropriate judgments about framing.

6. Heart, Hand and Eye: Preparedness, Confront, Observation, Selection and Post-Production

Q: **Could you explain what it was like working as a commercial photographer in the U.S.? What was your biggest takeaway from that high-pressure work environment?**

A: One thing I gained in the studio was strengthening my professional predictive ability; another was adaptive techniques. The former complemented my ability to mentally imagine an image in advance during observation in landscape photography, and the latter included the ability to adjust lighting (including avoiding reflections), adjust color temperatures (including how to coordinate with post-production color correction, editing, or distortion effects), and manipulation of the product.

Q: **Could you describe how you carried out your work in the Palace Museum?**

A: For the exterior scenes (the palace building), taken in the early morning before opening to tourists, I used natural light and a panoramic or a 4×5 large-format camera. For the cultural relics, I mainly used a 4×5 camera and continuous lighting (a lot of employees were looking on, blocking external light, barely allowing for a studio environment with standard lighting). To get even lighting, I used long exposures with the lights at a distance.

Q: **How do you plan your landscape photography itinerary – based on seasonal changes and weather conditions, or is it more spontaneous?**

A: I will collect information first to learn about the scenery of my destinations during the four seasons, and choose the right time for spring, summer, autumn and winter; that is how you grasp "the perfect conditions."

Q: **Do you have any standards that govern your choice of "shutter time," including "shutter speed" and "the moment you press the shutter?" Do those standards have any special or symbolic meaning?**

A: The shutter time determines the effects you get with things in motion (and also any fluttering or smeared lines in post-production) with respect to their state of motion, such as flowing water, branches in the wind, and tide water; but it has no effect on static objects or light and shadow. Therefore, when I arrive at a place, I choose a fixed point with suitable time and weather and local conditions (I usually choose a sunny day, morning or evening, when the sun is at an angle that highlights three-dimensionality), and feel whether the scene elements and the distribution of light and shadow in the lens provide for a satisfying aesthetic experience. The next step is to observe the drift and flow rate of the water flow or the water level at high tide, think about my desired effect, and then choose a shutter speed.

Q: **The textural strokes in Chinese paintings express the texture of stone in various ways; how do you observe textures and what configurations do you use to express them?**

A: Stone and wood have primitive textures. I will use large negatives or high-pixel digital camera backs, high-resolution lenses, and wait for the side light to create a three-dimensional effect. For black and white photography, I sometimes add a red filter to adjust the contrast. But the shapes of stones and mountain ridges are highly variable, and wood has different thicknesses. I adjust the range of the frame to find a balance in terms of brightness, thickness, curvature, and distance.

傳記式年表
BIOGRAPHICAL TIMELINE

| 1942 | 9月23日生於臺北市大稻埕（位於今大同區西南部），在八位手足中排行第五（兄、姊各兩位）。大稻埕地區為早期臺北商業與貿易往來頻繁的區域，也是布料交易集散地，莊明景父親（本姓陳，因過繼給姑姑而改姓莊）與伯父陳雲龍出身新竹陳氏望族，於大稻埕開設貿易公司從事染料銷售業務，由於地緣關係、緊密和在地布莊共生互惠而事業有成。 |

莊明景童年時與母親合影 / 1940's
Chuang in childhood, with his mother / 1940's

| 1947 | 就讀永樂國小附設幼稚園、太平國小一年級。 |

| 1948 | 舉家搬遷至臺北「城內」（今中正區）靠近北門的開封街，同時轉學至福星國小就讀。莊明景（家人）在此地住了四十七年。 |

| 1955 | 初中考入建國中學。 |

| 1958 | 高中就讀成功中學。在上下學途中經過臺北市館前路的臺灣省立博物館（今國立臺灣博物館），因參觀館內攝影展而開啟了攝影的契機。從此，借用家族裡的照相機自習攝影。 |

| 1962 | 因為大學聯考考上臺灣大學哲學系，父親贈送一台德國製Rolleicord 120雙眼相機作為獎勵，自此「瘋狂」地外出拍照。 |

| 1962—1966 | 加入臺灣大學攝影研究社（簡稱臺大攝影社），接受張才、湯思泮等老師的指導；社團活動內容以「外拍」和「作品觀摩」為主，外拍活動有風景攝影、沙龍攝影（崇尚美景美女為年輕人共同取向，當時還有社員為了搶拍裸體而跌倒），也有紀實攝影。

在作品觀摩時，莊明景受到張才的鼓勵與建議，將作品投稿到「台北攝影沙龍」比賽，不出半年即獲得第一名「年度優秀作家獎」的殊榮，因而確立了一生走上攝影創作之路，繼而嘗試參加各種攝影比賽以測試自己實力，結果均獲得佳績與獎項。 |

| 1966 | 從臺灣大學哲學系畢業。入伍服役。 |

| 1942 | Chuang is born on September 23 in Dadaocheng, Taipei City (in the southwest of today's Datong District), as the fifth of eight siblings (with two brothers and two sisters). In early Taipei, much commerce and trade went through Dadaocheng; in particular, trade in fabrics. Chuang's father (whose original surname, Chen, became Chuang after adoption by his paternal aunt) and his uncle Chen Yun-long were born to the important Chen family in Hsinchu, and opened a company in Dadaocheng to engage in the sale of dyes. Geographical factors and proximity to local fabric shops made the business a success. |

| 1947 | Chuang attends the kindergarten of the Yongle Elementary School and first grade at Taiping Elementary School. |

| 1948 | Chuang's family relocates to Kaifeng Street, near Taipei's North Gate; he transfers to Fuxing Elementary School. The Chuangs (his family) have lived there for 47 years. |

| 1955 | Chuang enters Jianguo High School. |

| 1958 | Chuang enrolls in Chenggong High School. Each day, going to and from school, he passes the National Taiwan Provincial Museum (now the National Taiwan Museum) on Guanqian Road, Taipei City. Visiting photography exhibitions in the museum instills a desire to take photographs. |

| 1962 | After passing entrance exams for the National Taiwan University (NTU) Department of Philosophy, Chuang's father presents him with a German-made Rolleicord 120 twin-lens reflex camera. |

莊明景拿著相機拍攝學士照，象徵攝影是他人生的重要
伴侶 /1966
Chuang poses for his bachelor's photo with a camera,
symbolizing photography's importance in his life / 1966

| 1962 – 1966 | Chuang joins the National Taiwan University Photographic Research Society, (i.e., the NTU Photography Club) and receives guidance from teachers such as Chang Tsai and Tang Sz-pan; the main club activities are outside photo shoots and viewing each other's work. Outside photo shoots include salon photography (the youths share a common appreciation for both scenic and the beauty of the female form) and documentary photography. |

During one viewing, Chuang is encouraged by Chang Tsai to submit his work to the "Taipei Photography Salon" competition, and within half a year, he had won "Outstanding Photographer of the Year Award," setting him off on a lifetime career as a photographer. He then begins testing his abilities by participating in various photography competitions, where he has excellent success and wins awards.

| 1966 | Chuang graduates from the NTU Department of Philosophy and is drafted to do mandatory military service. |

1967	退伍後，進入家族事業從事Ciba染料的貿易業務，同時從事業
―	餘攝影活動。
1970	

莊明景拍攝蘭嶼的工作照 / 1968
Mike Chuang photographing in Lanyu / 1968

| 1968 | 獲得中國攝影學會博學會士（Fellowship of the Photographic Society of China, FPSC）、英國皇家攝影學會碩學會士（Associate of the Royal Photography Society, ARPS）榮銜。 |

| 1970 | 有感於在工作與創作之間難以兩面兼顧，決定辭去工作、準備赴美深造，以強化攝影造詣。 |

| 1971 | 前往美國紐約，在柯錫杰個人攝影工作室擔任實習助手，觀摩商業攝影的製作模式，同時準備申請紐約攝影學院（New York Institute of Photography）的入學資格。後因審查委員認為莊明景自備的作品集，已具備專業攝影師的水準，建議他可以直接投入職場。 |

莊明景前往紐約時，雙子星大廈還未建好 / 1971
The World Trade Center had not been completed when Mike Chuang went to New York / 1971

| 1972 | 莊靈隨團報導亞東籃球隊訪美期間，引薦莊明景認識翁萬戈（留美華裔文物收藏家），莊開始利用假日到翁家位於新罕布夏州宅邸、為其收藏之骨董字畫做翻拍與建檔，同時協助參與製作翁萬戈所集資拍攝的《中國十三朝代》動畫電影。 |

1972	莊明景經柯錫杰引薦到威廉・西拉諾（William Silano）的工作室擔任助理；初次去工作室面談時，老闆詢問莊希望的待遇，莊以自己是新手，不便要求太高，就以當時臺灣的中等薪資水準提出「週薪75美元」（相當於臺幣3000元的週薪）的待遇要求。沒想到，這金額竟然低於當時美國基本工資的80美元。最後，老闆決定以最低工資「週薪80美元」聘任莊明景擔任攝影助理。
―	
1976	九個月後，升任為正職攝影師（junior photographer），再經過一年多，即升任資深攝影師（senior photographer）。
	升任正職攝影師之後，莊明景仍然在部分作業上親力親為、一人身兼數職，至於有關模特兒該如何擺姿勢、畫面元素如何安排的事，就交由助理去溝通調度。

1967 — **1970**	After his discharge from the army, Chuang enters the family business, trading Ciba dyes while continuing with amateur photography activities.
1968	Chuang is made a Fellow of the Fellowship of the Photographic Society of China (FPSC) and an Associate of the Royal Photography Society (ARPS) of England.
1970	Finding it difficult to balance work and photography, Chuang decides to quit his job and prepares to study in the United States to improve his photography skills.
1971	Chuang goes to New York and works as an intern assistant in Ko Si-chi's photography studio. He observes how commercial photography is produced, and prepares to apply for admission to the New York Institute of Photography. But a member of the admissions board believes his portfolio is already very professional and recommends that he should begin working professionally instead.
1972	Chuang, being acquainted with Weng Wan-go (a Chinese collector of cultural relics in the U.S.), makes photo archives of the antique calligraphy paintings at Weng's residence, and assists with production of the *Thirteen Dynasties of China* animated film for which Weng Wan-go raised funds.
1972 — **1976**	Chuang is introduced to William Silano by Ko Si-chi to work as an assistant in Silano's studio. During his time there, he works with three photographers (including a photographer of Chinese descent, Ray Tenn), and learns through observation. Nine months later he is promoted to junior photographer, and then promoted to senior photographer more than a year later.

莊明景與翁萬戈在故宮合影 / 1981
Chuang in the Palace Museum, with Weng Wan-go / 1981

1976 — 1980	莊明景開始轉換攝影工作跑道。先到譚瑞自立門戶的Photo Conception Studio擔任攝影師，再到規模較大的Ted Pobiner廣告攝影公司，拍攝以珠寶、鑽石、手錶為主的小型精緻商品。

郎靜山蒞臨參觀指導莊明景首次攝影個展 / 1981
Lang Jing-shan visits Chuang's first photography solo exhibition / 1981

1980	莊明景累積近十年（1971-1980）從事商業攝影的實戰經驗，養成三種攝影職能：（1）預視化（pre-visualize）功力：指莊明景在看到設計草圖時，能夠想像出設計師的構想和客戶端想要的照片氣氛，應該是什麼樣貌的功力；（2）依需的前置操作（on demand preproduction）能力：指能夠就商品物件的特色，先做好「燈光的選擇配置」與「被攝物件與道具處置」的操作；（3）因應後製而預留的措施：指能夠了解後製人員可行的（補救）措施，以便在攝影（棚）時能夠選擇預防的、或預留給後端處置的操作。

柯錫杰蒞臨參觀指導莊明景首次攝影個展 / 1981
Ko Si-chi visits Chuang's first photography solo exhibition / 1981

1980 — 1983	辭去商業攝影師工作，走上「壯遊」攝影之路；在此期間，一方面擔任美國圖片租片公司（FPG International）的特約攝影師，同時從事自主創作，一個人開車遊歷北美洲名山勝景。 行腳足跡包括美國中西部及加拿大的國家公園、各大城市與小鎮風情以及知名景點，總計跋涉近五萬公里。

1981	年初回臺灣，於1月22至31日在臺北市南海路的美國文化中心（今二二八國家紀念館），舉行首次風景攝影個展，內容為北美洲壯遊攝影作品。莊為展現作品色彩與畫質，均採用當時專業且先進的照片沖印技術與材料，包括轉染法（Dye Transfer）、西北彩色（Cibachrome）沖印、中間負片法（Inter-negative film）、雷射掃描印像法（Laser Scanner & Printing）等四種。 首展中，蒞臨參觀指導的貴賓，除了郎靜山、柯錫杰等攝影界大師，還有莊明景就讀臺灣大學時的班導師林文月教授。 秋季，受邀隨翁萬戈伉儷，搭機從紐約飛往北京，拍攝北京故宮風貌及文物，所有作品全數作為介紹北京故宮博物院英文專書*Palace Museum: Peking, Treasures of the Forbidden City*（翁萬戈、楊柏達合著，1982年出版）的插圖之用。

林文月蒞臨參觀指導莊明景首次攝影個展 / 1981
Lin Wen-yue visits Chuang's first solo exhibition / 1981

1976
|
1980

Chuang switches to the photography track, first working at the Photo Conception Studio established by Ray Tenn, and then at the larger Ted Pobiner advertising photography company. There he shoots small, elegant items such as jewelry, diamonds and watches, but the work continues to be difficult and high-pressure.

1980

Chuang accumulates nearly 10 years of practical experience (1971~80) in commercial photography, and develops three important skills: (1) pre-visualization; (2) on-demand preproduction capability; and (3) reserving certain measures for post-production. The ability to think in these ways about the operations in photography would have a definite influence on his later independent photographic work.

1980
|
1983

Chuang quits his commercial photography job to embark on a "grand tour" in which he serves as a contract photographer for FPG International (a photo bank) in the U.S. while also engaging in his own creative work, and drives on his own through the great mountain scenery of North America.

Chuang covers nearly 50,000 kilometers on this tour, traveling to national parks in the Midwestern the U.S. and Canada as well as major cities, small towns, and well-known attractions.

1981

Chuang returns to Taiwan early in the year and holds his first solo exhibition of landscape photography at the American Cultural Center (now the National 228 Memorial Museum) on Nanhai Road, Taipei City from January 22 to 31. Advanced professional photo printing techniques for the time are used, including dye transfer, Cibachrome printing, inter-negative film, and laser scanning and printing.

In the fall, Chuang is invited to fly from New York to Beijing with Weng Wan-go and his wife to photograph the Forbidden City in Beijing and its cultural relics. Chuang's photos are used as illustrations in the English-language book *Palace Museum: Peking, Treasures of the Forbidden City*.

北京故宮博物院英文版書影
Photo of the English edition of *Palace Museum: Peking, Treasures of the Forbidden City*

| 1983 | 夏秋之交，隨同中美友好協會（翁萬戈為會長）會友接受招待，到中國（新疆絲路一帶）觀光旅行。因為久聞郎靜山作品有許多取材自黃山，莊明景第一次計畫登上黃山拍照，此後，開始黃山系列之攝影。 |

| 1983 — 2012 | 平均每年一次（聘請挑夫）攜帶逾三十公斤裝備登上黃山拍照，每次停留時間約為一個月，到2012年最後一次上山為止，前後累計登山次數達二十六次。 |

莊明景在奧林匹克國家公園野餐 / 1983
Mike Chuang picnicking in Olympic National Park /
1983

| 1984 | 於年初冬季回臺灣定居。隨即從臺北、經香港轉機到杭州，花了六天時間抵達黃山。正逢山頂上落下半世紀以來持續最久的降雪，拍攝到罕見雪景，莊明景特別將「雪」加入公認的「黃山四絕：松、石、雲、泉」景物，並稱為「黃山五絕」；回程下山時經過黃山市（舊稱「徽州」），連帶拍攝當地古建築文明（後於2003年以「徽州古意」主題做系列發表）。行程結束回臺，率先於《世界地理雜誌》第4月號第4卷第2期（總號第20期），以〈天下第一奇山：黃山遊〉為題、賀景濱撰文的三十頁篇幅封面故事中發表作品。

於11月24日在國立歷史博物館國家畫廊，舉行第二次風景攝影個展。

榮獲中山學術獎攝影獎。

12月自行出版發行《黃山天下奇：莊明景攝影集》，由郎靜山序、賀景濱專文、黃金鐘主編、大拇指出版社製作監印。郎靜山在〈序文〉中提到，1934年首次造訪黃山時的第一印象「但見飛雲時出時沒，變化在頃刻間」，這印象與莊一樣，對於天雲的變化萬千特別關注。 |

莊明景收藏的骨董與雲石 / 1987
Chuang's antiques and marble pieces / 1987

| 1985 | 於臺北春之藝廊舉行「黃山天下奇」攝影個展。

由莊明景自行設計規劃，開始整修自家位於陽明山竹子湖的日式木造老房子（1987年完工時命名為「景明莊」），作為古董收藏處所，此屋也是「徽菌與時間」參與創作的實驗場所。 |

《世界地理雜誌》以莊明景作品為封面並率先發表黃山攝影系列
Chuang's photo on the cover of *World Geography*, the first to publish his Huangshan series of photos

1983　At summer turns to autumn, Chuang and members of the China-America Friendship Association (Weng Wan-go, president) accept an invitation for a sightseeing trip to China's Xinjiang Silk Road area, after which Chuang stays in Beijing alone. As it was long known that many of photographer Lang Jing-shan's works were based on Huangshan, Chuang plans his first Huangshan climb and photo shoot, from which began his Huangshan series.

1983 | 2012　Roughly once a year, for about a month, Chuang brings more than 30 kilograms of equipment (with a porter) to Huangshan to take photos. Including his last trip in 2012, he makes a total of 26 such trips.

1984　Chuang returns to live in Taiwan in early winter, but immediately sets out again to take photos at Huangshan. He photographs a rare snow scene after the longest snowfall in half a century there, and he adds "snow" to the original "Four Wonders of Mount Huangshan"—pines, rocks, clouds, and springs, thus making five. On his return, he passes through Huangshan City (formerly "Huizhou"), and photographs its heritage architecture.

Chuang's second solo landscape photography exhibition is held on November 24 at the National Museum of History's National Gallery.

Chuang wins the Zhongshan Academic Award for Photography.

1985　Chuang holds a solo exhibition, *The Wonder of Mt. Huangshan*, at the Spring Fine Arts Gallery in Taipei

Using his own designs, Chuang renovates his old Japanese-style wooden house in Zhuzihu, Yangmingshan (naming it "Jingming Chuang" after completion in 1987). It houses his collection of antiques, and is a site for his experimental "mold and time" photography.

莊明景位於陽明山竹子湖的老房子「景明莊」外觀 / 1987
The exterior of Chuang's "Jingming Chuang" home at Zhuzaihu on Yangmingshan / 1987

| 1986 | 受內政部營建署長張隆盛邀請，開始拍攝玉山、墾丁國家公園等自然景觀，作品主要作為國家公園觀光宣傳之用。 |

二度集結黃山攝影作品，由錦繡出版社於2月出版發行《黃山之美》攝影圖文書。該書為出版社發行人許鐘榮策畫之《錦繡中華》系列叢書開卷作，標榜（叢書）定位介於畫冊與專書之間，兼具優美圖片之感性與文字資料之知性，為當時罕見針對中國大陸進行單點深度報導之圖文出版品。

《大自然》雜誌於5月號（總號第11期）中，以〈萬里繽紛：美國國家公園攝影選〉為題、三十六頁的篇幅，專題報導莊「壯遊」北美所拍攝的作品。

於臺北春之藝廊舉行「玉山觀奇」攝影個展，同時自行出版、由董陽孜封面題字的《玉山觀奇》、《風景攝影：美國國家公園之美》兩本攝影專集，兩書均委由沈氏藝術印刷公司印製，該印刷公司為國內畫冊、攝影集的重要承印廠商。

《黃山之美》圖文專書榮獲民國75年度金鼎獎之圖書類獎；該書能在七百三十四冊參選圖書競爭中脫穎而出，實屬不易。

《黃山之美》圖文專書封面書影，該書獲 1986 年金鼎獎殊榮
The cover of *The Beauty of Huangshan*, which won the Golden Tripod Award in 1986

| 1987 | 受專案委託，特約拍攝太魯閣國家公園等自然景觀，作品主要作為觀光宣傳之用。 |

前一年受委託拍攝之玉山照片，收錄於內政部營建署玉山國家公園管理處出版，謝蜀芬、陳玉峯撰文之《玉山之美》專書，專書中亦收錄阮榮助、張正雄等攝影家作品。

| 1988 | 劉秉升主編、黃山誌編纂委員會編修、黃山書社出版發行之「安徽山水誌叢書《黃山誌》」將莊明景登錄為「游山名人」（頁265），毛澤東、鄧小平、趙紫陽等名人同列其中。 |

莊明景長時間「守候」美景姿態、宛若修行，隨行挑夫為保護人身安全，特以繩索將他與樹綁連在一起 / 1980
Like a spiritual practice, Chuang adopts a posture of waiting for the right composition, tying himself to a tree for safety / 1980

| 1989 | 原定於6月取道四川、前往西藏拍照，但因逢六四天安門事件爆發的敏感期間，當地人提醒西藏現況動盪不穩、不宜前往，因而選擇留在四川，拍攝九寨溝、海螺溝等自然景觀。 |

| 1990's | 經國小同學許作立（永大電機董事長）引薦，結識時任臺北故宮博物院院長的秦孝儀先生。由於三人對於骨董與古書畫之收藏與鑽研、擁有共同雅興，遂經常一起餐敘交流相關知識。 |

與秦孝儀先生同遊黃山 / 2007
Tour Huangshan with Mr. Chin Hsiao-yi / 2007

1986　Invited by Chang Lung-sheng, Director General of the Ministry of the Interior's Construction and Planning Agency, Chuang photographs the natural landscapes of areas such as Yushan and Kenting National Park for tourism promotion purposes.

Chuang once again assembles his photographs of Huangshan for publication as *The Beauty of Huangshan* by Splendid Publishing House in February. Intended as the opening volume of a *Splendid China series* by publisher Xu Zhong-rong, it combines the appeal of beautiful photos with the informative nature of a specialist book, and is rare in Taiwan at the time as an in-depth, focused report on one aspect of China.

Chuang holds a solo exhibition, *Views of Yushan*, at the Spring Fine Arts Gallery in Taipei, and self-publishes two photo albums, *Views of Yushan and Landscape Photography—The Beauty of American National Parks*, with cover inscriptions by Grace Tong. The albums are printed by Shen's, an important art printing firm responsible for issuing many important painting and photography albums domestically.

The illustrated book *The Beauty of Huangshan* wins the 1986 Golden Tripod Award in the book category, despite competition from a total of 734 other books.

1987　Chuang receives a special engagement to photograph natural landscapes such as Taroko National Park, mainly for purposes of tourism promotion.

Photos of Yushan commissioned from Chuang the previous year are included in the book *The Beauty of Yushan*, published by the Yushan National Park Management Office under the Ministry of the Interior. Text is by Xie Shu-fen and Chen Yu-feng, with work by other photographers such as Ruan Rong-zhu and Zhang Zheng-xiong.

1988　*The Huangshan Chronicle* (in the *Anhui Mountain Chronicle Series*, Liu Bingsheng, Editor-in-chief, with the Huangshan Chronicle Compilation Committee, published by Huangshan Publishing House, p. 265) lists Chuang as a "celebrity hiker."

1989　Chuang originally plans to travel through Sichuan to Tibet in June, but in the sensitive period following the Tiananmen Square Incident of June 4, locals indicate that travel to Tibet is inadvisable. Chuang chooses instead to stay in Sichuan and photograph the natural landscapes of Jiuzhaigou and Hailuogou.

1990's　Introduced by elementary school classmate Xu Zuoli (chairman of Yongda Electric Machinery), Chuang meets Mr. Chin Hsiao-yi, director of Taipei's National Palace Museum. With a shared interest in collecting antiques, ancient calligraphy and painting, they often meet to share news and information.

《黃山誌》登錄莊明景為「遊山名人」（左頁右下）
A photo (lower right) of Chuang in the *Huangshan Chronicles*, as a "celebrity hiker"

1990 　受邀參加於臺北時代畫廊舉行之「千里莽原萬里行：柯錫杰、莊明景、吳炫三南非聯展」，該展由時報周刊、臺北時代畫廊聯合主辦，同時出版同名攝影集。

　受委託與莊靈合作拍攝《采結攀緣：陳夏生中國結新造型圖錄》專書之「中國結藝」圖片，該專書之中國結創作者陳夏生女士為莊靈夫人。

1991 　受委託拍攝之玉山照片收錄於內政部營建署玉山國家公園管理處出版，呂志廣等撰文之《玉山國家公園》簡介，以及陳列撰文之《永遠的山》專書，專書中亦收錄呂志廣、阮榮助、張正雄、蔡佰祿等攝影家作品。同年4月，《大自然》雜誌144期封面故事，以五十一頁的大篇幅介紹玉山國家公園，亦收錄莊明景等人的攝影作品。

　由游本寬、呂良遠、全會華、張蒼松、杜宗尚、鍾榮光、鐘永和、林淑卿、高志尊等人，共同發起成立「台北攝影節籌備委員會」，舉辦「1991第一屆台北攝影節」活動，莊明景受邀擔任顧問委員。

1992 　受《時報周刊》之邀擔任731期（3月1日發行）特約攝影，與簡榮泰共同跨刀拍攝封面及封面故事專題之插圖照片。此為莊明景1976年轉換商業攝影跑道、專注拍攝商品之後，睽違十六年再度拍攝肖像。

　於臺灣拍攝之〈貓鼻頭〉、〈玉山主峰〉、中國大陸拍攝之〈瀑布雲〉、〈水墨天成〉等六件作品，獲臺北市立美術館典藏。

　受委託拍攝之玉山照片收錄於「內政部營建署玉山國家公園管理處」出版、葉世文發行「玉山國家公園解說叢書」之《玉山觀石》。同一專書中，尚有李武雄、蔡佰祿、陳隆陞等攝影家作品。

　受邀參加於臺北恆昶藝廊、彩虹藝廊、誠品藝文空間等場所舉行之「'92台灣‧台灣」聯展，展覽集結臺灣一百多位攝影家在1991年所創作的作品；為「1992第二屆台北攝影節」活動之一。攝影節另一重要活動為「台灣的24小時」，邀請各領域的攝影工作者在8月19日集體創作「台灣的一天」，分別記錄全臺每個角落、每位人民的各種生活樣貌，於10月31日出版《台灣的24小時》攝影專集。

1990 Chuang and photographer Chuang Ling jointly shoot photos of Chinese knot art in the book *Knot-tying and Climbing—Chen Xia-sheng's New Models for Chinese Knots.* Chuang Ling's wife, Chen Xia-sheng, creates the Chinese knots in the book.

1991 Photos of Yushan commissioned from Chuang are included in *Yushan National Park*, written by Lu Zhi-guang et. al. and published by the Yushan National Park Management Office under the Ministry of the Interior, as well as the book *Forever Mountain* by Lu Zhi-guang, which includes photos by Lu Zhi-guang, Ruan Rong-zhu, Zhang Zheng-xiong and Cai Bai-lu. In April, the 144th issue of *Nature* magazine features Yushan National Park in a large spread of 51 pages, with photographs by Chuang and others.

1992 *The China Times Weekly* engages Chuang for its march 1, 731st issue, and together with Jian Rongtai, they shoot photos for the cover and the cover story, marking the first time in 16 years, since beginning to shoot products as a commercial photographer in 1976, that Chuang shoots a portrait photo.

Six works, including *Mobitou* and *Yushan's Central Peak*, shot in Taiwan, and *Waterfall Mist and Ink Painting*, shot in China, are collected by the Taipei Fine Arts Museum.

Photos of Yushan commissioned from Chuan are included in *Viewing Stones at Jade Mountain* from the *Understanding Yushan National Park Series* published by the Yushan National Park Management Office under the Ministry of the Interior and issued by Ye Shiwen. The book also includes works by photographers Li Wu-xiong, Cai Bai-lu and Chen Long-sheng.

1993	受邀擔任「1993第三屆台北攝影節」顧問委員。本屆舉辦的系列活動之一，為前一年「台灣的24小時」集體攝影創作的成果作品展，於7月17至25日在臺北市立美術館、9月28日至10月4日在日本東京銀座Nikon藝廊等場所巡迴展出。
1994	受邀於「1994第四屆台北攝影節」系列活動中，以「深入西藏」為題主講青藏高原的攝影經歷，此為莊明景西藏攝影作品之首度對外公開。
1994 — 1995	參與林添福帶領的旅遊攝影團隊，走滇藏公路進入西藏拍攝，從昆明出發，沿途經過虎跳峽、德欽，拍攝梅里雪山山脈（含主峰「卡瓦格博峰」）等地。
1995	參與舉辦「台北攝影節籌備委員會」的成員，於1月22日正式成立「中華攝影文化協進會」社團，首屆理事長為杜宗尚，莊明景當選首屆常務監事，會務宗旨仍以籌辦「台北攝影節」活動為主。 原亦藝術空間出版發行《玉山風雲》、《黃山奇景》、《西藏風采》系列明信片。 受邀於「1995第五屆台北國際攝影節」系列活動之「面對名家」活動中，擔任風景攝影主題類指導老師，提供後進攝影愛好者相關專業諮詢。 受邀於中華攝影教育學會主辦之「自然與人為的對話：1995年學術研討會」系列活動之「風景攝影名家作品發表與座談」中，以「善用617全景機」為題分享全景搖攝（panorama）相機與120或135相機搭配廣角鏡頭拍照的差異。
1996	針對前一年於「自然與人為的對話：1995年學術研討會」主講之「善用617全景機」議題，莊明景另寫專文發表於《影像雜誌》第20期；該期雜誌以〈風景攝影專號〉為題，係改版為MOOK（Magazine＋Book）編輯型態後之首期發行。 於1月6日至2月16日在原亦藝術空間舉行「黃山、桂林黑白攝影個展」，同時出版發行《水墨天成》、《桂林山水》（雙黑印刷）套裝圖片集。 受邀於誠品書店敦南店舉行的「1996第一屆台北國際攝影節」系列活動之攝影講座中，以「徽州古情（中國老房子）」為題，首度公開分享「徽派建築攝影」作品。

莊明景拍攝印度石窟的工作照 / 1996
Mike Chuang photographing caves in India / 1996

1993　Chuang is invited to serve on the advisory committee for the 1993 3rd Taipei Photography Festival. One of the festival's activities is an exhibition of works from the previous year's collective photography project, "Taiwan in 24 Hours," which is shown on tour at locations such as the Taipei Fine Arts Museum and the Nikon Gallery in Ginza, Tokyo.

1994　Chuang gives a lecture on the experience of photographing in the Qinghai-Tibet Plateau with the title *Deep into Tibet* at the 4th Taipei Photography Festival in 1994.

1994

1995　Chuang joins a photography team led by Lin Tian-fu, which takes the Yunnan-Tibet Highway into Tibet. Starting from Kunming, they pass Tiger Leaping Gorge and Deqin and photograph the Meili Snow Mountain Range, including Kawagebo Peak.

1995　Members of the Taipei Photography Festival Preparatory Committee establish the Chinese Photography Culture Association on January 22. Its first director-general is Du Zong-shang, and Mike Chuang its first director of general affairs. The Association's main purpose is organizing Taipei Photography Festival activities.

Yuanyi Art Space publishes a postcard series, including *Yushan in Wind and Cloud*, *Amazing Huangshan Scenery* and *The Look of Tibet*.

Chuang is invited to serve as a landscape photography instructor for the "Face to Face with Famous Artists" activity at the 1995 *5th Taipei International Photography Festival*, providing professional consultation for young photographers.

Chuang is invited to give a talk on the use of the 617 panoramic camera as part of the *Discussion and Presentation of Famous Landscape Photographers' Works* series at the *Dialogue between the Natural and the Man-made – 1995 Academic Symposium* organized by the Chinese Society of Photography Education, in which he explains the differences between a panoramic camera and a 120 or 135 camera with a wide-angle lens.

1996　Chuang writes a special essay on the topic of using the 617 panoramic camera that he had addressed in the symposium the previous year, which is published in the 20th issue of *IMAGE* magazine; that issue is given the title "Landscape Photography Special Issue," the first issue to be released in the magazine's new MOOK (Magazine + Book) format.

Chuang's *Huangshan, Guilin Black and White Photography Solo Exhibition* is held from January 6th to February 16th in the Yuanyi Art Space, and at the same time, *Ink Painting* and *Guilin Landscapes* (in double black printing) are published.

Chuang is invited to take part in the *1996 1st Taipei International Photography Festival* series of lectures at the *eslite Dunnan* bookstore, and presents *Ancient Huizhou (Old Chinese Houses)*, in which he publicly shares photographs of the Huizhou style of architecture for the first time.

| 1996
｜
1998 | 出任由林淑卿創立的原亦藝術空間之藝術總監一職，期間參與承辦並指導由行政院文化建設委員會贊助之《臺灣攝影年鑑》編撰作業。 |

《無盡的影像》專集封面書影
Cover of the *Endless Images* photo album

| 1998 | 受邀參加於國立歷史博物館舉行之「傾聽大地的心跳：風景十三人聯展」，該展為「1998第二屆台北國際攝影：風景與人的合一」系列活動之一，參展者尚有張武俊、莊慶祿、余榮欽等國內名家。 |

於2月7－15日在爵士攝影藝廊舉行「無盡的影像」攝影個展，同時發行由原亦藝術空間出版之《無盡的影像：莊明景攝影集》專集。

創立大天地藝術坊擔任負責人，經營圖片版權授權事務並接受委託專案攝影。該位於臺北市敦化南路（後遷移至長春路）的藝術坊空間，於次年兼作展示空間之用，取名為「台北攝影中心」。

| 1999 | 《無盡的影像》系列之作品〈雜貨店〉獲國立臺灣美術館典藏。 |

| 2000 | 受邀參加世界攝影家「聚焦北京」攝影活動，該活動係因北京為申辦2008年夏季奧林匹克運動會之宣傳所需，邀集全球攝影師以一週的時間進行拍攝。莊明景與林添福是此活動中，唯二受邀參加的臺灣攝影家。 |

《青藏高原》專集封面書影
Cover of the *Qinghai-Tibet Plateau* photo album

於臺北攝影中心舉行「青藏高原」攝影個展，同時以個人創立之大天地藝術坊出版《青藏高原》攝影專集，封面書名委請史忠貴題字，收錄的作品包含1989年起十二年來，多次深入川、藏的攝影，除了青海湖、九寨溝、岡仁波齊神山、瑪旁雍錯湖等自然景觀，還有古格王朝歷史遺跡、生活環境等人文風采。莊明景在〈前言〉中指出，青藏高原攝影之旅，是他個人攝影生涯最豐富之旅，並以「秘／淨」二字，形容青藏高原為香格里拉之境。

1996
|
1998 Chuang serves as artistic director of the Yuanyi Art Space, founded by Lin Shu-qing, and assists in preparing the *Taiwan Photography Yearbook* sponsored by the Council for Cultural Affairs of the Executive Yuan.

1998 Chuang participates in the *Listening to the Heartbeat of the Earth-Thirteen Scenic Artists Group Exhibition* at the National Museum of History, as part of the *2nd Taipei International Photography Exhibition-The Unity of Landscape and People*.

Chuang's *Endless Images* solo exhibition is held at the Jazz Image Gallery, February 7th to 15th, while the album *Endless Images – Mike Chuang Photography Collection* is published by Yuanyi Art Space.

Chuang establishes the Da Tian Di Art Workshop, handling image copyright licensing and commissioned photography projects. Originally located on Dunhua South Road in Taipei, it later moves to Changchun Road; the following year, renamed the Taipei Photography Center, it is also used as an exhibition space.

1999 The work *General Store* from the *Endless Images* series is collected by the National Taiwan Museum of Fine Arts.

2000 Chuang is invited to participate in the "Focus on Beijing" event in connection with Beijing's bid to host the 2008 Summer Olympic Games. Photographers from around the world are invited to shoot for a week, and provided with an official car and driver as well as all expenses such as food and lodging, consumables, and photo developing costs. Mike Chuang and Lin Tian-fu are the only two Taiwanese photographers invited to participate.

Chuang holds the solo photography exhibition *Qinghai-Tibet Plateau* at the Taipei Photography Center, while also publishing the photo album *Qinghai-Tibet Plateau* through his own Da Tian Di Art Workshop, with the title inscription on the cover by Shi Zhong-gui. The album includes works taken in the 12 years after 1989 in Sichuan and Tibet, with landscapes from Qinghai Lake, Jiuzhaigou, Mount Kailash, and Lake Manasarovar, as well as cultural features such as the historical remnants of the Guge Kingdom and the area's living environment. Chuang indicates in the preface that the journey to the Qinghai-Tibet Plateau was the most enriching of his career; he describes the area as a kind of Shangri-La with the two words, "secret/purity."

秦孝儀先生特別致贈親筆（篆體）墨寶「天之涯、地之角」以為紀念。

受邀參加於國立國父紀念館舉行之「從傳統攝影到數位影像：醇化百年攝影史．營造影像創造力」聯展，展覽係「2000第三屆台北攝影節」活動之一，內容集結海內外一百多位攝影家的作品，為攝影節擴大為國際性活動以來，國外攝影師參展人數最多（逾半百）的展出。

《徽州古意》專集封面書影
Cover of the *Huizhou's Ancient Ways* photo album

2001　從1980年開始「壯遊」攝影滿二十年之際，接受賴素鈴專訪，首度向媒體公開陽明山宅邸「景明莊」頗具規模的骨董收藏，包含家具、陶瓷、唐卡、雲石等，其中尤以「雲石」為焦點、暢談石頭紋理與黃山雲彩之間的微妙連結。訪問中，莊回顧一路走來的攝影生涯（包含八十餘次的大陸行腳），雖然辛苦，但內在豐富。

2003　於誠品敦南店藝文空間舉行「黃山意境、徽州古意」黑白攝影個展，由秦孝儀先生蒞臨開幕剪綵；同時出版由秦孝儀封面題字之《黃山意境》、《徽州古意》兩本攝影專集。其中，《徽州古意》主題系列，係莊每次拍攝黃山回程時、經過徽州，聚焦於徽派風格建築的攝影集結。

李蕭錕著述的色彩學應用專書《台灣色》，由藝術家出版社策劃出版，書中收錄莊明景、郭東泰、劉伯樂、林枝旺等的攝影作品。

《黃山意境》專集封面書影
Cover of the *Artistic Conceptions of Huangshan* photo album

2004　於太魯閣國家公園拍攝之〈神祕谷〉、以全景（panorama）相機所拍攝之〈玉山全景〉獲國立臺灣美術館典藏。

8月，二度出版青藏高原攝影專集《緣在青藏高原：攝影紀行》。此書較前次更多人文風采，例如古格王朝遺址、康巴藝術節、雲南麗江市集、藏傳寺廟等，莊明景也透過文字記錄探訪旅程的艱辛與新奇，呈現當地神祕而多元的風貌。

黃山空氣潔淨，一年四季均為莊明景取鏡時機 / 1990's
The clean air on Huangshan allows Chuang to take photos year round / 1990s

Chuang dines with Chin Hsiao-yi, who presents him with a calligraphy work in his own hand, which reads, "The end of the sky, the far corners of the Earth."

Chuang participates in the joint exhibition, *From Traditional Photography to Digital Image - A Century of Photography History; Building Image Creativity* at the National Sun Yat-sen Memorial Hall, as part of the 3rd Taipei Photography Festival. The works of more than 100 photographers are shown, including over 50 foreign photographers, the largest number since the festival became an international event.

2001 Twenty years after beginning his "grand tour" of photography in 1980, Chuang accepts an exclusive interview and reveals the large antique collection at his Yangmingshan home, named "Jingming Chuang," which includes furniture, ceramics, thangka, and marble pieces. Focusing on the veined marble, he discusses the subtle connections between its texture and the clouds on Mount Huangshan.

2003 Chuang holds a black and white photography solo exhibition, *Artistic Conceptions of Huangshang; Huizhou's Ancient Ways*, at the eslite Dunnan bookstore. Chin Hsao-yi cuts the ribbon to open the exhibit, while two related photo albums are published, with cover inscriptions by Chin Hsao-yi. The photo album *Huizhou's Ancient Ways* focuses on the architecture that Chuang photographed passing through Huizhou as he returned from his Huangshan expeditions.

Taiwan Colors, a book on applying color theory by Li Xiao-kun, is published by Artist Publishing Co., and includes photographs by Mike Chuang, Kuo Tung-tai, Liu Bo-le, and Lin Zhi-wang.

2004 *Mysterious Valley*, shot in Taroko National Park, and *Jade Mountain Panorama*, shot with a panoramic camera, are collected by the National Taiwan Museum of Fine Arts.

In August, a second album of photography on the Qinghai-Tibet Plateau is published, this one more humanitarian, including photos of the ruins of the Guge Kingdom, the Kangba Art Festival, the market in Lijiang, Yunnan, and Tibetan temples.

莊明景曾經使用過與收藏的（骨董）相機與雲石 / 孫耀天攝 / 2022
Chuang's antique cameras and marble pieces / photo by Porsche Sun / 2022

《甲子風景》專集封面書影
Cover of the *Sixty Years of Landscape* photo album

2006　受邀參展由「台北市文化藝術促進協會」與北京「中華文化聯誼會」、「中國藝術攝影學會」聯合主辦之「彼岸・看見：臺灣攝影二十家1928-2006」展覽，該展集結臺灣老、中、青三代攝影家之兩百餘件作品，多元呈現臺灣攝影的精粹面貌，於北京中國美術館、上海市立圖書館巡迴展出。配合展覽發行《看見世紀光影：臺灣攝影二十家1928-2006》專集。

於天使美術館舉行「甲子風景」攝影精選展，同時出版《甲子風景：莊明景攝影精選》攝影專集，由秦孝儀封面書名題字、天使美術館館長賴麗純作序。

經攝影同好的引薦，看到北海岸的老梅綠石槽景致，而為之驚豔，自此開啟了《老梅海石》系列的攝影紀錄。儘管當地特色景觀範圍只有大約一公里的海岸線，但僅在此後七年間，即前往老梅海岸拍攝礁岩超過百次以上。

2007　受天使美術館館長賴麗純邀請，拍攝《貓系列》於9月在線上展出三十件作品。

2008　受委託赴大陸為企業拍攝「電梯」宣傳照，因為現場光線很暗，唯恐畫質不佳影響交件期程，基於現場校正之需，開始使用數位相機拍照（同步使用傳統軟片攝影作為備份）；接著，為了自行修色而使用Photoshop做後製，自此開啟數位攝影之路。除了逐漸轉向以數位相機攝取原生影像，還從過去保存的底片中，予以掃描再經後製軟體賦予新生。

2011　受邀參加於3月26日至6月26日在臺北市立美術館舉行之「時代之眼：臺灣百年身影」聯展。該展係臺北市文化局為慶祝中華民國建國百年所規劃的系列活動之一，由莊靈、張蒼松共同策展並選件，內容集結一百一十七位攝影家之二百七十一件作品，為歷來規模最大的臺灣攝影史展覽。

2006　Chuang participates in the exhibition, *The Other Shore/Seeing— Twenty Taiwan Photographers, 1928–2006,* organized by the Taipei Arts Promotion Association, Beijing's China Friendship Association of Cultural Circles, and the China Artistic Photography Society. More than 200 works by three generations of Taiwanese photographers present the essence of Taiwanese photography; the exhibition is shown at the National Art Museum of China and the Shanghai Municipal Library. A photo album, *Seeing the 20th Century's Lights and Shadows – Twenty Taiwanese Photographers, 1928–2006* is issued.

The Sixty Years of Landscape photography exhibition is held at the Angel Art Museum, and a photo album, *Sixty Years of Landscape – A Selection of Photographs by Mike Chuang* is published. Divided into Taiwan, North America, China, and Huangshan sections, it emphasizes that landscape photography is the pursuit of the perfect combination of "atmosphere" and "earth."

After a recommendation from a fellow photographer, Chuang is amazed by the Laomei Green Reefs on the north coast. He begins taking the photographs in his *Laomei Ocean Rocks* series. While this special landscape covers only a kilometer of coastline, Chuang travels to Laomei to photograph the reefs more than 100 times over the next seven years.

2007　At the invitation of Lai Li-chun, director of Angel Art Museum, Chuang shoots his *Cat Series* and shows 30 works online in September.

2008　Chuang is engaged to take publicity photos of elevators for a company in China. Because bad lighting on site might affect picture quality and delivery times, he uses a digital camera to edit on-site. Then he uses Photoshop for post-production color correction, and thus sets out on the road to digital photography.

2011　Chuang participates in the *Eye of the Times: Centennial Images of Taiwan* group exhibition at the Taipei Fine Arts Museum from March 26th to June 26th, one of the events planned by the Taipei City Department of Cultural Affairs to celebrate the centenary of the Republic of China's founding. Curated by Zhuang Ling and Zhang Cangsong, it features 271 works by 117 photographers, the largest photographic history exhibition in Taiwan.

2012　受委託拍攝之玉山照片，刊登在2012年版《玉山國家公園》簡介之封面與封面裡，該書由陳隆陞、林文和、陳玉釧撰文從早年拍攝荷花照片在後製軟體進行二創的經驗中，感受到數位科技應用在攝影創作的無限可能性，驚豔於它的不可預期性所帶來的美感延伸，從而將創作主力，逐漸轉向讀取檔案結合後製的嘗試，《繪影》系列的創作自此開展。

2013　受委託拍攝廣東佛山石灣陶藝家廖洪標之陶塑創作，該系列（交趾陶）作品於6月在國立歷史博物館「石灣陶魂：廖洪標陶塑藝術」公開展覽，莊明景拍攝之陶藝照片均收錄於同步出版的展覽專集中。

受邀參展由國立臺灣博物館、台灣攝影博物館文化學會聯合主辦之「鏡觀寶島 山·河──攝影家眼裡的臺灣大地」展覽。

於6月25日至9月23日在Epson影像藝廊舉行「禪荷繪影」攝影展，此為荷花《遊創》系列的集結。

參加於2014年11月7至10日在臺北華山文化創意產業園區舉行的「2014台北藝術攝影博覽會」莊明景首次發表《遊創》階段作品。

2015　發行《老梅海石：莊明景風景攝影集》，由李義弘封面題字、大天地藝術坊出版。內容集結2006年迄今，上百次前往老梅拍攝的作品。

於11月20至23日在臺北華山文化創意產業園區舉行的「2015台北藝術攝影博覽會」中，莊亦主打《老梅海石》系列作品。

畫家黃志超曾在參觀莊明景展覽中，表達購藏照片之意，莊原意無償贈與，並為其拍攝「畫室即景」，畫家以一幅黃山油畫（參考莊的黃山照片為原型）之作品回贈莊，以表致謝之意。

《老梅海石》專集封面書影
The cover of the *Laomei Reefs* photo album

2016　〈莫諾湖（美國加州）〉、〈黃山意境〉、〈徽派建築〉、〈太魯閣〉、〈玉山〉、〈墾丁〉、〈老梅〉等三十七件作品獲「國立臺灣博物館」（簡稱「臺博館」）典藏。這些作品原為「臺博館」所轄之「國家攝影文化中心臺北館（籌備處）」所購藏，藏品亦移交由「國家攝影文化中心」典藏。

《石灣陶魂：廖洪標陶塑藝術》專集封面書影
The cover of *the Soul of Shiwan Ceramics – Liao Hongbiao's Ceramic Sculpture Art* photo album

2012　A Yushan photo commissioned from Chuang is published on the cover and inside sleeve of the 2012 edition of *Yushan National Park* by Chen Long-sheng, Lin Wen-he, and Chen Yu-chuan.

2013　Chuang is commissioned to photograph ceramic sculpture by artist Liao Hong-biao of Shiwan, Foshan, Guangdong. His series of Cochinware works are shown in June in the exhibition, *The Soul of Shiwan Ceramics – Liao Hongbiao's Ceramic Sculpture Art*, at the National Museum of History. Chuang's photos appear in the exhibition album.

Chuang participates in the exhibition, *The View of Formosa's Landscape from Photographers*, organized by the National Taiwan Museum and the Taiwan Photographic Museum and Culture Society.

From June 25th to September 23rd, *the Zen Lotus Painted Images* exhibition, a selection from Chuang's *Lotus Creative Roaming series*, is held at the Epson Image Gallery.

2015　*The Laomei Reefs – A Mike Chuang Landscape Photography Collection* is issued, with a cover inscription by Li Yi-hong and published by Da Tian Di Art Workshop, showing photos from Chuang's more than 100 trips to Laomei since 2006. Chuang loves the scenery of its intertidal zone: The rising and falling tides and the impact of the waves and the sea and sky turning the same color at sunrise and sunset, in beautifully integrated scenes that reveal a natural heritage worthy of cherishing.

2016　Thirty-seven works are purchased by the Taipei preparatory office of the National Center of Photography and Images for the collection of its parent organization, the National Taiwan Museum. Works purchased include *Mono Lake (California), Artistic Conceptions of Huangshan, Huizhou Architecture, Taroko, Yushan, Kenting*, and *Laomei*.

左圖為莊明景紀錄黃志超畫室（經電腦後製調色）的景況，右圖為黃志超回贈交換的油畫作品
At left: Chuang's photo of Huang Zhichao's studio (after post-processing and color grading). At right: The oil painting given by Huang Zhi-chao in exchange

2016	受邀參展由臺博館、臺北駐日代表處臺灣文化中心聯合主辦之「影耀寶島‧攝影家眼裡的臺灣大地（II）」展覽，該展是繼2013年「鏡觀寶島 山‧河——攝影家眼裡的臺灣大地」之後的第二回合展出，內容以臺灣的山、海、河、平原、農村（兼及風土民情）為主軸。
— 2017	

2017　在赴日拍攝行程中意外受傷。自此，有感於年事已高、體力大不如前，不適宜出國拍照，決定（暫時）中止出國拍攝計畫，將鏡頭觸角回歸臺灣，也投入更多時間嘗試發展電腦後製效果。但即使傷後行動略有不便，莊明景仍會與攝影同好莊哲祥（負責交通事宜與八千萬畫素大片幅數位機背之器材整備）同行外拍。

2019　受邀於12月13至22日在臺北松山文創園區「天涯海角攝影展」，該展係由莊明景領軍，集合十一位不同領域的專家，以愛護自然、關注環境生態為議題，所共同展出「地球上不同角落」的照片。

2020　於天使美術館舉行「莊明景藝術影像特展」，其中包含《繪影》系列新創之作的公開發表。

2021　作品被選入黃建亮策展的「臺灣的模樣」展覽，該展以臺灣文化脈絡的思考為主軸，於國家攝影文化中心展出。

2021	位在大陸黃山的獅林酒店為祝賀莊明景八十大壽，於飯店藝術迴廊舉辦為期半年的黃山攝影展。
— 2022	於臺北銀河94藝文空間，與郭英松、莊哲祥舉辦「藝術攝影聯展」。

2016 — 2017 Chuang participates in the exhibition *The View of Formosa's Landscape from Photographers II*, following up the 2013 exhibition, jointly held by the National Taiwan Museum and the Taipei Economic and Cultural Representative Office in Japan.

2017 Chuang is injured in an accident during a trip to Japan for a photo shoot, and feels that such trips abroad may be less suitable now in light of his advancing age and physical condition. He temporarily suspends his plans for overseas work and returns his focus to Taiwan, investing more time in developing computer post-production effects.

2019 Chuang participates in *The Ends of Earth and Sea Photography Exhibition* at the Taipei Songshan Cultural and Creative Park from December 13 to 22. Led by Chuang, the exhibition brings together experts in 11 different fields, with the theme of caring for nature and the ecology. Together they exhibit photographs, entitled *Different Corners of the Earth.*

2020 *The Mike Chuang Art Image Exhibition* is held at the Angel Art Gallery, including public presentation of new works in the *Painting Images* series.

2021 Chuang's work is selected for the exhibition *Emerging Taiwanese Cultural Landscape*, curated by Albert J.L. Huang, focusing on the consideration of Taiwan's cultural fabric and shown at the National Center of Photography and Images.

2021 — 2022 Chuang participates in the *Art Photography Joint Exhibition* with Kuo Yingsong and Zhuang Zhexiang at the Galaxy 94 Art and Culture Space in Taipei.

莊明景拍攝外澳的工作照 / 2020
Mike Chuang photographing in Wai'ao / 2020

莊明景簡歷

1942年出生於臺北，臺灣
現居住於臺北，臺灣

個展選錄

2021-2022　「莊明景黃山攝影展」，「獅林酒店」藝術迴廊，安徽黃山，中國
2020　　　「莊明景藝術影像特展」，天使美術館，臺北，臺灣
2013　　　「禪荷繪影攝影展」，Epson影像藝廊，臺北，臺灣
2006　　　「甲子風景」攝影精選展，天使美術館，臺北，臺灣
2003　　　「黃山意境、徽州古意黑白攝影展」，誠品敦南店藝文空間，臺北，臺灣
2000　　　「青藏高原」個展，台北攝影中心，臺北，臺灣
1998　　　「無盡的影像——從具象到抽象」個展，爵士攝影藝廊，臺北，臺灣
1996　　　「黃山、桂林黑白攝影個展」，原亦藝術空間，臺北，臺灣
1986　　　「玉山觀奇」個展，春之藝廊，臺北，臺灣
1985　　　「黃山天下奇」個展，春之藝廊，臺北，臺灣
1984　　　「莊明景風景攝影展」，國立歷史博物館，臺北，臺灣
1981　　　「莊明景風景攝影展」，二二八國家紀念館，臺北，臺灣

聯展選錄

2021　　　「莊明景、郭英松、莊哲祥藝術攝影聯展」，銀河94藝文空間，臺北，臺灣
2021　　　「臺灣的模樣」，國家攝影文化中心臺北館，臺北，臺灣
2019　　　「天涯海角攝影展」，松山文創園區，臺北，臺灣
2016　　　「影耀寶島——攝影家眼裡的臺灣大地(II)」巡迴展，臺灣、日本
2013-2015　「鏡觀寶島 山·河——攝影家眼裡的臺灣大地」巡迴展，臺灣、美國
2011　　　「時代之眼——臺灣百年身影」展，臺北市立美術館，臺北，臺灣
2006　　　「彼岸·看見——臺灣攝影二十家1928-2006」巡迴聯展，北京中國美術館，中國
2000　　　「從傳統攝影到數位影像——醇化百年攝影史·營造影像創造力」聯展，國立國父紀念館，臺北，臺灣
1998　　　「傾聽大地的心跳——風景十三人展」，國立歷史博物館，臺北，臺灣
1990　　　「千里莽原萬里行——柯錫杰、莊明景、吳炫三南非聯展」，臺北時代畫廊，臺北，臺灣

作品典藏

2021　　　〈莫諾湖〉、〈黃山意境〉、〈徽派建築〉、〈太魯閣〉、〈玉山〉、〈墾丁〉、〈老梅〉，總計
　　　　　三十七件作品，國家攝影文化中心，臺灣
2004　　　〈神秘谷（太魯閣）〉、〈玉山全景〉，國立臺灣美術館，臺中，臺灣
1999　　　〈雜貨店〉，國立臺灣美術館，臺中，臺灣
1992　　　〈貓鼻頭〉、〈玉山主峰〉、〈瀑布雲〉、〈水墨天成〉，總計六件作品，臺北市立美術館，臺北，臺灣

Mike Chuang (Chuang Ming-jing) Biography

Born in 1942 in Taipei, Taiwan

Living in Taipei, Taiwan

Solo Exhibitions (Selected)

2021-2022 *Mike Chuang Huangshan Photography Exhibition*, Huangshan Shilin Hotel, Huangsha, China

2020 *Mike Chuang Art Image Exhibition*, Angel Art Gallery, Taipei, Taiwan

2013 *Mike Chuang Zen Lotus Painted Images Exhibition*, Epson Image Gallery, Taipei, Taiwan

2006 *Sixty Years of Landscape Photography Exhibition*, Angel Art Museum, Taipei, Taiwan

2003 *Artistic Conceptions of Huangshang; Huizhou's Ancient Ways*, Eslite Dunnan Bookstore, Taipei, Taiwan

2000 *Qinghai-Tibet Plateau* solo exhibition, Taipei Photography Center, Taipei, Taiwan

1998 *Endless Images* solo exhibition, Jass Image Gallery, Taipei, Taiwan

1996 *Huangshan, Guilin Black and White Photography* Solo Exhibition, Yuanyi Art Space, Taipei, Taiwan

1986 *Views of Yushan* solo exhibition, Spring Gallery, Taipei, Taiwan

1985 *The Wonder of Mt. Huangshan* solo exhibition, Spring Fine Art Gallery, Taipei, Taiwan

1984 *Mike Chuang Landscape Photography Exhibition*, National Museum of History, Taipei, Taiwan

1981 *Mike Chuang Landscape Photography Exhibition*, National 228 Memorial Museum, Taipei, Taiwan

Group Exhibitions (Selected)

2021 *Mike Chuang, Kuo Yingsong and Zhuang Zhexiang Art Photography Joint Exhibition*, Galaxy 94 Art and Culture Space, Taipei, Taiwan

2021 *Emerging Taiwanese Cultural Landscape*, National Center of Photography and Images, Taipei, Taiwan

2019 *The Ends of Earth and Sea Photography Exhibition*, Songshan Cultural and Creative Park, Taipei, Taiwan

2016 *The View of Formosa's Landscape from Photographers II*, Taiwan and Japan

2013-2015 *The View of Formosa's Landscape from Photographers*, Taiwan and the U.S.

2011 *Eye of the Times: Centennial Images of Taiwan,* Taipei Fine Arts Museum, Taipei, Taiwan

2006 *The Other Shore/Seeing—Twenty Taiwan Photographers, 1928–2006*, National Art Museum of China, Beijing, China

2000 *From Traditional Photography to Digital Image—A Century of Photography History; Building Image Creativity*, National Dr. Sun Yat-sen Memorial Hall, Taipei, Taiwan

1998 *Listening to the Heartbeat of the Earth—Thirteen Scenic Artists Group Exhibition*, National Museum of History, Taipei Taiwan

1990 *Thousand Mile Savannah Journey—A Ko Si-chi, Mike Chuang, and A-sun Wu South Africa Joint Exhibition*, Taipei Times Gallery, Taiwan

Collections

2021 Thirty-seven works, including *Mono Lake* (California), *Artistic Conceptions of Huangshan, Huizhou Architecture, Taroko, Yushan, Kenting, and Laomei*, National Center of Photography and Images, Taiwan

2004 *Mysterious Valley* (Taroko National Park), *Jade Mountain Panorama*, National Taiwan Museum of Fine Arts, Taichung, Taiwan

1999 *General Store*, National Taiwan Museum of Fine Arts, Taichung, Taiwan

1992 Six works, including *Mobitou*, Yushan's *Central Peak, Waterfall Mist and Ink Painting*, Taipei Fine Arts Museum, Taipei, Taiwan

〈蘭嶼（勢與穩）〉
臺灣 / 1968
Lanyu (Power & Stability)
Taiwan / 1968
P.60

〈蘭嶼（轉與凝）〉
臺灣 / 1968
Lanyu (Turning & Condensation)
Taiwan / 1968
P.61

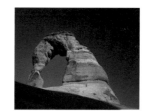

〈拱門國家公園（勢與點）〉
美國猶他州 / 1982
Arches National Park (Power & Focal Point)
Utah, the U.S. / 1982
P.82

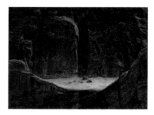

〈拱門國家公園（容與穩）〉
美國猶他州 / 1982
Arches National Park (Enfolding & Stability)
Utah, the U.S. / 1982
P.83

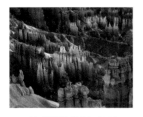

〈布萊斯峽谷國家公園〉
美國猶他州 / 1982
Bryce Canyon National Park
Utah, the U.S. / 1982
P.84

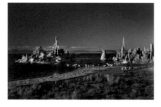

〈莫諾湖〉
美國加利福尼亞州 / 1982
Mono Lake
California, the U.S. / 1982
P.85

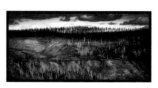

〈阿拉斯加州〉
美國 / 1982
Alaska
the U.S. / 1982
PP.110-111

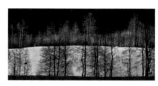

〈落磯山國家公園〉
美國科羅拉多州 / 1982
Rocky Mountain National Park
Colorado, the U.S. / 1982
P.112

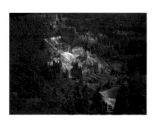

〈布萊斯峽谷國家公園〉
美國猶他州 / 1982
Bryce Canyon National Park
Utah, the U.S. / 1982
P.132

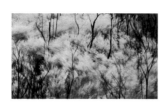

〈亞利桑納州（凝與流）〉
美國 / 1982
Arizona (Condensation & Flow)
the U.S. / 1982
P.133

〈紀念碑谷（漸與點）〉
美國亞利桑納州 / 1982
Monument Valley
(Permeation & Focal Point)
Arizona, the U.S. / 1982
P.139

〈黃轉經輪（西藏）〉
中國 / 1983
Prayer Wheels (Tibet)
China / 1983
P.77

〈紀念碑谷（質與約）〉
美國亞利桑納州 / 1983
Monument Valley (Texture & Restriction)
Arizona, the U.S. / 1983
PP.86-87

〈黃石國家公園〉
美國懷俄明州 / 1983
Yellowstone National Park
Wyoming, the U.S. / 1983
P.88

〈新罕布夏州〉
美國 / 1983
New Hampshire
the U.S. / 1983
P.89

〈優勝美地國家公園〉
美國 / 1983
Yosemite National Park
the U.S. / 1983
P.113

〈黃山（漸與點）〉
中國 / 1983
Huangshan (Permeation & Focal Point)
China / 1983
P.125

〈黃山〉
中國 / 1983
Huangshan
China / 1983
PP.130-131

〈亞利桑納州〉
美國 / 1983
Arizona
the U.S. / 1983
P.136

〈送客松〉
中國黃山 / 1984
The Greeting Pine
Huangshan, China / 1984
P.70

〈黃山（紛與覆）〉
中國 / 1984
Huangshan (Disparity & Coverage)
China / 1984
P.99

〈黃山（轉與易）〉
中國 / 1984
Huangshan (Turning & Change)
China / 1984
P.102

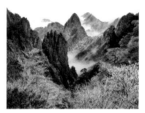

〈黃山（勢與紛）〉
中國 / 1984
Huangshan (Power & Disparity)
China / 1984
P.103

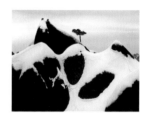

〈黃山〉
中國 / 1984
Huangshan
China / 1984
P.140

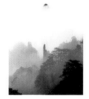

〈黃山〉
中國 / 1985
Huangshan
China / 1985
P.71

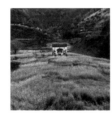

〈安徽〉
中國 / 1985
Anhui
China / 1985
P.137

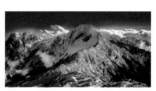

〈玉山（勢與利）〉
臺灣 / 1986
Yushan (Power & Sharpness)
Taiwan / 1986
PP.62-63

〈墾丁（紛與覆）〉
臺灣 / 1986
Kenting (Disparity & Coverage)
Taiwan / 1986
P.64

〈佳樂水〉
臺灣 / 1986
Jialeshuei
Taiwan / 1986
P.65

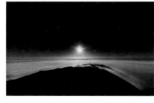

〈玉山（點與穩）〉
臺灣 / 1986
Yushan (Focal Point & Stability)
Taiwan / 1986
PP.92-93

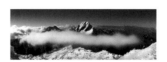

〈玉山（凝與流）〉
臺灣 / 1986
Yushan (Condensation & Flow)
Taiwan / 1986
PP.94-95

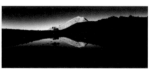

〈大水窟山〉
臺灣 / 1986
Dashuiku Mountain
Taiwan / 1986
PP.96-97

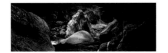

〈太魯閣（容與穩）〉
臺灣 / 1988
Taroko (Enfolding & Stability)
Taiwan / 1988
PP.66-67

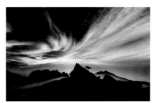

〈黃山〉
中國 / 1988
Huangshan
China / 1988
P.72

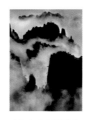

〈黃山（容與融）〉
中國 / 1988
Huangshan (Enfolding & Merging)
China / 1988
P.99

〈宏村〉
中國安徽省黟縣 / 1989
Hongcun
Yi County, Anhui Province, China / 1989
P.74

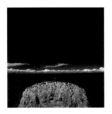

〈青海湖（約與穩）〉
中國 / 1989
Qinghai Lake (Restriction & Stability)
China / 1989
P.79

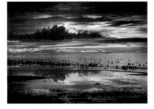

〈青海湖（漸與易）〉
中國 / 1989
Qinghai Lake (Turning & Change)
China / 1989
P.80

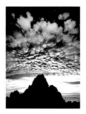

〈黃山（勢與漸）〉
中國 / 1989
Huangshan (Power & Permeation)
China / 1989
P.98

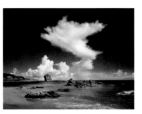

〈墾丁（揮與穩）〉
臺灣 / 1989
Kenting (Dispersion & Stability)
Taiwan / 1989
P.113

〈宏村〉
中國安徽省黟縣 / 1990
Hongcun
Yi County, Anhui Province, China / 1990
P.74

〈寶綸閣〉
中國安徽省黃山市 / 1990
Baolun Temple Pavilion
Huangshan City, Anhui Province, China / 1990
P.75

〈黃山（容與融）〉
中國 / 1990
Huangshan (Enfolding & Merging)
China / 1990
P.92

〈獨秀峰〉
中國廣西省桂林市 / 1990
Duxiu Peak
Guilin, Guangxi Province, China / 1990
P.104

〈徽斑弄紋（南門市場）〉
臺灣 / 1990
Patterns of Mold Spots (Nanmen Market)
Taiwan / 1990
P.156

〈徽之灑綴（北海岸）〉
臺灣 / 1990
*Embellished with a Spray of Mold
(North Coast)*
Taiwan / 1990
P.157

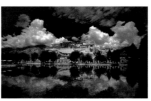

〈布達拉宮〉
中國西藏 / 1991
Potala Palace
Tibet, China / 1991
P.78

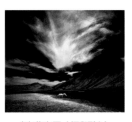

〈青藏高原（揮與點）〉
中國 / 1991
*Qinghai-Tibet Plateau (Dispersion & Focal
Point)* / China / 1991
P.81

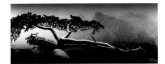

〈黃山（揮與凝）〉
中國 / 1991
Huangshan (Dispersion & Condensation)
China / 1991
PP.100-101

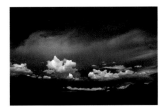

〈青藏高原（揮與凝）〉
中國 / 1991
Qinghai-Tibet Plateau
(Dispersion & Condensation)
China / 1991
PP.106-107

〈新安江〉
中國安徽省 / 1991
Xin'an River
Anhui Province, China / 1991
P.113

〈最後的鹽湖（西藏）〉
中國 / 1993
The Last Salt Lake (Tibet)
China / 1993
P.109

〈西遞村〉
中國安徽省黟縣 / 1995
Xidi Village (Huizhou)
Huangshan City, Anhui Province, China
/ 1995
P.76

〈黃山〉
中國 / 2000
Huangshan
China / 2000
P.73

〈桂林〉
中國 / 2000
Guilin
China / 2000
P.129

〈南雅（質與點）〉
臺灣 / 2005
Nanya (Texture & Focal Point)
Taiwan / 2005
P.68

〈桃花系列（西湖）〉
中國 / 2005
Peach Blossom Series (West Lake)
China / 2005
P.159

〈桃花系列（西湖）〉
中國 / 2005
Peach Blossom Series (West Lake)
China / 2005
P.159

〈桃花系列（西湖）〉
中國 / 2005
Peach Blossom Series (West Lake)
China / 2005
P.159

〈陽朔〉
中國廣西省桂林市 / 2010
Yangshuo
Guilin, Guangxi Province, China / 2010
P.105

〈杭州〉
中國 / 2010
Hangzhou
China / 2010
P.135

〈老梅〉
臺灣 / 2010
Laomei
Taiwan / 2010
PP.164-165

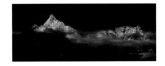

〈梅里雪山〉
中國西藏 / 雲南 / 2015
Meili Snow Mountain Range
Tibet, China / Yunnan / 2015
PP.110-111

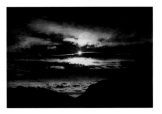

〈合歡山〉
臺灣 / 2015
Hehuanshan
Taiwan / 2015
P.132

〈安徽省歙縣〉
中國 / 2015
She County, Anhui
China / 2015
P.138

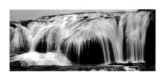

〈貴州陡坡塘瀑布（安順市）〉
中國 / 2015
Doupotang Waterfall, Guizhou
(Anshun City)
China / 2015
P.141

〈荷鏡（南投名間）〉
臺灣 / 2015
Lotus Mirror (Mingjian Township, Nantou)
Taiwan / 2015
P.146

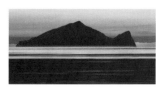

〈龜山島（漸）〉
臺灣 / 2015
Turtle Island (Permeation)
Taiwan / 2015
P.150

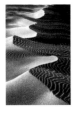

〈老梅（婉與約）〉
臺灣 / 2016
Laomei (Grace & Restriction)
Taiwan / 2016
P.117

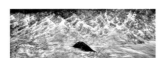

〈老梅〉
臺灣 / 2016
Laomei
Taiwan / 2016
PP.126-127

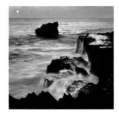

〈墾丁龍坑〉
臺灣 / 2016
Longkeng, Kenting
Taiwan / 2016
P.128

〈京都〉
日本 / 2016
Kyoto
Japan / 2016
P.139

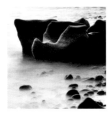

〈老梅〉
臺灣 / 2016
Laomei
Taiwan / 2016
P.140

〈臺北植物園（易與蜿）〉
臺灣 / 2016
Taipei Botanical Gardens
(Change & Meandering)
Taiwan / 2016
P.147

〈臺北植物園（紛與約）〉
臺灣 / 2016
Taipei Botanical Gardens
(Disparity & Restriction)
Taiwan / 2016
P.148

〈臺北植物園（點與凝）〉
臺灣 / 2016
Taipei Botanical Gardens
(Focal Point & Condensation)
Taiwan / 2016
P.148

〈臺北植物園（易與勢）〉
臺灣 / 2016
Taipei Botanical Gardens
(Change & Power)
Taiwan / 2016
P.149

〈京都（流與霞）〉
日本 / 2016
Kyoto (Flow & Sunset Glow)
Japan / 2016
P.149

〈臺北植物園（凝與約）〉
臺灣 / 2016
Taipei Botanical Gardens
(Condensation & Restriction)
Taiwan / 2016
P.151

〈天后宮（臺南市）〉
臺灣 / 2016
Tianhou Temple (Tainan City)
Taiwan / 2016
PP.160-161

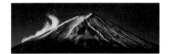

〈富士山〉
日本 / 2017
Mt. Fuji
Japan / 2017
PP.96-97

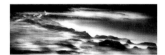

〈老梅（融）〉
臺灣 / 2017
Laomei (Enfolding)
Taiwan / 2017
PP.154-155

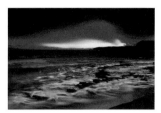

〈老梅〉
臺灣 / 2018
Laomei
Taiwan / 2018
P.132

〈臺北植物園（勢與漸）〉
臺灣 / 2018
*Taipei Botanical Gardens
(Power & Permeation)*
Taiwan / 2018
PP.152-153

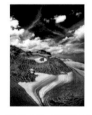

〈龜吼（蜿、覆與凝）〉
臺灣 / 2019
Guihou (Meandering, Covering, & Condensation)
Taiwan / 2019
P.116

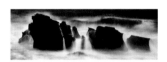

〈龜吼（流與凝）〉
臺灣 / 2019
Guihou (Flow & Condensation)
Taiwan / 2019
PP.120-121

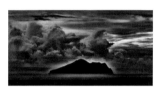

〈龜山島〉
臺灣 / 2020
Turtle Island
Taiwan / 2020
P.69

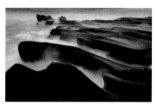

〈老梅〉
臺灣 / 2020
Laomei
Taiwan / 2020
PP.142-143

〈隨舞〉
臺灣 / 202
Spontaneous Dance
Taiwan / 2020
PP.154-155

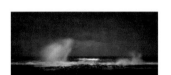

〈老梅（揮與凝）〉
臺灣 / 2021
Laomei (Dispersion & Condensation)
Taiwan / 2021
PP.114-115

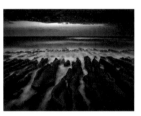

〈老梅（勢與凝）〉
臺灣 / 2021
Laomei (Power & Condensation)
Taiwan / 2021
P.118

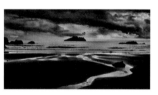

〈外澳〉
臺灣 / 2021
Wai'ao
Taiwan / 2021
P.119

〈老梅（流）〉
臺灣 / 2022
Laomei (Flow)
Taiwan / 2022
P.158

〈岩利紋〉
臺灣 / 2022
Yanliwen
Taiwan / 2022
P.162

〈和尚岩（龜吼）〉
臺灣 / 2022
Heshang Cliff (Guihou)
Taiwan / 2022
P.163

臺灣攝影家 Photographers of Taiwan

莊明景　Mike CHUANG

作　　者｜莊明景　胡詔凱　姜麗華
研究主編｜胡詔凱

指導單位｜文化部
出 版 者｜國立臺灣美術館、國家攝影文化中心
發 行 人｜廖仁義
編輯委員｜汪佳政　亢寶琴　蔡昭儀　黃舒屏　林明賢　賴岳貞
　　　　　尤文君　曾淑錢　駱正偉　吳榮豐　粘惠娟
諮詢委員｜張蒼松　簡榮泰　王雅倫　梁秋虹　賴雯淑
審查委員｜簡榮泰　張蒼松　龔卓軍　曾少千　鍾宜杰　沈柏逸　高榮禧
執行編輯｜王建鈞　江訢楉
地　　址｜403 臺中市西區五權西路一段2號
電　　話｜04-2372-3552
傳　　真｜04-2372-1195
網　　址｜https://www.ntmofa.gov.tw

編輯印製｜左右設計股份有限公司
專案顧問｜姜麗華
專書審訂｜高志尊
叢書主編｜呂筱渝
文字審校｜鍾悠儀
英文翻譯｜William Dirk（杜文宇）
英譯審稿｜林道明
影像提供｜莊明景　國立歷史博物館
總　　監｜施聖亭
執行編輯｜蘇香如　洪可殷
圖片編輯｜洪世聰
美術設計｜吳明黛　鍾文深
地　　址｜106 臺北市大安區仁愛路3段17號3樓
電　　話｜02-2781-0111

初　　版｜2023年2月
定　　價｜980 元
GPN　　1011101851
ISBN　　978-986-532-727-9

國家圖書館出版品預行編目(CIP)資料

臺灣攝影家：莊明景 = Photographers of Taiwan : Mike Chuang/胡詔凱研究主編兼主筆；姜麗華專文.
-- 初版. --
臺中市：國立臺灣美術館, 2023.02
224 面；21.5 × 27.1公分
ISBN 978-986-532-727-9（精裝）
1.CST: 莊明景 2.CST: 攝影師 3.CST: 攝影集
959.33　　　　　　　　　　　　111019137

國家攝影文化中心——臺北館
100007 臺北市中正區忠孝西路一段70號

國家攝影文化中心——臺中辦公室
403354 臺中市西區自由路一段150號5樓

國家攝影文化中心網址
https://ncpi.ntmofa.gov.tw/